...aly and studied Art History at ... the author of *Andes* (Granta, 2010) and *The Robber of Memories: A River Journey Through Colombia* (Granta, 2012), among many other books. He divided his time between London and a remote Spanish village. He died in January 2014.

ED VULLIAMY is an award-winning senior correspondent for the *Guardian* and *Observer* newspapers. He is the author of *Amexica: War Along the Borderline*, which won the Ryszard Kapuściński Award for literary reportage, and *The War is Dead, Long Live the War: Bosnia, the Reckoning*.

'The story twists and turns back on Jacobs: the boyish humanity and exuberance; his wide-eyed openness to wonder; his altogether un-English rush of enthusiasm – is all on show . . . An exceptionally gifted writer' *Financial Times*

'Jacobs writes from close up, as he would look at a painting, with openness, curiosity and passion' Marion Coutts

'His gift of cheerful observation, combined with profound intellectual interpretation, is compelling . . . A delight' *Literary Review*

'An interesting discourse on Velázquez's marvellous painting and a fitting tribute to a compelling author . . . [The] enormous discipline and dedication and the vivid lucidity that characterized [Jacobs'] writing is very apparent even in this incomplete text . . . a pleasure to read' *History Today*

'A heart-rending personal quest to piece together a painting that touches Jacobs, but ultimately eludes his grasp, as it does all of us. That it will remain unfathomable is surely by the Old Master's design, although all the enjoyably circuitous roads that the author takes away from the work itself – into London academic life and

the travails of contemporary Spain – eventually lead back, almost comically, to *Las Meninas* and to Michael. Perhaps my connection to his text is not just cultural or coincidental but universal, that what I relate to is his clear understanding of how works of art reach out to us all, if not equally then differently and profoundly, across barriers of time and place' Ossian Ward

'[A] clear-eyed look at Velázquez's masterpiece by one of our most animated and engaging writers on art . . . part travelogue and part autobiography, sadly interrupted but curated with much flair and affection by Ed Vulliamy, whose poignant coda is a tribute to friendship and shared passions. How uplifting to know that, right to the end, Michael Jacobs was still eagerly chronicling – with the same combination of droll scepticism and enthusiastic wonder – the many lands, both geographical and intellectual, through which he passed' Ross King

'Every book by Michael Jacobs combines adventure, autobiography and scholarship in a unique blend of warmth, humour and vivid prose. The wide-ranging story of the quest for Velázquez's *Las Meninas*, from Michael's school days to a contemporary crisis-ridden Madrid, is a perfect example. Sadly, this aptly titled last work is a bittersweet reminder that an untimely death has robbed us of the irreplaceable and irrepressible Michael Jacobs' Paul Preston

'A novel and highly beguiling fusion of art history, autobiography and observation of contemporary Spain' Martin Gayford

'Open-minded, fragmentary and full of curiosity' *Oldie*

EVERYTHING IS HAPPENING

Journey into a Painting

MICHAEL JACOBS

with a foreword, introduction and coda
by Ed Vulliamy

GRANTA

Granta Publications, 12 Addison Avenue, London, W11 4QR

First published in Great Britain by Granta Books, 2015
This paperback edition published by Granta Books, 2016

9 8 7 6 5 4 3 2

ISBN 978 1 84708 808 6 (paperback)
ISBN 978 1 84708 809 3 (ebook)

www.grantabooks.com

Typeset by Avon DataSet, Bidford on Avon, Warwickshire
Printed and bound by CPI Group (UK) Ltd, Croydon, CR0 4YY

After Michael became ill, every meeting with his doctors would begin with him saying 'I must go to Spain and I must finish my book'. He did go back to Spain and, thanks to Ed Vulliamy and Granta, here is his book.

Jackie Rae

CONTENTS

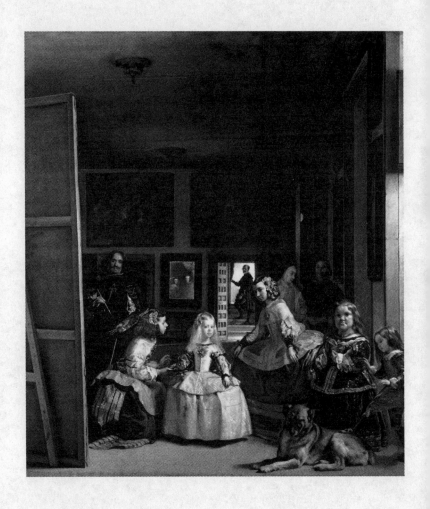

FOREWORD

The travel writer, Hispanist and art historian Michael
Jacobs was working on this book when he died. It was to
be his magnum opus: an attempt to unlock the secrets of
the painting he considered to be the greatest work by the
artist he esteemed above all others: *Las Meninas* by Diego
Velázquez. It was also intended to be a reflection on the
study and fruitful enjoyment of painting – which to Michael
were not necessarily synonymous. Michael Jacobs was a
writer who defied 'genre', and he planned to delve into his
own experience in art history to define a personal vision
for how to look at a work of art, which grew in part out of
his tutelage with perhaps the greatest British art historian
of his generation: the former director of the Courtauld
Institute and Surveyor of the Queen's Pictures, Anthony

Blunt. Michael remained fiercely loyal to Blunt after he was exposed in 1979 as a spy for the Soviet intelligence services; Michael's book was to have been about that too.

In late September 2013, Michael went for an examination of what he thought was probably lumbago, causing him an irritation of the back. He was instead diagnosed with aggressive renal cancer, and given between three and five years to live. Michael thought he had enough time to complete the book, to which he was passionately committed. But in the event, he was dead within three and a half months – passing away at St Bartholomew's Hospital, London, on 11 January 2014.

Though Michael had written half the book by the time of his death, it was not arranged in any order. And this is what Jackie Rae – Michael's partner since the 1970s whom he had married shortly before his death – painstakingly did, collating the manuscript on the basis of the dates on which Michael had written this passage or that.

So what follows is the book which Michael Jacobs had begun but left unfinished, preceded by an introduction to *Las Meninas* which I have written – based in part upon Michael's own writing elsewhere and biographies he trusted – and followed, in the interest of fulfilling Michael's wishes, by a coda, drawn from the conversations I had with Michael during his last months about how he wanted his book to unfold. Or rather – as death assailed him at a pace he himself refused publicly to acknowledge until the final few days – how it might have ended had he lived, even for six further months, to write it. Conversations which became

progressively poignant yet brilliant as death approached, right up until thirty-six hours before Michael's end. What results is a book that is indeed about Velázquez and his picture, but is also, as importantly, a heartfelt manifesto for the liberation of how we look at painting. An intelligent route carved out between the vulgarity of mass tourism on the one hand, and rarefied documentarism of 'art history' on the other.

Michael wanted this. So writing the bookends to his text and assembling the result, which you now behold, has been at once like a seance – more Ouija-board than keyboard – and an intense, daunting but strangely effortless homage to a lost friend to whom, and to whose work, no words can do justice. As Michel Foucault, whose ideas on Velázquez play a crucial part in what follows, wrote: 'It is in vain that we say what we see; what we see never resides in what we say.' And as Samuel Beckett – whom Michael admired, and whom we often discussed – asked: what will we do when even words fail? And answered, on another occasion: we try again, fail and fail better.

So here it is: me trying again, now that words have failed.

Ed Vulliamy,
Genova, October 2014

INTRODUCTION

At first glance, *Las Meninas* – which translates as 'The Ladies in Waiting' – appears to be what one might call in England a 'Conversation Piece'; a royal group of sorts, though more intimate. And yet there is no conversation. Quite the reverse: there is a powerful mood in the room and it is silent. Silence is the quintessence of the painting.

Here is the painter Velázquez, in a room at the royal palace of Philip IV of Spain, at work with his palette and before a canvas, in the company of the King's daughter and her entourage. The first thing we notice is that most of the figures are frozen – in their stares and manner, and some even in suspended gestures; their attention caught by, and focussed on, some presence outside the frame. The stare of those aware of this external presence is in our direction,

which is also apparently that of Velázquez's sitter or subject. This, one can presume from the reflection in the mirror on the back wall, is likely to be King Philip IV and Queen Maria Theresa, whose faded images we see, almost spectral, in the glass.

The awe experienced by a beholder of the painting is so profound, wrote Palomino, the first real chronicler of the lives of the great Spanish painters, that 'it ceases to become art, to become life itself'. 'Life itself' is a phrase Michael uses and relishes in the unfinished book to follow – the ultimate compliment, on the surface of things, to a work of representation. Michael is hardly alone in his wonder. The Italian master Luca Giordano, taken by King Charles II to see the painting, was asked by the King: 'What do you think of it?' and famously replied: 'Sire, this is the theology of painting.'[1]

The picture has become iconic: a national treasure of Spain, poster and fridge magnet, model for paintings by Picasso and others and a riddle that confounds to this day. 'At the beginning of the twenty-first century,' writes the art historian Suzanne Stratton-Pruitt, 'despite all the analyses of it, *Las Meninas* still somehow eludes us.'[2] '*Las Meninas*,' confers another expert, the painter Avigdor Arikha, 'is no doubt Velázquez's most remarkable and most haunting masterpiece. It hits one's senses like nothing else, and we don't grasp why.'[3]

Why is the painting so baffling? The stares directed towards us from within it, and the presence of the mirror at the back, reflecting the royal couple apparently in the

place where we are standing, are largely responsible for the enigma. The depiction of mirrors was common in painting at this time and earlier – most often in Flemish art. But this was invariably to offer a different view of what is contained in the frame or – as in the famous portrait of the Arnolfini wedding couple by Van Eyck – to optically distort the contents of the picture. Never until *Las Meninas* was a mirror deployed to reflect something outside the picture, in this eerie way. As Joseph-Émile Muller suggests, the mirror becomes: 'an ingenious device to give weight to the minor characters and turn into insubstantial ghosts the two who, in reality, occupied the dominant positions'.[4] 'Velázquez,' writes Marco Carminati, 'seems to want to involve us in a refined intellectual game in which what appears to be real turns out to be an illusion.'[5]

The fact of the mirror in this waltz between reality and illusion is crucial in itself, argues Enrique Lafuente Ferrari, former director of the Velázquez Institute in Madrid. 'Pure vision,' he writes, 'is the image, in an inaccessible space, that a mirror gives us. In a mirror vision takes on the character of a concept: things are or are not, exist or vanish, just as to Calderón life appeared to be a dream, and a dream life.' Ferrari refers here to the most famous work in Spanish Golden Age drama, by a playwright whom Michael Jacobs admired: Pedro Calderón de la Barca. *La Vida es Sueno* – Life is a Dream – was written in 1635 as a meditation upon fate and free will, and its theme, as the title suggests, is that what we live is but a dream, and that dreams are life, as experienced in the play by a prisoner called Segismundo.

The same notion preoccupied Shakespeare and another of Michael's Spanish favourites, Lope de Vega. Ferrari continues: 'Mirrors . . . play an important role in several paintings by Velázquez. He was fond of them: in the inventory of his household belongings drawn up after his death, ten mirrors are listed.'[6]

Does this, then, make *Las Meninas* a painting of and about Philip IV and his queen? Or is it a self-portrait of Diego Velázquez? Or a 'Conversation Piece' depicting the Infanta, her maids and inner circle? The first analyst of the painting, the Portuguese Felix da Costa, writing in 1696, thought that 'the picture seems more like a portrait of Velázquez than the princess'. Or is it a picture of us, indeed, as we observe the scene of those observing us? Or all, or none, of the above? Perhaps it is a painting about painting, some mercurial visual essay on the artist's act of representation? Or is it a depiction of the coexistence of reality and illusion? These are among the mysteries of *Las Meninas*, and so the innumerable questions continue.

'Velázquez is an artist whose works are so dazzling in their technique and so uncannily lifelike that it is difficult at times to think of him as a man of flesh and blood.' So opens Michael Jacobs's introduction to an earlier book, *Lives of Velázquez*, which combines the only two biographies of the Spanish master he considered dependable. One was that by Velázquez's father-in-law, Francisco Pacheco, the other the so-called Spanish Vasari – Antonio Palomino.[7]

Diego Rodríguez de Silva Velázquez came from a

Portuguese family on the side of his father Juan Rodríguez de Silva, possibly with some Jewish heritage, while the family of his mother, Dona Jerónima Velázquez, was native to Andalusia where the painter was born, in Seville during 1599. By Andalusian custom, he took his mother's name.

The Seville into which Velázquez was born was on the cusp; the beginning of its end as Spain's predominant city. By the middle of the twelfth century, it had become the third largest metropolis in the world after Rome and Venice, and the poet Luis de Góngora had called it 'the great Babylon of Spain, map of all nations'. But Seville was also headquarters of the Inquisition. Indeed, the 'Golden Age' which followed the unification of Spain in 1492 was accomplished, writes Michael Jacobs, 'in a spirit of brutal fanaticism', with the expulsion or enforced conversion of Andalusia's many Moors and Jews. This dogmatism and what we would now call 'ethnic cleansing' had a major and insidious demographic impact on the city, yet Seville remained characterised by 'an architecture . . . of great contrasts', wrote Michael, for 'alongside the Muslim-inspired love of decorative arts richness is an inherently Spanish love of the austere'.[8]

The proximity of people to one another, and of rich to poor, caused plague to scourge Seville during the 'Golden Age', including one pestilence at the turn of the century, 1599–1601, when Velázquez had just been born, decimating the city's population. Seville, writes Michael, 'barely had time to recover when, in 1609, all of Spain's *Moriscos* [converted Moors] were finally expelled from the country'.[9]

And yet 'the obsession with money was one which united all social classes' in Seville, Michael writes in a voluminous guide to Andalusia. The opening of new markets in the Americas created an economy based on the export of olive oil, wine, biscuits, gunpowder and slaves. Seville's population had doubled between 1530 and 1580 to an estimated 85,000 souls, a conurbation which embraced, writes Michael, 'a notorious underworld of thieves, murderers, muggers, swindlers, card-sharps, prostitutes, pimps, entrepreneurs, black-marketeers and all kinds of seekers of fortunes and refugees from justice'.[10]

Through the maelstrom of pestilence and expulsion, young Velázquez developed a passion for painting, and was admitted in 1610 to what Palomino calls 'a gilded cage of art' and learning run by Francisco Pacheco. Michael Jacobs calls it 'an important studio' for all Pacheco's own 'stiff, Michelangelo-inspired paintings and murals'. After five years as Velázquez's tutor, Pacheco writes: 'I gave him my daughter in marriage, persuaded to it by his virtue, chastity and good qualities, and by the expectations raised by his great native talent.'

Velázquez excelled. He had what Jacobs calls 'the innocent eye . . . responsible solely to his pictorial instincts'. Young Velázquez, Michael continued, 'stressed his independent position in two significant ways: he painted directly from human models rather than from the antique; and he loved producing genre scenes, or what the Spaniards of his generation began calling *bodegones* (literally tavern scenes)'.[11] Although Velázquez did paint religious subjects,

he painted relatively few, given the power of the church as patron and presence in society.

Michael liked to think that this suggested a roguish – epicurean and populist – trait in Velázquez's character, which he would have seen as typically Andalusian. He yearned for the kind of exposé of Velázquez's mercurial personality with which historians had unpeeled some of his favourite Spanish literary figures from the period.

It is of great frustration to Michael Jacobs that 'Palomino, like Pacheco before him, is so reverential towards Velázquez that it is difficult to imagine what the artist really was like as a person'. Although the Velázquez expert Enrique Lafuente Ferrari has this to say, which pleased Michael: 'One hesitates to imagine [Velázquez] as a gay and sociable comrade. Yet the imprint of the Sevillian genius seldom fails to make itself felt . . . And that imprint is stamped on the rare, pithy, pertinent phrases from Velázquez's mouth which have been preserved. In Madrid he was nicknamed El Sevillano. He never lost the delicate accent of his native province in his manner of speaking Castilian.'[12]

Michael was also interested in Velázquez's apparent obsession with his father's noble lineage. Velázquez claimed that the De Silva family was descended from Silvius, mythical founder of Portugal and son of Trojan Aeneas, creator of Italy and child of Aphrodite, no less. Palomino records of the Silvas that 'fortune unleashed its ire and changed their state', though Michael thinks the family – who came to Seville from Portugal during the 1580s – were probably middle-class merchants, as were Velázquez's maternal

forebears. But, as the Spanish writer José Ortega y Gasset observed in 1945: 'The preoccupation with their lineage must have been obsessive . . . In the initial and deepest layer of his soul, Velázquez found this commandment: "You must be a nobleman."'[13]

Such an obsession, posits Michael, would explain Velázquez's apparently brazen ambition when he reached court. In 1623 he was introduced to Madrid and Philip IV, on Pacheco's recommendation, by his friend Don Juan de Fonseca y Figueroa, Chief Officer of the royal chapel, who was also canon of Seville Cathedral, and immediately found favour with the King. In 1623, he was appointed 'Painter to the Bedchamber', for a salary of twenty ducats a month, which increased exponentially as favour and praise grew and further offices accumulated.

Philip IV – great-grandson of Holy Roman Emperor Charles V and grandson of Philip II, who had overseen the Golden Age – inherited an expanse spanning much of the mapped world, across Europe and the Americas. But King Philip took unnaturally to affairs of state, with keener interests in painting, theatre and learning, hunting and amorous relationships. He seems to have been manic depressive, oscillating between an innate vitality and a passion for things of beauty, and bouts of acute depression. Philip was a reluctant soldier, but for the first half of his reign, Spain was able to live in the aura of its fading Golden Age by squandering wealth plundered in the New World on relentless military campaigns. And at court, that aura lingered, nowhere more obviously than in the fabulous

collection of paintings collected by Philip IV's forebears.

Velázquez would have seen the mighty work of his predecessor as court painter, Titian, whose epic portraits of Charles V, Isabella of Portugal and Philip II hung in the palace and El Escorial. Also hanging there were paintings by Tintoretto, Correggio, Veronese and Ribera – and the turning point in Velázquez's own style came when he was granted his greatest wish, to visit Italy, in 1629–30. Velázquez stayed with the Spanish ambassador in Venice, where he studied the masterworks of Titian and others; thence to Ferrara and Cento to meet Guercino, and on to Rome.

Back in Madrid, the strong influences of Velázquez's Italian journey were quickly deployed in the service of the Habsburg dynasty during the latter half of the 1630s. He portrayed Philip's heir, Balthasar Carlos, and the epic *Surrender of Breda*, in which Velázquez notably pays attention just as carefully to roughneck foot-soldiers and onlookers as he does to the moment's main protagonists. This psychological perception, this interest in and ability to convey human nuance, charged Velázquez's great paintings of the late 1630s and early 1640s: his portrayals of the gods of Olympus bring them down to earth; Aesop and the Greek philosophers are portraits of everyman, of rugged, hermitic wisdom.

But above all, there is the poignant and percipient sensibility of the first great paintings of dwarves: *Calabazas*, apparently blind but all-seeing; *El Primo*, the wise and learned fool; and the delicately cocked head of young *Francisco Lezcano*, in his isolated affliction – culminating

in the defiantly wise stare of *Sebastián de Morra*, with his exaggeratedly foreshortened legs and fine red robe.

Velázquez the courtier was busy too, arranging for the decoration of royal quarters at the Alcázar palace and El Escorial retreat outside Madrid. In exchange for the copious favours bestowed upon him, Velázquez was to allow Philip free access to watch him at his canvasses whenever the royal spirit was so moved – which was often, compelled as Philip was by his court painter. The synergy between monarch as patron and painter as confidant opened the way for Velázquez's further career as collector for Philip IV, as the King sought to equal and even outflank the passion for art for which his grandfather, Charles V, had been renowned. And it was this task which set Velázquez en route for Italy a second time in 1648, arriving in March 1649.

This was a longer trip, again starting in Venice, travelling to Rome via Modena, Parma and Florence. Once in the eternal city, Velázquez the emissary arranged for casting of antique sculpture, that copies might be made for Spain – a bureaucratically arduous distraction from his study of the Italian masters, and the work that resulted. He did find time, though, to sire an illegitimate son and paint the magisterial portrait of Pope Innocent X – his posture pontifical, but his expression weary, his stare calculating.

Most of Velázquez's work from the early 1650s is portraiture as Habsburg diplomacy. By now, Philip had become a melancholy man: his queen, to whom he had begun to show belated affection, had died in 1644. The succession became a matter of increasing concern when his heir Balthasar Carlos

died two years later, after his betrothal to Princess Mariana of Austria – a match which had been intended to fasten ties between the Spanish Kingdom and the Habsburg Empire. Philip continued his matrimonial policy between the two branches of the Habsburg Dynasty – Spanish and Austrian – by marrying, in 1649, the very same woman to whom his son had been betrothed, now Queen Mariana of Austria (she was also his niece). Queen Mariana now of Spain gave birth in 1651 to Princess Margarita Theresa, of whom more later when we reach *Las Meninas*, of which she is formally the central figure.

But the long revolt of the Netherlands approached its denouement: defeat for Spain and loss not only of the Low Countries but with them domination over the Atlantic. Meanwhile, Spain's economy was sinking under the weight of the Thirty Years War. Velázquez was unable – given his patron's insistence on lifelike representations – to avoid this dejection around the monarch, whom he now painted with greater, and highly effective, simplicity, visibly worn by the cares of office. According to the historian Xavier de Salas, X-rays of Velázquez's portraits of the King show that his first sketches had a 'much less regal appearance: softer and sorrowful; the features were first painted in a realistic way, and afterward heightened to emphasize majesty'.[14]

Velázquez's favour with the King leads Palomino to consider what he calls 'envy' and 'spurious shadows' to which he was subject. Resentment among the nobility reached critical mass when Velázquez became a candidate for the Order of the Knighthood of Santiago, to which

he would be ordained at a sumptuous ceremony in 1658. Velázquez's desire to achieve admission to the order can only have been made more ardent by the fact that Titian had received the title of Count Palatine from Emperor Charles V. An 'impediment' was created by nobles who (rightly, from their pompous point of view) questioned the artist's aristocratic lineage, to which Philip retorted: 'Write down that I am certain of his nobility.' The story illustrates the intimate relationship between the painter and the monarch, even suggesting a degree of dependence by the man of power on a sole confidant. Palomino notes how 'His Majesty confided more in him than a King usually does in his vassal, and discussed with him difficult matters, especially in those more intimate hours when the noblemen and other courtiers have retired'. Whether the 'difficult matters' were personal or affairs of state, the scene is irresistible: the monarch staying up late with his brilliant favourite, pomp cast aside, man-to-man, *a quattro occhi*, as the Italians say, four eyes together.

Velázquez in later life was a master, writes Michael in his preface to Pacheco and Palomino, of 'canvasses in which the real life and the otherworldly are often effort-lessly interwoven', and this is what characterises the great late period. It began during a phase when Velázquez stopped painting the King, which was his job, and began two mythological subjects: *Apollo in the Forge of Vulcan* and the extraordinary *Fable of Arachne*, which braved new boundaries of composition and plane in order to make didactic statements about humanity, the gods and existence.

This innovative surge finally produced *Las Meninas* in 1656, which was both a zenith after what had come before and, with hindsight, the gateway to Velázquez's final period.

Velázquez died only four years after completing the picture – like Michael Jacobs, suddenly, though there was an uncanny prescience of his imminent end. According to Palomino, on 8 June 1660, 'when Velázquez entered his house, he was received by his family and friends with more amazement than joy, for news of his death had spread through the Court, and they could hardly credit their eyes. It seems as if this was a presage of how little time he had left to live.'[15] He gives no detail on how this eerie rumour of Velázquez's death came about.

But on the last day of July 1660, Velázquez became suddenly sick with a 'burning sensation', then 'great anguish and pains to the stomach and heart'. On 6 August, aged sixty-one – the same age as Michael – he died, according to Palomino, of syncopal tertian fever.

Velázquez's body was interred the following day, dressed in the habit of the Order of Santiago, four days after which his widow, Juana Pacheco, died also. The inventory of his possessions shows Velázquez to have been a wealthy man, with a large house full of expensive furniture, silverware, tapestries, books and paintings.

Velázquez is unlikely to have known that his end was so close when he painted *Las Meninas*, nor will we ever know whether he intended the painting to be a valedictory statement about himself, or a 'legacy' painting, as it appears to us now. The

group it portrays has an almost musical, albeit contrapuntal, harmony to it – a movement like that of a *concerto armonico* by that magician of baroque melancholy, Gianbattista Pergolesi – though all stand still. The movement lies between what we instinctively know to have happened immediately before, and feel might occur immediately after, this snapshot. And it is driven by the polyphonic tones of silver and deep shadow, the scattered bright colours which emphasise the casting of light from a multiple secrecy of sources. The room is in the *pieza principal*, or the royal family's residential apartments, rather than the artist's studio – which makes our glimpse of the scene all the more intimate.

Something like it is described in the diary of a courtier called Madame de Motteville, quoted in the first monograph to be written on *Las Meninas*, by Carl Justi, in 1888: 'In Madame de Motteville's memoirs,' writes Justi, 'there is a description of her visit to the Spanish Infanta, made while remaining in the doorway: "She is served with great honours, few have access to her apartments and it was by special favour that we were permitted to remain in the doorway. If she wishes to drink something, the page hands a glass to a maid of honour who curtsies while the page bows; on the other side another maid hands her a napkin, while in front of her is a lady in waiting." Does not this seem to you a description of *Las Meninas* by Velázquez?'[16]

Meninas is a word of Portuguese origin, to describe young girls of noble birth, daughters of aides to the crown placed by their fathers in the service of the Infanta as ladies-in-waiting, for career advancement all round. They could hold

the post until they were deemed old enough to wear high-heeled shoes. The group has been identified by Palomino. To the artist's left is Maria Agustina Sarmiento, daughter of the King's Chief Councillor for War, Don Diego Sarmiento. She has a beautiful porcelain complexion, slightly flushed at the cheek, or else wears rouge; she kneels forward with delicate elegance, her hair held back by a butterfly ribbon; the shine on her dress is like quicksilver but carefully less lambent than that of the Infanta. For all its awkwardness in her kneeling position, the dress flows. The maid is entirely focussed on the princess, and though she kneels, her perfectly poised left hand holds a jug known as a *bucaro* on a tray, with which to refresh – with whatever its contents are – the Infanta, who is about to take it with her right hand.

A *bucaro* took its name from scented, reddish earth from which special pottery was made, and which gave a fragrance to water stored in it. Considered a luxury, the pots were exported from Portugal, and were perhaps of interest to Velázquez for that alone. But Michael Jacobs was working on another theory when he was taken ill, to which his Hispanist friend Gijs van Hensbergen is also attracted: that the *bucaro* could contain a dose of 'cocoa'.

'Hot chocolate was prepared,' says van Hensbergen, 'that is to say pure cocoa beans chopped up, and served in a *bucaro*. It had psychotropic qualities and in those days, women of the upper classes became totally hooked on it. Priests would preach, in their sermons, about the evils of the chocolate craze.' J. S. Bach addressed a similar drug craze of its day: addiction among the ladies of Leipzig to coffee,

consumed in quantities that were also psychotropic, as a kind of eighteenth-century 'speed'. In his 'Coffee Cantata' of 1732–4, Bach set to music a poem by Christian Friedrich Henrici in which a Herr Scheldrian scolds his daughter Lieschen for her obsession with coffee over the pursuit of a husband.

And not only chocolate: 'It was said also,' reports van Hensbergen, 'that the *bucaro* contained a chemical, which may have been lead, that whitened the skin – and her skin is certainly very white. Ladies would bite off a bit of unglazed *bucaro* from the jug, made of this wonderfully mysterious clay from Mexico.'

On the Infanta's other flank is Dona Isabel de Velasco, daughter of Don Bernardino López de Ayla y Velasco, a 'Gentleman of the bedchamber' at court, Palomino informs us. She is a little older than her opposite number, having been appointed by the Queen on Boxing Day 1649; she died three years after the painting was done. Like her partner in care of the princess, her pale face is flushed or rouged. But unlike her partner, Dona Isabel, though she curtsies towards the Infanta, is focussed, almost as though startled, on this unknown and unseen presence outside the frame, where the viewer of the painting stands, which likewise, and strikingly, commands the stare of the artist, the Infanta and the dwarf to her left – of which more later, as Michael's book proceeds. Her hair, slicked back at the temple, is sumptuously decorated, and her dress, again though awkward, is painted with lavish care. Velázquez's copious application of impasto causes light to glisten across

the surface of the dress's material – a technique brought to perfection by his contemporary Rembrandt van Rijn, on the groom's sleeve in his *Jewish Bride* painted nine years later, in 1667.

Both *Meninas* wear the fashion of the day: dresses made voluminous by a crinoline – a structure of metal hoops formed into a dome-shaped cage over which the skirts were arranged. They also wear the kind of corseted bodice designed to create the slimmest waist and silhouette possible and constrict the bust – and a cause of agony in life after puberty. Dona Isabel compliments her fellow *Menina* harmoniously: choreographically and thematically, she appears to guard over as well as to serve the princess. The two *Meninas* create a kind of bower around the Infanta, their charge.

The two dwarves are strikingly different; one is the macrocephalous Mari-Bárbola, a 'senior' and famous dwarf at court 'of formidable aspect', says Palomino. Mari-Bárbola was of German origin, and features also in a painting of 1666 by Juan Bautista Martínez del Mazo, Velázquez's son-in-law, wherein she accompanies Prince Balthasar Carlos. Here, she is painted with all the compassion Velázquez afforded the dwarves in previous portraits, and with reverent respect. If her purpose at court and in the picture is in part to show off the beauty of the Infanta to even greater effect through contrast, Velázquez does not overstate this in the slightest; she is statuesque, commanding for all her small size. The other dwarf, a boy on the right with his foot on the dog, is Nicola – 'Nicolasito' – Pertusato who, absorbed in rousing

the animal, is unaware of the unseen presence.

Michael was fascinated by the role of these dwarves: court fools and wise jesters. Although they were intended, cruelly, to entertain with their abnormal physical condition, deeper and mysterious qualities were attributed to them: of intellectual prowess, clairvoyance and the wisdom of the fool – something sinister that cocks a snook at authority and watches the march of time as leveller of all men. Because of this sagacity, perceived or not, dwarves were not only allowed, they were *expected* to goad and pastiche the noble or monarch they served, forever reminding their masters, as did King Lear's fool, of transient existence and the hollow vanity of power in the final hour. When he died, Michael was researching the dwarf Pertusato's family, of aristocratic lineage in Piedmont (indeed, not long before the end, he and I were planning a trip whereby I was to drive him to Turin to find out more about the miniature nobleman). Pertusato entered the royal household in 1650, six years before the painting, and remained there for half a century. It is likely that he replaced the King's favourite dwarf, Francisco Lezcano, painted by Velázquez sitting in a landscape, before he died in 1649.

Nicolasito is here painted with delicacy to match his frame and features, playful in a way that gives the group an extra domestic intimacy, and testing the obviously accustomed patience of the sleepily unmoved hound. This breed of mountain dog, the Spanish Mastiff – referred to in Virgil's *Georgics* as a 'fierce Molossian' – was a fashionable breed in aristocratic homes, and likely favourite of the King

and his family. They were so highly regarded that a royal edict of 1273 restricted their use as sheepdogs.

Also unaware of the unseen presence are two figures behind Dona Velasco and Mari-Bárbola. The lady in a nun's garb, looking pensively aside, is identified as Marcela de Ulloa, 'a lady of honour', says Palomino. She was the widow of a courtier called Don Diego de Peralta, and seems to have taken holy orders upon his death and been recruited to the Palace in 1643. The man next to her is the only figure unnamed by Palomino, with a curiously 'stung' expression painted in broader brushstrokes than the others, as though distracted by some inner vision. He is identified by Palomino as simply *Guardadamas*, a chaperone or 'Ladies' Guard', though some researchers have identified him as a courtier called Don Diego Ruiz de Azcona.[17]

Then there is the figure at the back, proceeding through an open door, whether coming or going we cannot be sure. His glance is ambiguous too: he could, over his shoulder, be staring at the group assembled in the room, or at the unseen presence where we stand, or both. He is identified as Master of the Queen's Bedchamber, her *Apostentador*, called José Nieto. But this man's name has been further researched by Marco Carminati to find, weirdly, that his matronymic is Velázquez – an irony that becomes spine-chilling when we reach the end of Michael's adventure with *Las Meninas*.[18]

Also at the back, on the wall, is the mirror containing the reflected likenesses of King Philip and his queen. It could either show the royal couple sitting for Velázquez, or that which is shown on the artist's canvas itself, or – in

a *trompe l'œil* which would be characteristic of Velázquez and compound the tricks in this painting – both. In either case, it makes the royal couple Velázquez's likely sitters for the painting on which he works.

To the side, on the second plane, Velázquez dominates the scene in terms of mass, though not light. The red on his palette echoes that of the drapery across the top of the reflection in the mirror, suggesting that those we see in its glass are indeed the sitters for a royal double portrait. The brick red also refers to the colour of his cross of the Order of Santiago, which must have been painted on as an afterthought – by whose hand we know not – following Velázquez's inauguration to the order two years after the painting was done. Velázquez's hair is thick, long and free; his posture invites us to 'take me as you find me', his expression neutral but powerful. Of his stare, fixed but at ease, Michael has much to say.

The paintings hanging above the group are of significance. The one to the left tells the story of Pallas and Arachne, as originally painted by Rubens, only this is a copy after Rubens by Velázquez's son-in-law Juan Bautista Martínez del Mazo, who had married the painter's daughter Francisca. The possible importance of the painting to this scene is that it involves the jealousy of a god towards the talents of a mortal. As does the other: the musicianship of divine Apollo challenged by Pan, as originally depicted by Jacob Jordaens and here again copied by Martinez. In his earlier book *Mythological Painting*, Michael writes about the significance to Velázquez of the fact that the gods of Olympus were

flawed, and suggests, as does Marco Carminati, a subversion by Velázquez: that he wielded his paintbrush with greater art than the King wielded his power.[19] If this audacity was inferred by the monarch, it appears to have either been forgiven, or caused no offence.

In the middle of the group stands the royal couple's daughter, Infanta Margarita herself; young but regal, a child but beautiful and dressed in the resplendent finery of her station. In her book on Velázquez, Elizabeth Ripley calls the Infanta 'the darling of court', whose previous portraits had been sent 'to every court in Europe'. Ripley relates that 'Velázquez felt sorry for the little model who [had before] posed so stiffly for her portrait. Then one day . . . Margarita suddenly announced that she did not want to pose. In this fleeting moment, Velázquez saw the princess as she really was, a lively wilful child. The scene remained so vivid that he decided to make it the subject of a painting.' That painting, claims Ripley, was *Las Meninas*.[20] Velázquez has painted her expression to convey both innocence and sagacity, a certain haughtiness but short of a degree that would make her unbecoming. She is majestic, but puckish, lively and wilful indeed. Her dress shows her wearing the latest fashion: a crinoline even at that young age. Carminati relates the Infanta's 'illustrious destiny', betrothed in 1666 'to Emperor Leopold I of Habsburg in order to become Holy Roman Empress, Queen of Germany and Queen Consort of Bohemia and Hungary'. Van Hensbergen tells the story differently: 'she was bred to death, basically, seven years after marriage. By the age of twenty-five or twenty-

six, she would have been pregnant nineteen times. After one miscarriage, she was pregnant again within three months.'

The Infanta's presence leads Palomino to regard the painting as Velázquez's bequest to his own immortality, likening it to 'Phidias's portrayal of himself on Minerva's shield, or Titian's holding an image of Philip II – so that so long as the Goddess and King are recalled – likewise royal Infanta Margarita alongside whom Velázquez places himself in this painting – so lives the artist.' Uncharacteristically, Palomino thus takes an aesthetic priority over royal seniority and protocol, seeing the princess as the focus of the painting – and 'qualification' for Velázquez's legacy – not her father the King or her mother, even though it is they who sit on the throne, command the stare and appear to constitute the all-important unseen presence.

Velázquez had not painted King Philip IV for nearly a decade before *Las Meninas*, even though this was his primary role at court – no doubt because of the ill fortunes of Spain in the Netherlands, in the Thirty Years War and in its domestic economy. Yet here, suddenly and perhaps poignantly, is a painting which has the King 'off-stage' and embraces both his best friend, the painter, and the only surviving child with his wife. (His son, Felipe Próspero, would be born the following year in 1657, subject of a poignant portrait by Velázquez, with charms attached to his skirts to try and ward off the sickness that killed him.) The fact that the King's reflection is faded – on opaque glass, rather than crisp like those mirrors in Flemish art – speaks for itself. The poignant power of this scenario is enhanced

by the fact that – with Felipe Próspero as yet unborn – the succession had been settled in favour of Philip's illegitimate son.

This intimate but gently tragic aura of the painting is in part suggested by the initial hanging of *Las Meninas*, not in the public space that its size would suggest, but in a small private office in the summer quarters of the Alcázar palace called the *Cuarto Bajo de Verano*, where the King himself worked. As the usually lone viewer of the finished painting, and as sitter in the painting's 'off-stage' focal point, Philip IV would be the primary figure around whom the painting is constructed, both as senior member of the family portrayed, albeit in miniature at the back and in reflection, and subject of the canvas on which the artist in the painting works, target of his stare both in the scene depicted in the painting, and in reality as it hangs upon his office wall. But even this interpretation is ambiguous, even questionable: the angle of the mirror in which the royal couple are portrayed in reflection at the back of the scene may *not* actually correspond with the object of Velázquez's stare. This would make sense with reference to Velázquez's palpably erotic earlier painting of reclining Venus, lying with her back to the viewer, to whom Cupid holds a mirror in which her face is reflected. As Michael pointed out, the reflection feigns modesty by showing the face, rather than what it 'would reflect' according to the optical logic of its position and angle: 'a much lower part of the woman's body'.[21] Velázquez may here be up to the same trick, though this time more subtle, baffling and complex, so that the King and Queen

are present, but spectrally, illogically, mysteriously. And so that even the idea of a 'royal portrait', however ingenious, only constitutes part of the answer.

Carminati suggests the possibility of a grander work in progress, depicting what we see in the painting. He posits: 'Let us suppose there was a large mirror – a device typically used for self-portraits – in the viewer's place (that is, where we are standing). The painter could have portrayed himself, the Infanta and her entourage, arranging the models beside him rather than in front of the canvas, in order to reproduce the whole composition reflected in the hypothetical mirror before him. What he is painting on his canvas would be what we see as we look at the painting now.' Then Carminati subverts his own intriguing idea by saying that 'according to the laws of geometry, the mirror in the background cannot possibly reflect what is outside the picture space but must necessarily reflect what is painted on the canvas in front of Velázquez'. But then again: 'there is something else that does not add up. The size of the canvas in front of Velázquez is enormous and almost coincides with the actual size of *Las Meninas* . . . Not one individual or double portrait on such a large scale is known to exist in all the painting of the period.' And so the mystery and questions go round and round in a circle game until, Carminati concludes: 'we should to some extent accept the fundamental ambiguity of this composition – an ambiguity that was certainly deliberate on the part of its author' – and this is Michael's point of departure.[22]

The painting remained in the possession of the royal family – narrowly escaping a fire – until 1819, when the Museo del

Prado was opened. Here, it arrives not as *Las Meninas*, but as *El Cuadro de la Familia* of Philip IV, catalogue number 1174. The name *Las Meninas* appears for the first time in a Prado catalogue written by Pedro de Madrazo in 1843. Michael here traces some of its adventures within the museum itself, but not so much – as he intended to do it later – the painting's 'sanctification and nationalisation', as the historian Alisa Luxenberg calls the rise in status of this work in Spanish culture. Luxenberg traces (and Michael had hoped to explore) how, ironically, it was the interest and attentions of French Romantic, then Impressionist, enthusiasts which initially promoted *Las Meninas*, seeing in it a prescient herald of the revolution in art and representation they themselves advocated, as portrayed in one of Michael's favourite books, *L'Œuvre* ('The Masterpiece') by Émile Zola, about radical intellectual circles around Manet – influenced by Delacroix but forging the Impressionist school. In *Voyage en Espagne*, an early version of the kind of art-travel writing at which Michael was so adept, a famous Frenchman from the Manet circle, Théophile Gautier, wrote of his 'very important artistic pilgrimage' to see the painting.[23]

By the last quarter of the nineteenth century, *Las Meninas* was already becoming the major attraction it remains, as visitors to Madrid blazed a trail for the kind of mass tourism of today which preoccupied Michael as much as its nemesis, the rarefied elitism of art history. And yet even then, the painting's mystery was established as part of its appeal: '*Las Meninas*, which the world looks at, and no one sees,' wrote P. L. Imbert in 1875.[24]

Paul Stirton – Michael's best friend at the Courtauld, and future co-author of a number of books – has written on 'the cult of Velázquez' among artists in Britain at the end of the nineteenth century, itself following in the slipstream of 'the *espagnolisme* that had gripped the French Romantics over the previous three decades'.[25] Crucially, one of the painters hugely influenced by Velázquez was John Singer Sargent, who – along with Michael Jacobs's favourite critic, R. A. M. Stevenson – was a student of Carolus-Duran in Paris. Carolus-Duran, writes Stirton, 'reputedly hectored his students with the rising trivium of "Velázquez, Velázquez, Velázquez, ceaselessly study Velázquez". Sargent, more than any other, had the technical facility to exploit this lesson.' Walter Sickert followed with the confidently simple verdict, of great import to Michael's book, that 'Velázquez was an Impressionist' – a judgement which, says Stirton, 'would later be echoed by virtually all the painters of the New English Art Club, the Glasgow School and the other groupings . . . British artists interested in Velázquez, and by now many were, had to make the pilgrimage to Spain as an essential part of their training' – thus laying Michael's own trail.[26]

Michael himself wrote about those who travelled after Sargent but also before him, including two artists from the Glasgow School 'who introduced to Britain their own brand of Impressionism and accordingly distanced themselves from the stuffy Royal Academy' (thereby clearly impressing Michael!). Joseph Crawhall and Arthur Melville travelled to Spain, where the latter 'developed a literally fatal passion

for the place: he would return to Spain, mainly to Andalusia, every year until 1904, when he contracted typhoid and died at the age of forty-nine'.[27] Edward Burra, writes Michael, 'fell in love with Spain even before he got there' on the basis of paintings he saw in the Louvre, and was traumatised by Franco's Fascist insurgence against the country he came to love, as was – famously – Michael's tutor at the Courtauld, Anthony Blunt, who became a communist during those years. However, 'the one British artist of this period whose work was dramatically transformed by Spain', judges Michael, 'was David Bomberg, who was responsible for perhaps the most exciting landscapes ever painted of this country'.[28]

The composition of *Las Meninas* is crucial to the mystery that compelled these pilgrims and, Michael believed, part of the key to understanding it. The bewildering use of perspective towards multiple vanishing points will, for reasons important to Michael's ensuing text, be considered later. But for now: what an edifice and artifice it is! If the Russian literary critic Mikhail Bakhtin can deploy the musical term 'polyphony' to pertain to a novel, here is its visual expression: a breathtaking range of timbres, of intonations, tones and tonalities; of plane and of palette. It is a dramatically (as in stage-like) harmonious arrangement of figures, at once elegant, caught in a 'snapshot', but Caravaggesque in its dynamism. The two *Meninas* are balanced on each flank by the statuesque figures of the artist and Mari-Bárbola, his right arm and her left in nearly mirror-image of one another. The walls and ceiling of the room become a vast, enigmatic

chamber of light, half-light, shade and space defined by a maze of horizontals and perpendiculars, emphasised by the paintings within the painting, and crossed by the diagonals of Velázquez's canvas.

Then there is Velázquez's technique. Michael writes elsewhere: 'Something should also be said about the artist's handling of paint, which from a distance and in reproduction seems meticulous, yet on close inspection is as bold as every other aspect of the picture: the glittering sheen of silvers and greys is achieved by the minimum of brushstrokes.'[29] An opacity of greys and blues defines the atmosphere: monumental and perhaps impervious – apart from the open door at the back, which will play its part in the story that ensues – but never turbid. The back of Velázquez's canvas complements but defies the blue-grey-green hegemony of the room's colouring with burnt sienna, while the floor and the quicksilver sheen of the ladies' dresses capture much of the light. Elsewhere, the greys merge into blues and greens, even yellows – that the light might catch them and work its magic. Indeed, the whole upper half of the painting becomes a chamber of half-light. Michael's friend Gijs van Hensbergen says: 'Something Michael loved about this picture was the painting of light and shade, and the volume of light in its top half. It's so Spanish: what he loved, and what I love, about Spanish interiors is that half-light, something you see and feel between the walls of the buildings and churches.'

Palomino sets the painting in 'the prince's chamber', which the architectural evidence, plus that of the pictures on the walls, would place in the *pieza principal* of the Alcázar.

But Velázquez transforms the room into a mysterious composition of structure, arrangement, light, colour, choreography and human condition – synthesised, sculpted and composed into a mysterious whole so much greater than the sum of its many parts.

This mercurial, multi-layered quality in *Las Meninas* has drawn in and compelled artists, art historians, philosophers, poets and viewers looking for reasons and themes beyond and behind what is portrayed, but failing, as Arikha acknowledges above, to produce a definitive 'explanation'.

And this mystery is Michael Jacobs's point of departure, as he here returns to consider the first painting with which he really fell irrevocably in love, on his first, defining adventure abroad.

Ed Vulliamy,
Bayswater/Glastonbury, September 2014

EVERYTHING IS HAPPENING

Journey into a Painting

MICHAEL JACOBS

1

MEANINGS

The envelope, postmarked Madrid, torn slightly on the left-hand corner, released, on opening, the pieces of a puzzle. 'A jigsaw postcard,' explained a hand-written note inserted amidst the scrambled contents. 'I found this in the gift shop of the Prado,' continued the mysterious sender. 'I couldn't decide at first whether you would want the picture as a fridge magnet, a notebook cover, a mouse pad, or a laminated coaster.' The rest of the message, I gathered, would only be revealed once I had put the card together.

I was able to do so almost without thinking. I knew the painting so well that I felt now almost extraneous to its reassembly. As if I was just a spectator watching a group of actors silently taking up their positions at the start of a play: the painter behind his easel; the child princess centre

stage, the maids of honour alongside her; the shadowy couple behind; the dwarf and midget in front; the mastiff beside them; the lone courtier in the distance, posed on a flight of steps.

The pieces were all there, to my surprise. The envelope had arrived at my London address in a transparent post-office bag warning of damage in transit and possible loss of what was inside. I wondered if this too had its significance. I had reached a stage in life when everything appeared to have some meaning, when nothing appeared to happen by chance. The oddity of the card, the enigma surrounding it, the faint suspicion of my mail having been tampered with, all reinforced a sensation I had experienced a few weeks earlier, when policemen broke down the front door of my London house, supposedly by mistake: a feeling of inexplicable intrusion into my private world.

I turned the card over carefully, as if handling evidence from a crime scene. I glanced automatically over the identifying inscription reading 'Diego Velázquez, *Las Meninas*, 1656, Museo del Prado', before turning to a signature as cramped and barely decipherable as the sender's handwriting. I pored over it for ages, until suddenly I realised whose it was. The person I remembered simply as Royce, whom I had not thought of in more than thirty years.

We had studied Spanish together during our privileged days at a school attached to London's Westminster Abbey. I had been with him briefly in Madrid as a seventeen-year-old, and had even gone with him once to the Prado. He did not share then my great enthusiasm for the visual arts,

and had once mildly mocked me for socializing at school with an intellectually pretentious and elitist group whom he liked to characterise as the 'swarthies'. Royce and I had little in common, other than an interest in Spain and the Spanish language, which he professed to have cultivated largely in the belief that the Hispanic world would one day be the driving force behind the global economy. He envisaged a career as a businessman. He went on to achieve this ambition, as I discovered from regular Christmas cards he persisted in sending me for several years after we had last seen each other.

And now he was writing to me again, in so bizarre a fashion, and after such a long silence. His reason for doing so became gradually clearer as I struggled on with his near illegible words on the back of the jigsaw. I managed at last to find out that he was retired, divorced, and living on his own in Madrid, where he hoped I would go and visit him one day. He said he had written to me at my old address, after hearing from a mutual friend that I still used this. 'However, I get the impression from your books that you're rarely there, and that you're based most of the year in a remote village north of Granada.'

'Reading your books,' he added, 'has brought back so many memories of the time I knew you. You'll be amused to hear that I've taken to visiting the Prado whenever my health allows. I often stop to study *Las Meninas*. You always said it was your favourite painting. You used to speak about it with such passion.'

I tried imagining myself as I was then, standing with

Royce in front of *Las Meninas*, expounding on the painting with the gushing hyperbole of an adolescent. I was still at the innocent phase of my lifelong infatuation with Spain, and was probably telling my companion about the quintessential Spanishness of the work, its exotic and surreal character, its mixture of sombreness and sensuality, its element of the grotesque, its underlying magic. I might also have talked about the painting as an expression of national decline, having just read a history of imperial Spain by J. H. Elliott, who had written that Velázquez had caught in his works 'the sense of failure, the sudden emptiness of the imperial splendour which had buoyed up Castile for more than a century'.

I had certainly spoken to Royce about Velázquez's uncanny naturalism, his unrivalled ability to convey fabrics with a few rushed brushstrokes, to create spaces that invite you to enter, people with whom you feel you can talk, children that actually look like children, dogs you want to stroke, skin that has the true colour of skin. For it must have been at this point in our Prado visit, as I elaborated on the confusion in Velázquez between painting and life itself, that my hitherto silent companion decided he couldn't bear any more of this.

He suggested that I was devoting far too much time to art and not enough to living. He interpreted the passion with which I spoke about painting as my way of sublimating sexual frustration. He told me that what I really needed was a girlfriend, and that I would be better off going to bars and discos than spending so many hours visiting monuments

and museums. Though I would gradually recognise the truth of his words, their immediate impact was to irritate me profoundly, as did his subsequent gesture of walking off in the direction of a young woman whom he said was more beautiful than any of the pictures we had seen. It was as if he had violated the inner sanctuary of a temple.

Looking back now to that incident in the Prado, I saw it as encapsulating a moment in my life when, for all my complexes and self-doubts, I was fired by an absolute, unembarrassed conviction in art's spiritual, redemptive powers. Later, after going on to study art history at London's Courtauld Institute of Art, my views on art became more complex and sceptical, leading eventually to a gradual disillusionment with my chosen discipline, and with the academic world in general.

What I never lost was my fascination with *Las Meninas*, partly because it was so tied up with my developing relationship with Spain and the Hispanic world. For, as I began returning to Spain with ever greater frequency, and as a passion for life subsumed one for art, I came almost to think of the painting as a watchful, background presence, accompanying me as I became progressively more caught up with a country moving from a repressive dictatorship to a vibrant democracy, to a disenchanted place on the verge of collapse. Even in the heart of the Spanish countryside, where I have been largely living for more than a decade, far from the world of high culture, I have been reminded of the painting in the most unexpected ways: by a reproduction of it on a builder's grubby T-shirt; by a solitary exhibition

catalogue in the house of my goatherd neighbour; by a
puppy I was given who has grown up to be identical to the
mastiff in the work's foreground.

Reading Royce's card, I was reminded of the bumptious
and proudly philistine schoolboy I had known, and of a
now ageing, ailing and lonely-sounding man discovering at
last the haunting appeal of *Las Meninas*. And I started to
speculate as to whether this work, painted only a few years
before the artist's death, held new depths of meaning for
those evermore conscious of mortality. And then I wondered
if the puzzle I had been sent was Royce's way of telling me
this. Of encouraging me perhaps to head deeper into what I
would soon perceive as an ever-expanding labyrinth.

So I decided, as I neared the age of sixty, to look more
closely at a painting that is famously a mystery. A mystery
which at first sight might not seem like one. A work that
could easily strike the viewer simply as a realistic portrayal
of Spanish court life, with the artist painting in his studio,
and a young princess visiting him there with her retinue.
'Life itself' was how *Las Meninas* was characterised by
Velázquez's eighteenth-century biographer Antonio Palo-
mino, who was able to name all the people in the painting,
and to state that the mirror in the background, with its
reflection of the King and Queen, was the artist's clever
way of revealing what is on the front of the large canvas on
which he is working. Palomino was lucky enough to have
been able to research his account of *Las Meninas* when
there were still people around with memories of when it
was painted. He is a reliable source.

And no one at first would doubt him, or think of *Las Meninas* as anything other than an informal, ingenious and exceptionally lifelike portrait of an extended family which the artist has proudly come to feel part of. Indeed it was as a marvel of naturalism, as an almost photographic representation of reality, that the painting first achieved international recognition, from the early nineteenth century onwards, during a period in art when the search for such qualities became a dominant obsession.

But there is something about *Las Meninas* that ultimately persuades the viewer that there is much more to it than what immediately meets the eye. The way in which all of the figures appear isolated in their own worlds. The almost supernatural brilliance of a technique whereby, in the words of Palomino, brushstrokes that from close up are barely intelligible should appear miraculous from a distance. The possibility that the composition's exact mathematics should harbour secret codes. The hint of wondrous worlds lying beyond the mirror and the open door beside it.

Which is why *Las Meninas* has come to appear increasingly less straightforward the more people have thought about it. Questions are still regularly asked that challenge even the most basic previous assumptions of what is happening in the work. Have the princess and her retinue come to visit the studio, or has someone come to visit them? Is the midget placing his foot on the dog with the intention of playing with him or of rousing him from sleep? And, if the dog is being woken up, does this imply that everyone in his party is on the point of leaving the room? And has the background

door been opened in preparation for this possible departure, or because everyone has just entered from there?

Above all, there have been speculations about the mirror, for, as early as the 1880s, there have been critics and historians who have claimed that this does not reflect the hidden picture on the easel but rather the actual King and Queen, who have approached the studio so as to watch the artist paint their daughter, or perhaps even the canvas later known as *Las Meninas*. Why, others have asked, does everyone blindly accept Palomino's identification of the figures in the painting but not always his assertion about the mirror? But the debate as to what the mirror was intended to show had at least the effect of drawing attention to the monarchs' likely presence in the room, whether as models or as spectators. And this in turn helped promote an idea that would give the painting an especial relevance to the modern age: that the monarchs, if they really are in the artist's studio, would be occupying the same position as we ourselves do in viewing the work.

This was a notion that opened up a whole new range of interpretative possibilities. It marked a turning point in the appreciation of *Las Meninas*. A moment when an icon of realism was transformed into what the contemporary British artist Mark Wallinger has called the first 'self-conscious' work of modern art. A moment when a painting that captures so astonishingly the surface of life became as well a profound meditation on the relationship between life and art.

And I can recall exactly when *Las Meninas* revealed to me

this philosophical dimension. I had only just got back from my time in Madrid with Royce. I was still dwelling on his criticisms of my rarefied existence, while preparing hard for summer exams. I had also become infatuated with a fellow pupil called Ruth, who came from the London suburb of Sheen, and whom I likened – in poems to her that were never sent – to the 'silvery sheen' in Velázquez's paintings.

A school friend of mine, Gavin, one of the swarthies, organised one May afternoon a tea party at his parents' house in Cheyne Walk. He had lured me with the promise that Ruth would be there, but I arrived late, and she had already gone. The strawberries and cream had also all been eaten. The remaining few guests were having their fortunes read by our school's self-styled expert in tarot cards. 'Only at the end shall you taste the strawberry,' the boy told me after reading mine.

Afterwards, worried that a life of largely unrequited yearnings lay ahead of me, I glanced distractedly at a coffee table piled high with books that had been sent to Gavin's father, an elderly editor at the *Times Literary Supplement*. A corner of one of the covers was taken up by a reproduction of *Las Meninas*, below the words 'The Order of Things'.

'Foucault,' grinned Gavin impishly beneath his long, tightly curled hair. 'He's become really fashionable, he's worth taking a look at.' Gavin, a classics student with a way of speaking both jerky and considered, belied his academic manner with a pride in following the latest trends. Foucault, according to him, was 'absolutely huge' in France, and about to become big in Britain and America. *The Order of Things*

had finally been translated into English, four years after it had first appeared.

I found it difficult to imagine how a book I had assumed to be about an old-master painting could be massively successful anywhere. Or indeed to imagine Gavin himself taking any interest in such a work. His own artistic tastes, as far as I was aware, were for the more puritanical manifestations of contemporary art, such as the newly installed Mark Rothko room at the Tate Gallery, where he claimed to spend hours squatting in front of abstract expressionist canvasses of mesmerizing emptiness and sobriety.

But *The Order of Things*, as Gavin quickly corrected me, was not really about *Las Meninas* at all, despite its having a long and famous opening chapter devoted to the painting. It was about 'epistemes', which Gavin explained to me as ways of thinking peculiar to a particular period. *Las Meninas* was apparently an example of the change between one episteme and another, more specifically between classical and modern ways of representation.

I skimmed through the chapter on *Las Meninas* while Gavin went off to the kitchen to make some more tea. I had picked up at school the ability to get to the essence of an author's thought through settling on a few scattered lines. By the time Gavin had returned to the room I had already gleaned that Foucault's almost complete absence of any specific information about the painting was entirely intentional. That he had wanted to create a 'grey, anonymous language' which was 'neither prescribed by, nor filtered through the various texts of art-historical investigation'.

That only through the application of such a language might the painting release, 'little by little, its illuminations'. And that this whole theory was based on the assumption that we, the viewers, have taken over from the King and Queen, and 'are looking at a picture in which the painter is in turn looking out at us'.

'And representation, freed finally from the relation that was impeding it, can offer itself as representation in its pure form,' concluded Foucault, highlighting the pioneering modernity of *Las Meninas*, and exciting me with the thought of reconciling my passion for the old masters with my championship of today's avant-garde. But what affected me most was his baroque elaboration of the idea of a 'compelling line' emanating from the eyes of the painter, running through and beyond the real picture, and then finally becoming 'a slender line of reciprocal visibility which embraces a whole complex network of uncertainties, exchanges and feints'. This was an idea I was soon converting in my mind into a vision of *Las Meninas* as a mass of connections waiting to be made.

And in turn it was a vision that raised in me grand expectations of the study of art history that could never be realised. My years as an undergraduate at the Courtauld would prove in many ways to be a necessary injection of common sense. 'Remember, you're an art *historian* and not an art *critic*,' I was regularly told whenever I proposed meanings in art that could not be substantiated by historical fact or probability. I came eventually almost to accept that there was no place in art history for too much emotion or

imagination. For a long while I even emulated the example of my Courtauld peers, who were then mainly focusing their highly praised minds on the generally prosaic task of reconstructing the historical and architectural context for which a work had been created.

And then I witnessed a dramatic transformation in art history that seemed at first to open up interesting new possibilities. Many of the younger lecturers and researchers, conscious perhaps of the lingering popular image of their discipline as a precious and elitist pursuit, began adopting what rapidly became the prevailing art-historical method-ology – a pseudo-Marxist one. People who might once have become connoisseurs in tweeds reinvented themselves as boiler-suited proselytisers dedicated to exposing in art revealing traces of the social conditions of a period, often resorting in the process to a hermetic prose peppered with terms I had first come across in Foucault, such as 'discourses' and 'the gaze'.

But this new art history, for all its attempts to give the discipline a greater depth and relevance, failed to provide me with what I had perhaps been hoping for ever since choosing to go to the Courtauld – the realisation of my childlike illusion that in studying a work of art I would be following a detective trail that might lead to some ultimate illumination. As I entered my final year as an undergraduate, I kept alive what was left of this glamorous notion by being drawn ever more to the Courtauld's sister institution, the Warburg, a place describing itself as 'existing principally to further the study of the classical tradition in art', but which

had as the basis of its teachings the study of iconography – the study of meanings in art.

I had been fascinated by this postgraduate institution since schooldays. My language teacher, Dr Ernst Sanger, was an Austrian immigrant who had studied in pre-war Vienna with the Warburg's future director and leading luminary E. H. Gombrich. 'Dr Sanger', who frequently compared the evermore specialised university education of today with the immensely broad one he had received in Vienna, talked to me often about iconography, a branch of learning that had received much of its impetus from a handful of mainly Jewish refugees from Central Europe. 'You needed a truly encyclopaedic mind to write about art history in that way,' he insisted in his firm, dogmatic manner. 'A mind like Gombrich's. Or Edgar Wind's.'

Edgar Wind was another Warburg associate, and the author of the book that best encapsulated all that I had once wildly envisaged of achieving as an art historian, *Pagan Mysteries in the Renaissance*. Encouraged by Dr Sanger, I read it while still at school. Filled with recondite information about neo-Platonism and secret areas of Renaissance belief, it drew you into an interpretation of Botticelli's mythological and allegorical paintings that read like the most involved of thrillers, with each dense chapter driving you on with relentless virtuosity to an all-embracing conclusion.

The problem with Wind, and other such figures, was that their scholarship had an inhibiting effect, making me aware more than anything of the limitations of my own classical knowledge. The Warburg itself, which I first visited when

I was twenty-two, was similarly intimidating. Embarrassed by my initial inability even to decipher the Greek letters above the main portal, I was then cowed by its library, each of whose four floors was dedicated to a particular concept, beginning with 'The Image', proceeding to 'The Word' and 'History', and ending with 'Religion'. In the course of a preliminary erratic search from shelf to shelf, I soon grasped that the 'classical tradition' was a concept that had been interpreted to include almost everything, from old Baedekers to treatises on palmistry and highland dancing.

I had been to the Warburg on that occasion to investigate another of Europe's great problem pictures, Giorgione's *The Tempest*, a small painting featuring a naked woman suckling her baby during a thunderstorm. I was optimistically convinced that the key to this puzzle unsolved even by Wind was to be found in those didactic illustrated texts known as emblem books. The hunch turned out to be wrong, though not before I had uncovered, in a recent bibliography of emblem literature, a reference to an article on *Las Meninas* by J. A. Emmens, a scholar of Dutch art.

Giorgione and his mysterious painting were temporarily abandoned as I rushed off in search of this work. Though I had been at the Courtauld for over two years, the lectures and classes I had been promised on Velázquez had yet to materialise. And my favourite painting had somehow slipped during this time to the back of my mind. For all I knew, the mystery surrounding it had already been solved through emblems.

But it hadn't. When I finally located an offprint of

the article, dated as early as 1961, I quickly digested an ingeniously argued but depressingly pedestrian theory which made out that Velázquez's enigmatic and elusive canvas was none other than a primer on family values, with each figure having its specific symbolical role. However, Emmens had at least the virtue of originality, for, until Foucault, the only other person to have interpreted *Las Meninas* in a way other than as a snapshot of court life had been the Frenchman Charles de Tolnay, who, in 1949, had argued that the painting was an allegory of artistic creation.

With my curiosity about *Las Meninas* stirred briefly afresh, I determined one day to delve more deeply through the Spanish-related material in the Warburg. I was sure that a greater understanding of the painting could be had by taking a broader look at the Spanish Golden Age, with the extraordinary prominence it assigned to drama, its obsession with illusion and disillusion, its spectacular contrasts between wealth and poverty, the vividly realistic and cruelly satirical aspects of its literature, its pervasive sense of life as a dream. And the Warburg, with its interdisciplinary approach to art, was the perfect starting point for such research.

However, I would soon be sidetracked from this intention. The director of the Courtauld, the then *Sir* Anthony Blunt, persuaded me to remain at his institute, to carry out a PhD on architectural illusionism in Baroque Italy. This would take me seven fitful years, during which time I would regularly use the library of the Warburg, but without allowing myself to be too distracted by Velázquez. I stopped going there in 1982, and had never thought of going back

until receiving Royce's card, when I started to think again about *Las Meninas*, about art history, and about the search for meanings.

And thus, almost instinctively, I found myself, one January morning in 2013, walking once more the familiar route of my student years, past the rows of electrical-goods shops along Tottenham Court Road, and then past the bookshop once known as Dillons, until finally, in the university heart of Bloomsbury, the horizon was taken up by an unprepossessing red-brick building containing what I had once thought of as an Aladdin's Cave of learning.

Before stepping any further into the Warburg's library, I paused for a moment beneath its entrance, as if to make sure that the Greek letters were still there, which of course they were, spelling out the name of the goddess of Memory, Mnemosyne, whom I thought of now as accompanying me as I walked on into a world apparently almost unchanged since my last visit. Along the bland corridors, and within the functionalist reading room, I kept on meeting people whom I hadn't encountered since 1982, and who returned my greetings as if I had just gone away for a long holiday. They themselves looked like the veterans whom I had once fearfully observed in the old British Library, people who visibly aged before you as they remained trapped in their sunless world, pursuing researches whose origins they probably no longer remembered.

I hurried along with my appointed task, rummaging through the seventeenth-century Spanish shelves to try and

find out what had been happening in Velázquez studies over the past three decades. The task proved more daunting than I had imagined. Even taking into account art history's dramatic growth in popularity over this period, and the ever greater pressure among academics to publish, I had not expected this section of the library to have expanded so much, or that so many of the new works would be about *Las Meninas* itself. From recent conversations I had had with friends, I had been surprised by how many of them had not even heard of the picture, or at least needed me to remind them that it was 'the one with the artist at his easel', or 'the one with the dog'. I had assumed from all this that *Las Meninas* had lost over the years its former status as 'the culminating work of universal painting'. Yet, though this might have been true of popular perceptions of the work, scholars seemed to have been busier than ever in trying to uncover its secrets. In the words of one of them, *Las Meninas* had become since the late 1970s 'one of the most written about paintings of all time'.

Foucault had been heavily to blame for this. As I started poring through the countless new theories about *Las Meninas*, I was struck by how many of these were philosophical responses to *The Order of Things*, but more obtuse still, and so dense with paradoxes that I was pleased to read, in an article by one of Foucault's detractors, Joel Snyder, that 'paradoxes are boring'. After making my way through so much near impenetrable philosophy, I was almost won over by Snyder as he proceeded to expound his Emmens-inspired thesis that the mirror in *Las Meninas* had

nothing paradoxical or Borgesian about it at all but was rather a mirror of virtue to be held up before the princess.

Welcome too, if only for their lucidity and meticulous scholarship, were the writings of the main opponents to the philosophers, the historical empiricists, the ones who practised exactly the sort of sensible art history that had been encouraged in the Courtauld of my undergraduate years.

The leader of this pack was the man widely acknowledged as the doyen of Velázquez scholars, Jonathan Brown, a tall, moustachioed American. Brown had established his name in 1978 with *Images and Ideas in Seventeenth-Century Spanish Painting*, the central chapter of which was on 'The Meaning of *Las Meninas*'. Brown's thesis, which he repeated and refined in later publications, was that the painting was all tied up with Velázquez's long-held and desperate ambition to become a Knight of the Order of Santiago, Spain's highest noble order. This ambition, extensively documented, required prior proof of nobility. No proof of Velázquez's nobility was ever found, but the artist got the distinction all the same, which was celebrated by adding the knightly cross to his self-portrait in *Las Meninas*. The painting itself, in Brown's opinion, was part of the artist's campaign for his ennoblement. It was none other than a propaganda piece promoting the nobility of the painter's art.

Seeing photographs of Brown proudly standing next to the present Spanish king and queen, looking like a Spanish grandee of old, made me conclude that all his talk about Velázquez's noble aspirations had finally affected him as well, which was perhaps what he really meant when he

wrote that all those who try to interpret *Las Meninas* are only doing so in the hope that something of the artist's genius will rub off on them.

I moved on to other interpretations, beginning with the large number of these that have concentrated on the artist's impressive knowledge of perspective, and on his use in *Las Meninas* of multiple vanishing points. Though I found it as hard to get to grips with the mathematics of the painting as I did with its paradoxes, I understood enough to appreciate that the artist's peculiar use of perspective had complicated the efforts of those who had tried to prove by purely scientific means such issues as what actually would have been reflected in the mirror, or whether or not the King and Queen would have been standing in the viewer's position.

At the same time, I realised how much this unusual perspectival system had contributed to the unusualness of the painting, and how it had led the more imaginative observers, such as the surrealist painter Salvador Dalí, to superimpose upon the work elaborate webs of lines deciphered variously as astronomical and astrological charts.

And still I persevered, reading interpretations of progressive unlikelihood, suggesting, for instance, that *Las Meninas* was a seventeenth-century equivalent of a reality television show, that it was a painted documentary about the making of a painting, and that its brushstrokes were not brushstrokes at all but Hebraic lettering pointing the viewer towards the source of all life's mysteries, the kabala. And, just as I was becoming almost nostalgic for the type of Marxist interpretation of my youth, I was excited to

encounter an article of 2010 whose stated aim was of viewing *Las Meninas* 'through the lenses of materialist and postcolonial theory'.

As with so many other articles advocating new ways of looking at *Las Meninas*, the author of this one, Byron Ellsworth Hamann, began by finding fault with his predecessors, in his case with those 'Madrid-centric' scholars who have concentrated on 'the elite artistic culture of seventeenth-century Madrid'. Then he outlined his own approach, which, taking its cue from an earlier Marxist who had imagined himself as Lenin walking 'through Velázquez's painting asking questions about Spain's mid seventeenth-century economy', involved using 'details within the painting to unearth the unseen conditions of possibility that made this scene, and much of the splendour of the seventeenth-century Madrid court, possible'.

And for a while I paid Hamann my full attention as he discussed the tiny clay jug held by one of the ladies-in-waiting, the silver of the mirror, and the red of the distant curtain, all of which, as Velázquez would certainly have known, were examples of expensive New World materials whose extraction was due to the exploitation of indigenous workers. I liked the idea of the whole Spanish Empire being somehow present in *Las Meninas*. I even amused myself by picturing Velázquez in a boiler suit, thinking, as he painted the mirror, not of paradoxes or emblems, but of the oppressed miners at Potosí.

But then, as with the adolescent Royce in the Prado, I suddenly couldn't contain myself any longer. I wanted

to shout out that all these endless interpretations of *Las Meninas*, all this copious research into its every single detail, had brought us no closer to an understanding of the artist's intentions. In the absence of what Brown called 'any conclusive documentation', the work's true meaning would always elude us. Its elusiveness was inherent in its greatness. This was also the factor that kept art historians in business, allowing them enormously to complicate what I had decided long ago was an essentially simple discipline rightly characterised by Nabokov as 'the last resort of the second-rate'.

I didn't know what to do next. So I did what so many others do today in this situation. I started mindlessly scrolling on my smartphone. Until I wondered what would happen if I typed '*Las Meninas*' into one of its search engines. And a tweet immediately popped up that echoed my present mood: 'I have 7 thousand tabs open on Velázquez and *Las Meninas*. I understand f*** all.'

But I didn't give up. I stayed on in the library, partly to read, but mainly to daydream, just as I had done throughout my PhD years. I was reverting to a favourite fantasy, thinking of myself as a detective reopening an investigation into an unresolved mystery. The blank sheet of paper in front of me became like a crime board to which I started mentally attaching photos of the painting's protagonists: the artist Diego Velázquez, Philip IV and his consort Mariana of Austria, the Infanta Margarita, the ladies-in-waiting Maria Agustina Sarmiento and Isabel de Velasco, the courtiers Marcela de Ulloa and José Nieto Velázquez, the anonymous

chaperone, the dwarf Mari-Bárbola, the midget Nicolasito Pertusato, the unnamed dog.

Simultaneously I scribbled down random observations of possible bearing on the case: my sharing of a birthday with Foucault, Foucault's death at the same age that Velázquez had begun the painting, the realisation that the word 'meaning' was nearly an anagram of *Meninas*.

Then I lifted my eyes from the desk and recalled what the Serbian novelist David Albahari has defined as 'our remarkable ability as humans to attribute a meaning to everything'. The greatest secret, as he also wrote, is that there is no secret. And yet there was something about *Las Meninas* that still made me want to think of it in terms of a mystery. A mystery that had nothing to do with the work's intended meaning. A mystery that could not be solved by conventional art history. Or by wild speculations akin to those of conspiracy theorists, or of believers in UFOs or crop circles.

The mystery, if there was one, was that of life itself. The painting, so strange and yet so mesmerisingly lifelike, seemed at times less of an object than a living entity endowed with the secret of eternal life. I knew of few other works of art open to so many interpretations, that have mirrored to such an extent the changing preoccupations of each succeeding era, or that have inspired so many of its viewers to claim that their whole lives have revolved around it. And, as I thought about this, I thought about the seventy-six-year-old Picasso manically embarking on a series of fifty-seven variations of a painting he had not seen since he was a child, and which

had come to embody all his longings for a Spain to which he could no longer return. And in this image of Picasso restlessly reinterpreting each small detail of *Las Meninas*, I saw a metaphor of all those people who have found in this painting a bridge into the past, a mirror of their lives, a potential oracle, a limitless source of memories. And, with my mind wandering off now in every direction, I realised how amidst all this chaos of thoughts I kept on returning to a solitary memory, a memory that always came up whenever *Las Meninas* surfaced in my consciousness, a memory of myself as a sixteen-year-old, searching for a reserved seat on a train at Victoria Station, pulling down the window to wave goodbye to my anxious parents.

'Michael Jacobs?' murmured an unexpectedly close voice, interrupting me from my reading-room daydream. A gaunt, handsome old man, perhaps in his early seventies, was standing above me, a person undoubtedly familiar, and in whom I slowly recognised the features of the kindly faced young scholar David Davies. I'd almost forgotten that we had arranged to meet, in the hour before the Warburg closed.

He had given me my first class on Spanish art at the Courtauld. He had spoken then about El Greco, the artist whom he would continue researching over the next decades, as I had gleaned from the three or four times we had coincided over the years. He had now written on *Las Meninas*. He wanted to talk to me about this. He proposed doing so in a quiet room upstairs, where no one would overhear us. He took with him a book with a large reproduction of the painting.

He searched occasionally for words, snapping his fingers in desperation. 'What I never took into account when I retired was that I would start losing my memory,' he said, before deciding that the objects to which he was pointing in the picture were lamp holders. These two objects proved for him beyond a doubt that the picture represented what Palomino actually said it did. The simplicity with which he then explained himself made you wonder why anyone had ever doubted Palomino's description, or had managed to produce geometrical diagrams of such unnecessary and unhelpful complexity. His own findings, he claimed, had been reached through a cardboard reconstruction of the painting carried out by the man who had eventually taught me Velázquez, Philip Troutman.

The lamp holders, he stressed, would be in line with the central longitudinal axis of the ceiling. And, while the mirror is perpendicular to that axis so as to be centrally placed on its wall, the Infanta and the implied position of the King and Queen are not in line with the lamp holders above, but are to the right of them. Which means that the King and Queen would be at an oblique angle to the mirror, thereby confirming that it is not they who are reflected in it but rather the portrait of them on which Velázquez is shown working. Which makes it absolutely clear that it is the Infanta who is paying them a visit, and not vice versa. Which is precisely how the painting is usually interpreted by those seeing it with an innocent eye.

And so I was back to where I was at the beginning, or almost. David's lucid and convincing exposition of the

mise en scène was merely the prelude to a theory about the painting that had been casually dismissed as unhistorical by those respected authorities J. H. Elliott and Jonathan Brown. 'Elliot and Brown were unnecessarily rude about it,' said an obviously still pained David. 'And yet neither they nor anybody else had previously bothered to explain the absence in the painting of the King's eldest daughter, María Teresa.' She was not there, he insisted, because in becoming recently betrothed to Louis IV of France, she had renounced her succession to the Spanish throne, which would have been inherited by her younger sister Margarita in the case of a male heir not being born. David argued that *Las Meninas* was neither solely a manifesto for the noble art of painting, nor exclusively a scene of everyday court life. Instead he believed it to be ultimately a microcosm of the body politic of the Catholic monarchy, of which the King was the head, and the Infanta Margarita his potential successor.

This was the most persuasive theory about *Las Meninas* I had come across so far. And yet David talked about it quickly as if wanting to get it out of the way, so as to get on to more important subjects, such as our shared memories of the Courtauld in the 1970s, our mutual respect for the eccentric Troutman, the eventual fate of their cardboard experiments. And, as the tone of excitement grew in his voice, he started trying to convey what exactly it was about *Las Meninas* that made such an indelible impression on the viewer. He stumbled again over words as he talked about the painting's extraordinary sense of suspended animation, of its similarity to a fairground carousel on the point of

revolving, of its evocation of a world in which everything is about to happen. And, as his speech hesitatingly gained flow, I was led back again to a platform at Victoria Station, to a train about to leave, to a whistle that was blowing, to a first-time journey to Madrid, to a moment in life of awakening possibilities.

2

CONSIDER THE SETTING

'Consider the setting,' echoed a pompous voice from my art historical past, as I reclined on the 07.55 Eurostar from London to Paris, recreating the first stage of a journey I had last done by train in the early years of Spain's transition to democracy. I was heading towards Madrid. I had once been addicted to the place, but had hardly been there since the late nineties. Then Royce's puzzle had arrived, opening up a trail of memories and associations I envisaged as leading me ever further back in time, towards the very room where *Las Meninas* had been painted.

As the train neared the Channel Tunnel, I was considering the Spain I had first known, and the ridiculous school textbook on which so much of my initial knowledge of the country was based. This book, written during the last

years of Franco's regime, and banally titled *The Spain of Today*, gave no hint of Spain's repressive military regime, but instead referred to the country's 'growing agricultural and industrial prosperity', and to the 'happy coexistence of the old and the new'.

The book's role as a catalyst for my early, life-changing Spanish journeys was due entirely to its black-and-white photos, which neglected this supposedly modern and prosperous country in favour of basket-laden donkeys, adobe-walled farms, palm groves, sun-scorched white alleys and other such images that endowed Spain with a predominantly medieval and African look. Even Madrid, so regularly criticised by past travellers for its brash modernity, was made to seem more exotic and rural than any other western city I had seen. The sole street-scene was one of a large flock of sheep being herded in front of a neo-Baroque, cathedral-like post-office building popularly dubbed 'Our Lady of the Post'.

The rest of the photos of Madrid were entirely of paintings from the Prado, including inevitably one of *Las Meninas*, which I saw here for the very first time. I wondered if the sheep in the preceding photo passed anywhere near it. I also mentally added it to the list of other Spanish marvels for which the book had first prepared me: the Roman aqueduct at Segovia, the Alhambra in Granada, the late-Gothic cathedral at Burgos, the Great Mosque at Cordova.

When I finally went to Spain, in the spring of 1968, I found a country that lived up to the proverbially exotic image I had formed of it. I had gone there with my Spanish class on

a two-week visit to the northern Spanish town of León. I wrote home postcards evoking a vast dusty plateau backed by a faraway snow-capped range, 'just as in the paintings of Velázquez'. I also brought back a gory model of a bull with *banderillas* sticking out from a blood-soaked flank. This sorry creature, later incorporated by me into a Dadaist-inspired collage, had been a present to my parents from the mother of the welcoming family where I had stayed. She thought it would give them an idea of what Spain was like. She herself had not a clue about Britain. Her two young boys had had to show her that Britain was an island off Europe's northern coast.

I returned to Spain the following spring, this time on my own, and with the intention of going to the south by way of Madrid. The train I took at Victoria Station set off at 19.35, according to my father's characteristically detailed diary entry, which also recorded the 'worried look' on my face, and my mother's regret at having allowed me to travel alone. She was so concerned on my behalf that she had made me a secret money-belt out of an old string vest. She had also stuffed a large paper bag with hardboiled eggs, apples and tuna sandwiches. Her parting words, shouted from the platform, were to remind me to eat.

My fears slowly diminished after the train had left London, and I had reached the point of no turning back. A residual umbilical cord had been broken, and a faint exhilaration had taken over me as the train pulled up at Dover, and the passengers were herded along a half-lit wooden corridor into an awaiting boat. A full moon was

shining over Dover's cliffs as I stood propped against the boat's railings watching with relief the last of England. By midnight we had crossed the Channel, and had come to what was then quaintly known as 'the continent'. By seven in the morning the night train to Paris was approaching its destination, after six hours of near continual stopping, to shunt backwards and forwards for no discernible reason, at empty stations where red-capped guards appeared out of the misty gloom with their flags and whistles. I hadn't slept at all, and a day at the Louvre lay ahead of me.

The spending of a few hours in the Louvre before continuing south by night became part of the ritual of my journey to Spain. And it was the main reason why I had chosen now to return to Madrid by train. I hadn't been to the Louvre in over two decades. I had always found it one of the world's most exhausting museums, though this clearly hadn't mattered to me much when younger. 'I could hardly keep my eyes open when I got out of the train this morning,' I wrote to my parents in a long, rambling letter eventually posted from Cordova towards the end of my first trip south, 'but the Louvre was worth it. I couldn't believe how many works there were that I had always wanted to see. I must have walked twenty miles in my attempt to do everything. I ended up almost running.'

The Louvre of today took me immediately by surprise. The present entrance, approached from the metro station directly by an underground passage, sucked the visitor into a giant shopping centre that had grown up beneath the glass pyramid in the building's central courtyard. I smiled

at the thought as to what my reaction would once have been to the desecration of a temple of art by this invasion of McDonald's, Starbucks, Gap, and other international chain stores and eateries. But, as I entered the galleries themselves, I realised that something of the bland spirit of this new vestibule had managed to affect my mood and perceptions.

What worried me most was being at the start of a pilgrimage focused on *Las Meninas* and finding how many of the similarly iconic works of art left me now cold. The customary crowds in front of the *Mona Lisa* looked to me like serried rows of commuters waiting for platform announcements on a screen. Even such inspirational nineteenth-century blockbusters as Géricault's *Raft of the Medusa* had become inexplicably flat.

I darted madly from room to room, as I have always done in galleries, but eventually concentrated my searches on a work that perhaps illustrated more than any other the fickleness of artistic appreciation: a portrait of the Infanta Margarita. I finally came across it in a side room, near a group of Greek and Russian icons that had been put there for want perhaps of any other space. The painting, the very first Spanish one to be acquired by the Prado, was thought in the nineteenth century to have been a study by Velázquez for the figure of Margarita in *Las Meninas*. It was now cautiously relabelled 'Velázquez and School'. I stared at it disbelievingly, trying to work out how this lacklustre painting could once have been hailed for its proto-Realist, proto-Impressionist qualities, how it could have been copied by artists such as Courbet

and Degas, how it had first established Velázquez's name in nineteenth-century Paris.

And, as I left the Louvre, to make my way to the Gare d'Austerlitz, I thought of Manet and all the others of his generation on whom this portrait had had an effect comparable to that of the silly textbook I had been made to read at school. It had been an incentive to travel to Spain, to visit the city where most of Velázquez's paintings were to be seen, to undertake a journey that itself would become integral to the whole experience, a journey whose perceived hardships and exoticism would be considered by one recent art historian as accentuating an aspect of *Las Meninas* as important as its pictorial qualities. Its aura of mystery.

An elderly Spaniard was sharing my compartment on the night train to Madrid. His daughter, whom he wasn't going to see for several months, had left him there, asking me with a smile if I would make sure he was all right. He started talking to me the moment she had gone, telling me that he was from a village near León and had recently moved back there after nearly half a lifetime in Paris. I politely waited for an excuse to go off to the dining car, but when I attempted to do so, he gestured to me to stay where I was. Out of an ancient rucksack he pulled a leather gourd, a hunk of bread and a large chorizo sausage. He offered me a swig of wine, and then sliced off a chunk of sausage and handed this to me on a piece of the bread. And in those gestures I had a glimpse of something I no longer hoped to find – the old days of Spanish rail travel.

Soon, as the gourd was passed repeatedly between us, he revealed how much he too loved travelling by train, which reminded him of his youth, when he had often done the journey between France and Spain. We exchanged memories of what the journey had once been like, about the way Spaniards always used to offer you whatever they had, about the change of gauge at the Spanish border, about the sense of regressing twenty years or so the moment you entered Spain, about the third-class carriages of old, the wooden benches, the cloth-wrapped goods, the odd chicken and goat that used to be smuggled in.

'I met a man who had once travelled by train with *Las Meninas*,' said my new companion, topping all the previous anecdotes. 'That was after the Civil War. All the paintings in the Prado were being returned from Geneva.' I plied him for more information, but he couldn't remember much else. The wine was beginning to affect him. His eyes were closing, and he was soon lying down on his bunk.

I went on to the dining car, more for the nostalgia of the experience than for any remaining appetite. As a teenager I hadn't been able to afford more than a bottle of mineral water and a packet of crisps, but I had gone there then to get away from the heat and claustrophobia of the sleeper car. Now the waiter brought me a half bottle of wine and a plastic-covered tray of tapas as I sat in the near-empty dining car, observing the little that was going on here in a framed mirror at the back. A smart Spanish family behind me was playing cards, until interrupted by a woman, staggering, in a low-cut black dress with silver epaulettes.

The mirror heightened the unreality of it all, and of course reminded me of *Las Meninas*, and of the old man's story of it travelling by train, which, together with my slight inebriation, began slowly to unleash a further stream of Spanish train memories, the ones of my first journey on my own eventually merging with those of the year after, when I had travelled all over Spain on a ticket of unlimited mileage, and had come back to London looking tall and emaciated, 'just like Don Quixote', as my family had joked.

And the memories flowed as I stared into the dining car's mirror: of being covered in soot after a night on one of the last steam trains, of a royally upholstered carriage that had been relegated to a branch line, of the horse and cart that awaited passengers at the station of Osuna, of the peasant who had asked me if I had ever been to the moon, and of my having said yes and that the oranges there were as good as the ones in Valencia. And all the while I could see in the mirror the woman in black becoming progressively drunker until finally she reached my table, collapsed on the seat in front of me, grabbed my napkin, blew her nose on it, and threw this to the floor. I paid my bill and left.

The sun was already out when I woke up. It had broken through the black, wintery clouds and was casting an ominous orange-red light on the dome and witch-hat spires of the colossal palace monastery of El Escorial. Snow had fallen on the mountains behind, and more snow was predicted for the day ahead. The train veered abruptly south, through a scraggy landscape of boulders and bulls, towards a flat, grey distance.

We were almost at Madrid, where trains had once pulled up at a station that is now another of the city's half-redundant cultural centres, the Estación del Norte. Nina Epton, an American traveller who had been brought up in Madrid in the 1920s, recalled the moment of arrival from Paris in the most implausibly emotional terms, with everyone on the train waving, laughing, crying and shouting, 'as if there had been a free distribution of champagne'. All that I remembered of this moment was the faint fear of reaching an unknown city. And the oblique view from the station of the royal palace, rising above the rocky outcrop on which Madrid had been founded.

As we now slowed to a halt beyond the two boldly leaning blocks at today's northern entrance to Madrid, I quickly gathered together my luggage, intending to go as soon as I could to the Prado, as I had done on my first visit to the city. The Prado was the only reason most tourists had ever come to Madrid.

I hailed a taxi to take me down the broad thoroughfare that turns from the Paseo de la Castellana into the Paseo del Prado, one of the most exhilarating urban highways of Europe, even on a wet and blustery January morning. I was presented with a history in reverse of modern Madrid, as we drove past the metal-and-sheet-glass structures so emblematic of the optimistic Spain of the 1980s and 1990s, and then the neo-Fascist arcades of Franco's Nuevos Ministerios, and then the former palace of the disgraced property speculator the Marquis of Salamanca, who had initiated the city's dramatic expansion in the late nineteenth century.

The elderly driver had started talking to me as we neared the neo-classical fountain of Cybele, and the elegant shaded heart of the Enlightenment city. He had mysteriously decided I must be 'either a writer or perhaps even an artist'. He elaborated on this as he stopped the car alongside the elongated museum building so unfairly described by Hemingway as looking like an American high school. 'You don't do this job for so many years without studying your passengers. If you don't mind me saying so, you don't have the look of someone here on business, and you're unlikely to be a tourist.' I couldn't understand why I couldn't be a tourist. 'Tourists don't normally come here at this time of year, unless they're Japanese. Especially not now.'

I was left to ponder his last three words as I walked towards the Prado's ticket office, past a living statue of one of Velázquez's Meninas, who gave me an unexpected curtsey. I reached the stadium-like barriers that divided the anticipated crowds into those who were picking up tickets and those who were buying them. There was not a single other person. Not even the museum's new vestibule, linking the neo-classical museum with a modern extension, showed much sign of activity. The cafe was almost empty, and only a handful of people were poring over the books and souvenirs of the museum's shop.

One of them was someone I recognised, someone who had studied with me at the Courtauld and had become the director of a leading British museum. He had a suit and tie, and an air of self-importance. 'What are you now working

on?' he asked almost immediately, nonplussed by our chance meeting, and perhaps convinced that I could only have spent my life researching art history. He smiled briefly when I told him about *Las Meninas*. 'Must rush,' he said, leaving only the ghostliest of traces of our short reunion. 'It was good to catch up.'

I aimed straight for the museum's central hexagonal gallery, where *Las Meninas* had been displayed continuously ever since being the centrepiece of a major Velázquez retrospective held in 1990. I was sure that this was where I would find the museum's missing crowds. *Las Meninas* was like a magnet to which everyone in the Prado was eventually drawn. 'When I heard that the centenarian German writer Ernst Jünger had been spotted in the Prado,' a Dutch novelist friend had told me, 'I knew he had to be in front of *Las Meninas*. And sure enough, he was.'

I had never seen *Las Meninas* without having to wait for the crowds briefly to part. I was even anticipating spending more time today studying how people reacted to the painting than looking at the painting itself. On my last visit to the Prado, less than a year before, I had been won over by a catalogue of a German photographer, Thomas Struth, who had received permission to set up a camera next to *Las Meninas* and spend days on end recording the responses of the public. The accompanying text included quotes by Proust and by one of the more profound art historians of modern times, Svetlana Alpers. Proust, writing on Rembrandt, had spoken about paintings as being not just beautiful objects but also the thoughts they inspired in

their viewers. Alpers was cited as saying that 'looking at a work in a museum and looking at other people looking at a work in a museum is like taking part in the life story of this work and contributing to it'.

It was Struth's enormous photos I was now thinking about as I continued towards the round gallery, remembering all the faces of the bored, the transfixed, the distracted, the deeply serious, the adults whose only concern was to get the perfect snap, the school children who were wondering when their ordeal would be over, the others who fooled around or diligently made notes, the few whose lives were being transformed. And orchestrating all these scenes into which so much could be read were the guides and teachers, variously shown cracking worn jokes, gesticulating passionately with their hands, repeating monotonously into headsets what they had said hundreds of times before. I could picture their faces more than all the others, because I had been a guide myself for most of my working life, if only once or twice a year. Indeed, I could barely remember having been to the Prado without a group in tow.

The novelty of being here now on my own was making me almost light-headed as I neared the main Velázquez room, just as a large Japanese group was leaving. The few groups I had seen that morning were Japanese, exactly as the taxi driver had told me. But as I entered what was officially known as Sala XII, I didn't notice any tourists. There was almost no one. *Las Meninas* appeared almost naked and vulnerable without people massed before it. I strode quickly across the immense room, hoping to have at least a few

undisturbed minutes contemplating my favourite painting. I would have at least twenty.

The figures appeared to be welcoming me back as if I were the prodigal son, asking me why I had seen so little of them in recent years. I was almost on the point of telling them how well they had aged since I had first known them, and how, in contrast, the *Mona Lisa* had turned into a desiccated mummy. I was enjoying the deluded sensation so many people have before great works of art: the sensation that the work was speaking directly to them and to no one else.

Then, ensuring beforehand that I was still on my own, I tried out an experiment I had always meant to do. I took out a round hand mirror and held it at an angle of roughly forty-five degrees to the painting. The Prado had once sold mirrors exactly for this purpose, ever since the time when the museum authorities had removed from the painting's former individual room a large mirror that had been hung on one of the lateral walls. The idea behind the mirror was to give the work a three-dimensional, hologram-like quality, accentuating both its reality and its inexplicable unreality.

My own mirror did little to enhance the painting, partly perhaps because of the difficulty I had in finding exactly the right angle at which to hold it. In one absent-minded moment I even tilted the mirror in the wrong direction, so that I had an unsettling view of myself, baggy-eyed, weathered and balding. The French psychiatrist and psychoanalyst Jacques Lacan, expanding on Foucault's concept of the gaze, had famously described paintings as mirrors that secretly reflected their viewers. I did not like what I saw.

I put away the mirror, and soon entered that Proust-like state in which the thoughts provoked by a painting have increasingly little to do with the painting itself. The absence of people to interrupt my thoughts became eventually the dominant theme of these thoughts. What had been at first a pleasant surprise was becoming progressively disturbing, as I considered the broader implications of an empty Prado, the implications contained in the taxi driver's last words to me, 'especially not now'. Especially not now.

A mood of worsening national gloom had been instantly noticeable on my coming back to Madrid. Spain was already several years into its 'crisis', but I had witnessed this mainly from my remote Spanish village, where, for all the talk of 'crisis', most people had quietly resigned themselves to there being less money around than before. Only in the towns and cities, and Madrid more than elsewhere, was the impact of the crisis so visibly shocking: closed shops wherever you looked, restaurants offering 'crisis menus', daily protests, and graffiti and posters revealing grievances with everyone and everything, from the monarchy, to the banks, to the multinationals, to the European Community, to the politicians who made Spain the country with the highest number of politicians per capita in Europe.

The most positive outcome of all this, and for a while the main cause for hope, was the emergence in Madrid in May 2011 of a social-protest movement that would have major international repercussions. Demonstrators started occupying the Puerta del Sol, the city's hub, having marched

there in their thousands from the Cibeles fountain. The uninspired socialist government of José Zapatero fell by the end of 2011, and was succeeded by that of the conservative Partido Popular leader Mariano Rajoy. The '*indignados*', though finally ousted from the Puerta del Sol in the spring of 2012, had continued with their marches, amidst growing austerity measures, and escalating scandals.

During my last stay in the city, accompanying a group of millionaire trustees from a North American museum, I saw the departure from the Puerta del Sol of the remaining *indignados*. I was also present, a few days later, at one of their large-scale demonstrations. I was with the Americans at a smart cocktail reception in the exclusive Casino de Madrid, where we were standing on an art nouveau balcony, watching below a flood of people pour down the broad Calle de Alcalá. Some of the banners called for the resignation of Rajoy, others for the downfall of the monarchy. One read simply, 'Eat the Rich'. Yet the crowd's make-up was striking for its lack of fanatical agitators and the presence of so many normal-looking people, from every walk of life, and of every age. A pacifist, almost festive mood predominated, with some of the protesters waving at the elegantly dressed Americans on the balcony, who happily waved back.

Angrier sounds now greeted me as I left the Prado, and they were coming from the place to where I was headed, the Ritz. A small crowd was clustered around the hotel's entrance, shouting abuse at the occupants of a departing limousine. The porter explained that the directors of a newly scandal-hit insurance company were staying there.

He couldn't remember the name. 'There are so many scandals these days,' he joked.

I slouched into a red velvet armchair, under a plasterwork ceiling evocative of the French *belle époque*. Royce had suggested we meet up here for a drink, 'perhaps even some lunch'. 'Don't worry,' he added, 'I'll treat you. I know you writers don't earn a fortune.' My impatience to meet up had greatly lessened after this phone conversation I had had with him an hour earlier. He told me how the Ritz had become almost his second home now that he was such a regular at the Prado. He sounded like a pompous aristocrat in his dotage.

I ordered a beer while waiting for him, and took a look at today's papers. There was more about the ongoing scandal involving the King's son-in-law, Urdangarín, who was implicated in a major tax fraud. There was a lot about a new scandal that had broken out a couple of days before my return to Spain, and concerned the former Partido Popular treasurer Luis Bárcenas. He was exposed as having 22 million euros stacked away in a bank account in Geneva, which he claimed to have earned from activities such as art dealing. The money came almost certainly from illegal donations to party funds, most of which were said to have been used for under-the-table payments to leading party members, including Rajoy himself. Bárcenas was a leading suspect in an earlier and unending scandal cryptically named Gurtel after the German word for Correa – the name of the businessman at the centre of a PP-related corruption ring accused of bribery, tax evasion and money-laundering.

None of the Gurtel suspects had so far been punished, and the only victim had been Spain's inveterate campaigner for justice, Baltasar Garzón, who had been suspended as a judge in his country after secretly recording conversations between the accused and their lawyers.

I didn't imagine Royce as sympathizing with Garzón, or as being anything other than a dedicated PP supporter. But in the end I wouldn't find out. After I had ordered a second beer, one of the hotel's receptionists came up to me with a transcription of a phone message from Royce. 'Am very sorry, but won't be able to see you today. I've had another of my relapses. Give me a ring in a couple of days or so, and we'll go from there.'

I finished my day in the crowded, book-lined flat where I always stayed in Madrid. It was the home of my oldest Spanish friends, Carmen and Pepe, who laughed when I told them about Royce, the puzzle he had sent, and our thwarted meeting at the Ritz. 'You're always turning your life into a novel,' smiled Carmen, a professor of political history at Madrid's Autónomo University. Pepe, a psychoanalyst, gave out one of his deep-throated chuckles, and lit his pipe.

The two of them had been watching the news on television when I arrived. 'The world's gone mad,' commented Carmen about a programme in which long items about the scandals affecting the government and the monarchy had been superseded by the announcement of the Pope's resignation. 'The madder the better, as far as my work is concerned,' beamed Pepe.

I had known them since the early 1980s, and seen through their eyes the dramatically changing Spain of the past three decades. I had also come to form part of their similarly liberal and youthful-minded circle of childhood friends, all of whom were now being seriously affected by the crisis. One of them, an architect, was thinking of moving to Uruguay in search of work. Another, a senior university lecturer, hadn't been paid by his university for several months. A second-hand book dealer had barely sold a book. His wife, a nurse, felt they should save money by staying as much as they could at home. A local government official was working twice the hours for less than half the pay.

The conversation turned more generally to the crisis; to the cynicism of politicians who exploited all their privileges while telling others to tighten their belts; to the incompetent directors of Bankia who had assured themselves of good handouts before abandoning their investors; to the bankers who had offered ridiculous incentives to purchase mortgages only to kick out onto the street many of those who did; to the alarming increase of suicides in these buyers who had lost their homes; to the senator who had greeted Rajoy's latest announcement of cuts with the triumphant shout of 'let the people be fucked'. To Bárcenas.

'He'll never be imprisoned,' said Pepe. 'He's threatened to bring down the whole government if he is.'

Carmen, a person with a consistently optimistic spirit, said that there was at least one good consequence of the crisis. They and their friends were now meeting up more than ever. 'To participate in demonstrations.'

But where would all these protests lead? To the Spanish equivalent of the Arab Spring? To another Civil War?

Pepe wasn't convinced by either of these possibilities. The very fact that the protesters attracted people of such diametrically opposed ideological tendencies, from a handful of fanatical young anarchists to the most straight-laced of PP voters, meant that major social upheaval was unlikely. As with Bárcenas, 'nothing was going to happen'.

'Things will get a bit worse, and then perhaps a bit better, but nothing will happen,' he repeated as he showed me into his consultancy room. The smell of pipe smoke filled this darkly lit space. A scattering of illegible notes covered his desk. The couch for his patients had been made up as a bed for me.

I lay down on it, thinking of its appropriateness to my present reflective mood, sorting out the day's thoughts in preparation for sleep, dreamily recalling a couch in London's Harley Street where I had been psychoanalysed as an undergraduate for panic attacks dating back to a gap year's stay in Vienna.

The root of all my problems was a deep-seated fear of confronting powerful emotions, concluded the specialist who treated me, a lugubriously grey and emaciated Harley Street specialist in a pin-striped three-piece suit whose principal usefulness was as a sounding board for half-formed art historical ideas usually revolving around such disturbed figures as Géricault or Ruskin.

But once I talked about an essay I was writing on Velázquez, whose personality attracted me for the fact

that almost nothing was known about it, and so could be interpreted in whatever way you liked. I speculated on the psychological impact on him of the emotional repressiveness of Spanish court life, and of his view from the top of a crisis-ridden Spain that was beginning to fall apart. I diagnosed the ageing Velázquez as someone trying desperately to hold on to his sanity through 'taking increasing refuge in the realm of the imagination'.

As I searched now for a more comfortable position on the couch, I began seeing *Las Meninas* itself as a refuge from the disintegrating world outside. In the stream-of-consciousness state to which I was gradually being reduced, everything seemed to lead back to *Las Meninas*, even the small abstract canvas on the wall in front of me, a work by the Spanish-Filipino artist Fernando Zóbel to which I had never paid much attention before. With my vision blurred from tiredness, and in a semi-darkness that made the painting's smudged rush of lines seem like shooting stars vanishing into oblivion, I recalled having recently read how Zóbel had died 'with *Las Meninas* imprinted on his retinas'.

Gabriele Finaldi, the Prado's assistant director, was waiting for me the next morning in his high-ceilinged office in the Casón del Buen Retiro, an annex of the museum. I had been warned that he was a devout Roman Catholic, and as serious in his work as he was in his religion. We had in common a Courtauld education and a mixture of British upbringing and Italian blood. But I was intimidated by his reputation, and worried that he might see me for what I

was: a lapsed Catholic and a renegade art historian.

We had met once before, though he didn't remember. My memory of him was as a boyish figure, very unlike the tall and dark-bearded man who greeted me now. He was imbued with a new gravitas, as if his years in the Prado had given him the proverbial solemnity of a seventeenth-century hidalgo. I wasn't quite sure how to explain my interest in *Las Meninas*, or what it was I wanted of him. So I began with small-talk about the crisis.

He understood my surprise at having seen the Prado so empty. Though this was the height of the low season, when only the Japanese appeared to take advantage of low-cost offers, the drop in the number of visitors was noticeable and very worrying. These worries were compounded by the cut in the government grant to the museum, which, though 10 per cent lower than that of other cultural institutions, was still an alarming 30 per cent.

I had been vaguely hoping to extract from Gabriele a deeply personal response towards *Las Meninas*, a painting with which he had been in daily contact for years, and to which he had written an excellent short introduction. But, as I observed his direct, no-nonsense manner, I decided to try and keep the conversation to a more specific and factual level. I asked him about the different ways in which the painting has been displayed in the Prado since the nineteenth century.

As someone with a solid background in museology, Gabriele saw paintings in a different way to how I did. He immediately talked about an aspect of *Las Meninas* I had

never properly noticed – its frame. The painting had had the same, relatively simple beaded black frame since the 1930s; but before then its frame had been a Dutch one in carved wood, which had been obviously intended to emphasise the work's realism, and the characteristics it shared with Dutch scenes of everyday life. Gabriele spoke about the way in which particular frames corresponded to the whims of particular directors, before getting on to the issue of these directors' greater whims. Taking out a series of plans of the Prado, he started considering at last the setting of *Las Meninas*.

The elongated hexagonal gallery in which the painting now occupied the prime slot, at the centre of the end wall, had originally been intended as a lecture hall. Earmarked almost immediately for the exhibiting of the Prado's greatest treasures, the room was filled at first with Italian Renaissance works. 'It says much of changing tastes,' said Gabriele, 'that by far the most popular work in the whole museum was once Raphael's *Madonna with a Finch*, which had hung in the nineteenth century exactly where *Las Meninas* is today.'

The latter's development of iconic status from the late nineteenth century onwards was not due entirely to artistic fashions or to a growing Spanish nationalism. It was due to a significant change in how the work was presented. 'I don't know when you first came to the Prado,' continued Gabriele, 'but you might have seen the work when it still had a special room of its own, the Sala de las Meninas. I know of so many people over the age of fifty who have a better memory of this room than of the painting itself. It was a room that always roused the strongest reactions.'

From 1928 to 1978, the Sala de las Meninas had formed part of a new suite of rooms built parallel to the museum's long gallery. From 1899 to 1910 this room had been a rather flimsy construction added to the building's exterior. It was conceived as part of Velázquez's third-centenary celebration, when the hexagonal gallery, to which it was attached, was rehung with the artist's greatest works.

'Many visitors commented on the shrine-like character of the Sala de las Meninas,' said Gabriele, pushing towards me a recent article on the room that he had commissioned from one of the museum's curators. 'After 1910, when the room was closed, there were lots of complaints, particularly as *Las Meninas* was placed on one of the sides of the hexagonal gallery, and not in its present position, which was taken for many years by a work considered by others his greatest, *The Surrender of Breda*.'

One of those upset by the work's downgrading in 1910 was quoted at length in the article Gabriele had given me. According to this person, 'the soul of Velázquez' was felt with 'greater intensity' in the Sala de las Meninas than it was when surrounded by other masterpieces by him. He talked about its former room as a space where everyone spoke in a low voice, and walked around on tiptoes so as not to disturb its atmosphere of devout solemnity.

'The look of the room obviously changed considerably over the years,' said Gabriele as I flicked through the photos in the article, pausing in front of one in which the painting was raised above the ground on a wooden dais, and shown against walls hung with drapery, 'but the basic layout was

always the same, with the main source of light on one side of the painting, and a mirror of the same size on the other.'

'There was always much debate as to whether the painting should be lit from the top or from the side,' continued Gabriele, 'but the main controversy was to do with the mirror.'

The idea of having the mirror was presumably suggested by the presence of a mirror in the painting itself. It also pays homage to Velázquez's apparent fascination with mirrors, of which he owned ten. But, more than anything, the mirror was an inspired way of raising attendance figures at the Prado. The way it reflected *Las Meninas* seemed to have had a greater appeal to visitors than the painting itself. Some people were glad of this, for it meant initially there were fewer obstructive visitors in front of the actual painting. However, the mirror's popularity contributed greatly to the eventual overcrowding of the room itself, and made the British art historian Sir Kenneth Clark complain in 1960 that this 'silent and dark' space was so congested as to make the painting almost impossible to appreciate.

A work as great as *Las Meninas*, argued many of the more serious visitors to the Prado, did not need what many called 'a cheap fairground attraction' to enhance its greatness. The Catalan sculptor José María Subirachs, known above all for his work on Gaudí's Sagrada Família, published in 1960 a homage to Velázquez that included an appeal to 'break the mirror in the Sala de las Meninas'. Yet, ironically, it was the mirror's presence in the room that anticipated the painting's emergence in the 1960s as an avant-garde, proto-conceptual

work addressing questions of representation, illusion and 'the gaze'.

'We don't know if Foucault ever visited the Prado,' said Gabriele, 'but Borges, whom he mentions at the start of *The Order of Things*, did.' The Argentinian writer, with his lifelong obsession with narratives within narratives, was completely absorbed by the Sala de las Meninas, whose combination of painted and actual mirrors dovetailed with his thoughts about multiple layers of reality. Borges's brief and little-known comments about *Las Meninas* predated by almost thirty years Foucault's discovery of the work's modernity.

Gabriele's allotted time with me was nearing an end, after he had persuasively demonstrated the Prado's important role in orchestrating responses towards *Las Meninas*. He left me at the entrance to the museum's library, to continue on my own the unravelling of the painting's history. I entered an opulent room with a faint whiff of the Habsburg past.

GETTING CLOSER

I was in a reading room that had originally been a ballroom. The Casón del Buen Retiro was the principal remaining fragment of a massive palace complex built for Philip IV during the earlier, more optimistic years of his reign. The palace was a centre of the arts and recreation dreamt up by Grand Duke Olivares, who, at this stage of his career, had the King almost completely under his power. The buildings were erected at enormous speed and with flimsy materials, and almost nothing remained of them by the 1830s.

Above me was a glorious illusionist fresco commissioned from the Italian baroque artist Luca Giordano during the very last years of Habsburg Spain. But no one ever paid this work much attention, particularly not when I had first visited the room, in the spring of 1981. All eyes were fixed

then on a huge Picasso painting newly arrived in Spain after forty-one years of exile in New York. Picasso had always insisted that his pictorial testimony to Franco's destruction of the Basque town of Guernica should be shown in Spain only after the restoration of democracy. He vaingloriously wanted the painting to be shown at the very heart of the Prado, alongside old masters such as *Las Meninas*. The Casón del Buen Retiro was chosen as a compromise. I queued for hours to see it. There were security scanners, a bullet-proof glass screen, and soldiers wielding machine guns.

Guns and soldiers were now again in my thoughts as I pursued my researches into *Las Meninas*'s past. I had reached the Civil War and on my desk were a couple of books about the wartime history of the Prado's treasures. I was reading about the Communist poet Rafael Alberti, and how he was in charge of the Prado at the time the war broke out. He had been living in Madrid since the age of fifteen, and had had early dreams of becoming a painter. Many of his mornings as a teenager were spent drawing the classical sculptures that once filled what he described as the 'enchanting' Casón. Many of them had been purchased by Velázquez in Italy.

I was assimilating all this when everything was temporarily put on hold by the arrival into the library of someone I knew. He was a conservatively dressed figure with thick, neatly parted grey hair, a jacket and tie, and a V-necked yellow jersey. I called out his name as he passed my desk deep in thought.

Mauricio was known to be one of Madrid's finest specialist art guides. Our paths had crossed the year before,

during my week in Madrid with the American museum trustees. So many other professional, full-time guides I had known had become jaded through repeating over the years the same facts and jokes. However, Mauricio was in a category of his own. For a start, his knowledge of art was immense and ever-increasing. He confessed to spending all his spare time catching up with the major new publications on art history. He said he had no time to read anything else, especially not novels. He was also receptive to new ideas, and reluctant to quarrel, not even after I had railed against a painter who turned out to be an uncle of his, the author of a portrait of the Baroness Thyssen-Bornemisza that made her look like a Christmas-tree fairy. 'Everyone is entitled to their opinions,' he said quietly when I later apologised to him on discovering the artist's identity.

He now responded to my greeting with genuine warmth, though held in check by his habitual shyness and reserve. We began talking in whispers, as if spies partaking of secret information. When I answered his question about what I was now doing in Madrid, he nodded and looked pensive. 'Let's meet up, say, at one-fifteen. At the entrance. I might be able to help you.'

So we met at the Prado, where, like a conventional art historian of old, he spoke at first about the possible influences on *Las Meninas* of paintings Velázquez would have known. He showed me a Dutch cabinet picture with an open door in the background, and a Tintoretto religious scene with a dog in the foreground. And he mentioned Van Eyck's *Arnolfini Marriage*, which had once been in the

Spanish royal collections. Its round mirror, reflecting the artist in the same position as the picture's viewer, could well have inspired Velázquez.

Yet Mauricio had a way of talking about art very unlike that of the pedantic connoisseur, or of consummate art bureaucrats such as Gabriele. He discussed the paintings of the Prado as if they were intimate members of his family, constantly noticing new things about them. 'The plain ochre floor,' he said, as we stood in front of *Las Meninas*, 'it's quite odd. I was only thinking that the other day.'

We resumed our gossip about *Las Meninas* over a drink in the former Our Lady of the Post. The spectacular post-office building had been transformed a few months earlier into a vast new cultural centre, much to the annoyance of many of my Madrid friends, who saw it as another enormous waste of civic money. A basement exhibition of art treasures belonging to the Duchess of Alba was drawing in some of the more snobbish elements in Madrid society, but the rest of the building looked like the abandoned set of some Cecil B. DeMille spectacular. Its most attractive new feature was its rooftop bar, where I had gone straight to Mauricio.

Our conversation was interrupted by the tall head waiter. 'Maiquel!' he said. 'Don't you recognise me?' And of course I did, though I hadn't seen him in over fifteen years. He had been a porter at the now-derelict hotel where I had always stayed while accompanying tour groups to the city.

'Maiquel,' he revealed to Mauricio, 'was famous for being always the last guest to get back to his room at night. He

sometimes wouldn't get in until seven in the morning, and then get up an hour or so later to take a group to the Prado. We couldn't understand how he did it. He always looked so fresh and alert. Though there was that one time when the Velázquez exhibition was being held at the Prado, and you were unable to get your group to see it . . .'

I tried stopping him before he exposed one of my more embarrassing moments as a tour leader. But he persisted all the same.

'Don't you remember that time? Your whole group was waiting for you in the hall, and there was no way we could wake you up, even after banging repeatedly on your door. When you finally emerged, we all gave you a round of applause.'

I had woken up fully clothed on top of my bed, nauseous and almost voiceless. I had rushed down to the hall without having had time to wash or change my wine-stained shirt.

'The stress got to all of us,' chipped in Mauricio, rushing to my defence. 'No one had expected such crowds, especially as most of the paintings on show could be seen all year round in the Prado. Spain had never seen anything like it. Pre-bookings and blockbuster exhibitions were as yet unheard of. The queues had stretched almost all the way to Atocha station.'

The head waiter had to leave us, but his brief appearance had introduced a more personal tone to our talk about Velázquez. We reminisced further about the 1990 exhibition, remembering this time the hefty catalogue, which people bought as if acquiring some holy relic, and

that lay around unread for months afterwards in bars and cafes throughout Spain.

'Even those who couldn't get into the exhibition got the catalogue,' said Mauricio, mentioning in particular a 'strange Englishman' he had met recently. 'He had flown over from England just to see the exhibition, and had been totally outraged by the idea of having to queue for many hours without even being assured of eventually getting in. He had resorted to all his important contacts, yet none was able to do anything for him. He had to console himself with the catalogue. The last time I saw him, he said that the catalogue was his most prized remaining possession.

'He didn't strike me at first as your typical art lover,' he continued. 'I had got to know him when guiding around a group of high-powered businessmen. Then he settled in Madrid, and wanted me to give him private tours of the Prado. Until meeting him I'd never been asked before to dedicate an entire session to *Las Meninas*. He was keen to know about every single detail of the painting. He said that he had been introduced to the painting in the late 1960s by a school friend. I think that's why he liked having me as a guide. I reminded him of this person. Also he said he found reading too tiring these days. He had some rare wasting disease.'

I wasn't quite as surprised as I should have been when I finally established that this man was Royce. As a teenager I had found all the chance encounters in Cervantes' *Don Quixote* to be utterly absurd. But as an adult I had begun seeing the world as little different to one of Cervantes'

fantastical-seeming inns, as a place where I needed only a few minutes before establishing some connection with somebody else.

'The world's a handkerchief, as we say in Spain,' smiled Mauricio, after I had told him all about my old friend, and his curious reappearance in my life. The two of us were soon wondering if illness had begun affecting his mind.

'What I found so strange about him,' Mauricio continued, 'was the way he kept on referring to *Las Meninas* as if it were an actual person. He even seemed to be hoping for heroic tales of bravery when he once asked me about what had happened to the painting during the Civil War. He was very impressed when I told him about how my family had helped in bringing the painting to Geneva and back. He said this made the painting come even more alive for him.'

Mauricio was such a self-effacing person that he had never spoken up till now about his family's close involvement with *Las Meninas*.

I now learnt that his family were the Macarróns, a name that had meant little to me a few hours ago, but which featured prominently in one of the books I had just been reading. The family used to have a celebrated shop alongside Madrid's Teatro de la Zarzuela. For over a century, they had been dealers, restorers, packagers and sellers of artists' materials. Mauricio's passion and deep feeling for art began to make more sense.

'My uncle Ángel, the brother of the painter you know, is the family's official historian. He's the only person still alive

who can give you an eyewitness account of our activities in
the Civil War.'

The ninety-four-year-old Ángel Macarrón lived on the other
side of the Retiro Park from the Prado. He apologised on
the phone for the back problems that were preventing him
at present from going too far from his home. He hoped I
wouldn't mind meeting him there. He warned me about his
apartment's smell of newly applied varnish.

After three days of near continual rain and sleet, the sun
had finally come out on the afternoon we had arranged
to meet. I decided to walk to my appointment on foot, to
follow a route I had taken after my very first visit to the
Prado, when I had left the museum in a state of emotional
hangover, worn out by having stayed on until closing time,
but still with a couple of hours to spare before getting the
night train south to Andalusia. I had imagined then that
the Retiro would have a calming effect, but it had merely
intensified an incipient nervous depression. An image from
one of Goya's Black Paintings had become lodged in my
mind, briefly displacing the memory of *Las Meninas*. An
image of a terrified dog buried up to his neck in sand, against
a uniformly brown background.

I now skirted past the park's central lake, where a laughing
young couple were steering a pedalo beneath the massive
colonnaded monument to the short-lived Alfonso XII. I was
aiming, as I had done as a morbidly sensitive sixteen-year-
old, towards the remote corner of the park once occupied
by Madrid's zoo. At the end of a broad long alley, I found a

handful of its empty enclosures, all of which were marked with information panels recording their former history.

The dingy pit attached to 'The Wild Beast House' was described today as having been 'one of the zoo's most popular attractions'. I could still remember its threadbare lions, and the leery man who had exacerbated my gloomy mood by telling me about the right-wing sympathisers who had been fed to the beasts at the start of the Civil War. I had got away from him only to be confronted a few minutes later by a Goya-like scene taking place at the tiny, prettily nouveau 'Bear Cage'. Next to a sign instructing visitors not 'to spit or throw sunflower seeds at the animals', children and adults alike were doing precisely that, tormenting further a polar bear desperately parading in circles to avoid the spray from a central jet of water.

I was now approaching the park's northern gate, and leaping forward in time to 1982. The zoo had been closed for ten years, and in its place was an annual spring book fair full of the cheerful, lively spirit of the new democracy. People went there for the atmosphere rather than out of any love for books. I was with my friend Carmen, who told me discreetly to look to my right. An old man with long, flowing white locks and a glass of sherry in his right hand was merrily addressing a small group of admirers. 'It's Rafael Alberti,' said Carmen.

He had just got back to Spain, almost at the same time as Picasso's *Guernica*, and after an equally long period in exile. He was being treated as a god. Every word of his commanded a Gospel-like respect. Carmen wondered if I had read an

interview with him that had appeared the week before in *El País*. He had talked about the Prado, an institution as full for him of nostalgic associations as his native Bay of Cádiz. He thought of the museum as the house of his youth, as the place where he met up with his fellow poets and writers, and made trysts with his many girlfriends. He returned there in a mood of elated anticipation, and was utterly dismayed. Everything had acquired a dark, sad, yellowing patina, the complexion of the ill. He blamed Franco's dictatorship for all this, just as he would later attribute to democracy the miraculous restoration of a painting whose state in 1982 he thought to be terminal, *Las Meninas*. He loved this painting more than any other. He had personally overseen its evacuation from Madrid in 1936.

An old-fashioned art book, with its pages open at a reproduction of the painting Alberti had helped to save, lay on the sofa, in between me and a tall, quizzical-faced old man in a brown cardigan. Ángel Macarrón was a sprightlier person than I had imagined, attentive, alert, and with a courteous manner of another age. When I started asking him questions about his family, I soon realised I would be in for a long session.

'The Macarróns were probably of Scottish origin,' he began, taking out a piece of paper on which he had drawn for my benefit a family tree featuring his more immediate relations. He had lots of brothers, cousins and nephews, most of whom, like Mauricio, seem to have been involved in some way with the visual arts. Out of his own three

children, one was a restorer and another a painter. The most famous artist in the family was his recently deceased brother Ricardo, the author of the Thyssen portrait I had tactlessly maligned. One of Ricardo's slick and colourful portraits, of a youngish blonde, decorated the wall behind me, together with an Impressionist-style landscape by a well-known Castilian painter, Benjamín Palencia.

Palencia, I was told, had been a regular customer at the Macarróns' shop, along with almost every important artist who had worked in Madrid. 'Picasso bought his art materials from us,' added Ángel, making me calculate that this would have been around 1902, when Picasso saw *Las Meninas* for the last time.

I waited with growing impatience for the opportunity to bring *Las Meninas* into the conversation, but Ángel kept on digressing. He appeared especially keen to tell me about a visit to the Dominican Republic in the early 1960s, when he had been responsible for attaching some neo-Baroque panels to the ceiling of the country's National Pantheon. 'The heat was so intense that the canvasses kept falling off. I had to invent a special glue.' He showed me some photos of these in a booklet his children had made for him for his ninetieth birthday. The booklet was entitled *Ángel Macarrón, Protector of Works of Art*.

He had brought this out in preparation for my visit. It served eventually to remind him of the main reason I had come.

'I was only sixteen when the Civil War broke out,' he began. 'I was just learning my craft. But I remember when

the first bombs began falling over Madrid, and my family's anxiety about what would happen to the Prado.'

The family's concerns were shared by Spain's Republican government, which hastily formed a committee for the protection of the country's works of art. Thousands of works were taken into the museum's basement, after which plans were made to evacuate them all to Valencia, to where the Republican president Manuel Azaña and his government soon moved. The Nationalists, later to pride themselves on being the saviours of Spain's artistic heritage, repeatedly bombed the Prado on the night of 16 November 1936. The need to get the paintings out of the building became more urgent than ever. Alberti's partner María Teresa León was put in overall charge of the operation, helped by Alberti himself. They brought in the Macarróns, who were given an unrealistic deadline by which to get the works ready for their journey.

'My father Graciano and my uncle Juan were asked to place the works in wooden cases,' continued Ángel. 'They worked non-stop in the museum's basement, they came home at night looking like sleep-walkers. "We've packed the Goyas," they would say, or "We've packed the Velázquezes."'

I had read beforehand María Teresa León's account of what it had been like to visit the Prado at this time. She included this in the book she wrote during her Argentinean exile, *Memoir of Melancholy*. She and Alberti had wandered incredulous around the deserted museum, with its empty rooms and shattered glass. They were led by a lantern around a basement crammed with precariously arranged

canvasses. Alberti anxiously wondered if the task he and María Teresa had taken on would be too much for them. He was apparently a perfectionist who hated any form of improvisation.

The Macarróns were also preoccupied. 'My family,' said Ángel, 'hated the idea that the paintings they were preparing would soon be leaving the Prado, in the middle of a war, and with no certainty of ever returning. It was as if their whole world was being dismantled.'

'Some of the paintings simply were not fit for travel,' he added, mentioning in particular *Charles IV of Spain and his Family*, Goya's homage to *Las Meninas*. 'Apart from its unwieldy size, large patches of paint were falling off. A technical report was drawn up to prevent it from leaving the building. But this was ignored. The evacuation of all the chosen paintings had to go ahead.'

One of the tensest days in the whole process was 10 December, when the third of the convoys set off from the Prado. For several hours the open army trucks carrying the works were kept waiting outside what is now the Casa de América, a pompous eclectic building on the opposite side of the Paseo del Prado from the museum. The official order to leave had still to come. Franco's bombing of Madrid had begun that day in earnest. A nervous Alberti told one of the soldiers to stop smoking next to the lorry containing the convoy's two largest paintings. One of these, marked on its case with the number 3 and the dimensions 3.18 × 2.76, was *Las Meninas*. Next to it was an equestrian portrait by Velázquez's beloved master, Titian, *Charles V at the Battle*

of Mühlberg. The two works would remain inseparable travelling companions.

Finally the trucks got going, only to encounter a major problem just to the south of the city, at Arganda del Rey. The enclosed ironwork bridge across the Jarama river was too low to allow the larger of the protruding cases to pass. The Velázquez and the Titian had to be taken off the truck and virtually dragged across the bridge, almost destroying the cases. The convoy's nerve-racking progress was reported by phone at regular intervals, and the paintings miraculously arrived undamaged at Valencia the next day. However, the stress of waiting up all night for news of the convoy, combined with the bridge fiasco, proved too much for María Teresa León. She immediately resigned from her post.

The Macarróns stayed behind in Madrid, where they soon were caught up in the safeguarding of two major works by El Greco, *The Burial of the Count of Orgaz* in Toledo and *The Martyrdom of St Maurice* in El Escorial. 'My father and his assistants were taking the *St Maurice* down from the monastery wall, when the sound of approaching aeroplanes led his companions to flee, leaving him to hold the heavy painting on his own. He got a hernia as a result.'

The Velázquez and the Titian stayed put for the time being in Valencia, first of all in the neo-rococo Hotel Palace, where I once gave a military-style address to a group of rebellious British tourists stranded in Spain by a volcanic explosion. Later the Velázquez was transferred to the massive former convent housing today's art school and museum, where a photo was taken of the painting resting frameless on the

ground, flanked by members of the Republican committee responsible now for the safekeeping of the nation's art treasures. Among these figures was a painter about to assume a major role in the whole affair, Timoteo Pérez Rubio, who arrived in Valencia in time to witness a woman having her leg blown off by a bomb. In his subsequent reckless efforts to protect the Prado's works, he would frequently put his own life in danger. As one of his colleagues wryly observed, he was 'trying to find a way of committing suicide should his mission fail'.

In May 1937, the Republican government was forced to abandon Valencia. There was talk of hiding the works in an abandoned quarry, but in the end the decision was made to disperse them in a handful of old buildings near the French border. Though a few Republicans still held on to the hope of winning the war, many others were planning what to do if they didn't. If they really had to go into exile abroad, then they would take the Prado's treasures with them. The Republicans were after all the legitimate government of Spain. The Nationalists were barbarians who would have no qualms about destroying Spain's artistic heritage. This at least was how the Republicans justified a course of action that could easily have led to the greatest loss of art in modern times.

I had essentially come to see Angel to talk about how his family had become involved again with *Las Meninas* near the end of the most turbulent two years in its history. But I would have liked to have heard his views on the interim period in between the packaging of the work for

the Republicans and their bringing it back from Geneva for the Nationalists. I had already discussed the painting's journey into exile with his nephew Mauricio, who went against current politically correct opinion by believing that what the Republicans did was not an act of commendable heroism but one of irresponsible stupidity whose successful outcome was due purely to luck.

The Republicans, no less than the Nationalists afterwards, exploited for blatant political reasons their role in saving the Prado's paintings. Timoteo himself tried distancing himself from these politically inspired motivations. Though admitting to having liberal sympathies, he rigorously denied belonging to any left-wing political party. He appears genuinely driven by a pure love of art, complemented perhaps by a desire to make up for his own mediocrity as a painter. The Macarróns were probably similarly apolitical, though I doubted if the discreet-seeming Ángel would allow himself to be drawn into the subject of political affiliations, let alone into the wisdom of the Republicans' artistic actions. In any case, Ángel, so lucid up to now in his recollection of the distant past, was beginning to show signs of his age. He was becoming distracted, remembering back to his time in Santo Domingo, confusing me with modifications to his genealogical tree.

I tried asking him about his trip to Geneva, but he kept on promising to get me a photocopy of an article that had been written about it. Then eventually he went off to fetch this, leaving me to mull further over the whole madness of wanting to get Spain's main art works out of the country.

The Nationalists could not be blamed for thinking that the Republicans were effectively robbing Spain of its treasures, possibly with a view to raising money for armaments. However, they themselves were hardly in a position to claim the moral high ground when it came to the protection of these treasures. Right until the very end, the Nationalists knowingly and repeatedly bombed the convoys carrying the works, as well as the buildings housing them immediately prior to the final evacuation in April 1939. In their blindly vindictive desire to kill as many of the fleeing Republicans as possible, they appear to have been oblivious to the destruction of art.

Amazingly, only one work was damaged during the first stage of the journey from Valencia. Goya's *The Second of May 1808*, ironically one of the most powerful war paintings in the history of art, was seriously ripped when its lorry passed under the balcony of a burnt-out house. *Las Meninas* was luckier. Together with other works by Velázquez and the Titian equestrian portrait, it safely reached a turreted Catalan castle now famous for its wines, La Peralada, where it remained undisturbed for a couple of years. Then the nightly bombings began.

One of the witnesses to these was the besieged Republican president Manuel Azaña, who suffered from despair and intense guilt as he lay awake at night thinking about the great paintings in the cellar below him, and knowing that only one direct hit was needed for him to go down in history as the man ultimately responsible for the loss of much of his country's artistic legacy. His whole attitude towards works

of art had changed radically in the course of the war. Before the war, when anarchists and peasants had begun burning down churches, he claimed it preferable that all churches should go rather than a single Republican life be lost. By July 1938 he was telling his minister Negrín that 'the Prado Museum is more important for Spain than the Republic and the monarchy put together'.

The issue as to whether art mattered more than life would come to the fore after April 1939, when a solution was finally found as to what should be done with *Las Meninas*. With the whole of Europe on the point of a major war, the only place thought fit to receive the works was Geneva's politically neutral Society of Nations. International concern for the fate of the works, intensified by Franco's relentless bombings, had made it ever more urgent for a decision to be reached. The necessary permission was given for the works of art to travel to Geneva, and a means for them to get there was arranged: the French promised to provide lorries for the transport to the French frontier, while the rest of the journey would be undertaken by train. Timoteo, in his memoirs, described how the agreement was drawn up in the course of a manic all-night session at La Perelada, when the only light available for the typing-up of the documents came from a vehicle's headlights. The collaboration of the Nationalists had largely been secured through the intervention of the remarkable Catalan painter José María Sert, whose Nationalist sympathies, which later cost him his reputation as one of Spain's greatest painters of the early twentieth century, were put completely aside in his efforts to save the Prado.

The lorries offered by the French never turned up, forcing the Republicans to use their own in their dash to the border. Sert pleaded with the Nationalist authorities at Burgos to let the art-carrying Republicans travel unimpeded, but Franco appeared not to pay much attention to him. Furthermore all roads to France were blocked by the hysterical exodus of Spanish citizens. For a while the French kept the frontier closed, leading to a great increase in the death toll. The *Telegraph* correspondent in Spain, Henry Buckley, was present at the frontier, and made an impassioned plea on behalf of the refugees. A man of inherently conservative and Catholic tendencies, he was turned by his Civil War experiences into one of the most open-minded and humanitarian of the foreign war correspondents. He also expressed his horror that international observers were concerned far more by the fate of a group of paintings than by the sufferings of people. No matter how interesting were the works by artists such as El Greco, Velázquez and Goya, a person's life, in his view, was what was truly important.

I would once have unhesitatingly agreed with him. From having given an exaggerated importance to art as a teenager, I became from my twenties onwards someone for whom no work of art was worth more than a single human life, and who had had violent disagreements with Italian friends who believed that the 1981 mallet attack on Michelangelo's marble Pietá was a tragedy worse than any terrorist atrocity. But now, as Ángel reappeared in the sitting room, I tried putting myself in the position of an ordinary art-loving Spaniard at the end of the Civil War, numbed by the

mounting horrors, suffering from acute personal loss, and unable fully to comprehend the forces that had led to his or her country being torn apart. To hear of the destruction of a work such as *Las Meninas* might perhaps have meant nothing after all this. Or it might have deprived their life of one of the few remaining factors that gave it some sort of meaning.

Ángel was no longer on his own. He was with a middle-aged woman whom I thought at first to be his nurse. She was in fact one of his children, the only one not involved in the arts. She had found the article Ángel had been looking for, and was determined to read it out to me. I waited politely for Ángel to intervene, and to give me his own personal account of events. I began to worry that this would never happen.

She repeated facts I already knew, and then went straight from the terrifying last days at La Perelada to the time when the Prado's paintings were exhibited with enormous success at Geneva's Museum of Art. The article from which she was reading had clearly been written when Franco was still alive. No mention was made of the paintings' prior stay at the League of Nations (where, as the Republicans intended, the Nationalists could do little to touch them), or of how the Nationalists agreed to the exhibition at the League of Nations only as a way of getting the works into their own hands. Nor was there any hint of how the exhibition – despite the protests of Sert – excluded all mention of the Republicans' role in getting the works to Geneva.

'And what happened to Timoteo?' I asked Ángel. He shook

his head and said he never met the man, but thought he had gone straight into exile in Brazil. The daughter continued with her reading, finally reaching November 1939, when the Macarróns were asked to come over to Geneva to collect the works. 'Juan Macarrón took on the job, together with his eighteen-year-old nephew, Ángel.'

I turned to Ángel in the hope that he might elaborate on this. He duly obliged, even while his daughter carried on with her muttered recital. Ángel's commentary was hesitant to begin with, but, like a train picking up speed, it gradually started getting into its stride, encouraged by regular prompts on my part.

'My father,' he said, 'was with some paintings in Paris, so the task of going to Geneva fell to my uncle Juan. He wanted me to help him. I had learnt my craft by now, and he thought that the experience would be good for me.'

'And how old was Juan by now?' I asked, largely so that he would persist with his reminiscences. I thought he might have lost the plot again after he took out a pocket calculator and made mysterious scribbles on a piece of paper.

'About forty-five,' he eventually concluded, 'but he was prematurely aged. The Civil War had been terrible for his health. He was suffering badly from stomach problems. His journey to Geneva would be his last.'

'So tell me about this journey,' I implored, ignoring as best I could the daughter's continued background mumblings.

'Well, of course, I was immensely excited. I had never travelled further than Toledo and Segovia before. And I had never been in a car as grand as the one in which we were

taken to Burgos by Don Pedro Muguruza, the aristocrat who was put in charge of the nation's art heritage. That was in August 1939. We were going to go by train from there.'

The article the daughter was reading out stated that the journey had taken place in November 1939.

'Oh that was the second journey,' explained Ángel, just at the point when the daughter broke off her reading to ask her father if he had told me about Santo Domingo.

'So why were there two journeys?' I asked, ignoring the daughter as politely as I could in my desperation to extract the true facts from the last person alive able to give these.

'Well, when we got to Burgos the first time, in August, we were having supper in our hotel, when the waiter came up to Don Pedro to tell him that he had a phone call from Geneva. Don Pedro came back looking slightly nonplussed. "There's been a change of plan," he announced, "we'll be returning to Madrid."' The exhibition in Geneva had apparently been so successful that the museum authorities had gained permission from Spain for it to be extended for another month.

I was now identifying with Ángel to the extent that I could imagine how he must have felt at having his life's first major adventure temporarily curtailed. A month's delay might not seem much, but it must have seemed so to an ardent teenager, especially at a time when war could have broken out at any moment in Europe, which in fact was exactly what would happen during the exhibition's extension.

'My mother was very pleased to see us back,' added Ángel, following a long pause during which I too had begun to feel

the frustration of his interrupted journey. I feared he would no longer regain his previous momentum as a storyteller.

'She did not like us going away during those difficult weeks. She was even less keen when we did so the second time.' His mouth remained open, as if he wanted to say something that was then forgotten. The daughter renewed her reading, in a voice so low that she appeared to be doing so more for her own benefit than for ours.

'And so when was that?' I prompted Ángel.

'Oh we didn't set off again until November,' he answered. 'The exhibition had been extended for even longer. This time we went all the way by train.'

'And how long did that take?'

He took out again a pen and a piece of paper.

'Well, let's see,' he said, his pen poised to write. 'We got to Irún in the late afternoon, and had to spend the night there. We must have reached Geneva early the following morning. I remember being so excited that I didn't want the journey to end. I fell in love with train travel. All those mysterious little stations you stopped at during the night. When we got to Geneva, though, we really had to work hard.'

They were given only a few days in which to pack the works, even less time than Juan had had to get them ready for departure from Madrid three and a half years earlier. Germany had invaded Poland on 1 September, and Britain and France had declared war on Germany three days later. By November travel across Europe was becoming virtually impossible. Thanks again to the contacts of José María Sert, a train had been found to take the works back to Spain.

It was the last non-military train to be allowed to leave Geneva.

'I remember exactly the conversation my uncle had with Don Pedro Muguruza on being told about the deadline. He said that there was no way he and I could do the job properly on time. If we did everything so hurriedly, some paintings would inevitably get damaged en route. "We'll just have to take that risk," Don Pedro replied. But my uncle wouldn't let him get away with this. "And what if one of those paintings was *Las Meninas*?" he persisted. "Well so be it," answered Don Pedro. This time my uncle really was stuck for words. As a professional with a lifelong veneration for that picture, for one of the culminating works in the history of art, he couldn't really understand the need for such haste. What difference would a day or two make to ensure the safety of a masterpiece that had survived the centuries? But Don Pedro wouldn't budge an inch. He said he had received orders from above.'

So Juan and Ángel worked flat out day and night to get the job done. Many members of Geneva's Spanish community helped out, as did Don Pedro himself, 'and even Don Pedro's wife'. All available wood was used for packaging, no matter its appropriateness. I imagined that Ángel didn't have any time to see anything of Geneva, his first foreign city. 'Well, I did have one spare moment,' he said. 'I went to buy myself a pair of shoes. I'd never before been able to afford any item of clothing.'

The chosen train was finally loaded with the paintings, but there was still no time to relax. The situation in Europe

was degenerating so fast that the sooner they crossed into Spain the better. The quickest way back would have been through Barcelona, but 'there was no train on that route with carriages low enough to get the paintings through the tunnels'.

Progress was slower even than they had imagined. 'Military trains always had priority, so we spent hours at a time waiting in sidings I had found so enticing on the outward journey. Our nerves were becoming evermore frayed. Would we and our invaluable cargo ever make it back in one piece? I felt especially worried for my uncle. His stomach complaints were getting worse all the time.'

The worst moment came on the first night. Manuel Arpe, the Prado's restorer since Republican days, had decided on impulse to see how the paintings were coping with the journey. 'He discovered that two of the largest cases, the ones carrying *Las Meninas* and Goya's portrait of the family of Charles IV, had come apart, and that the two paintings were leaning over the train's side. Should we have entered a tunnel at that point, the works would have been mangled and slashed in two.' The train immediately went into a siding, and a further delay was caused as the canvasses were re-cased.

'When we got at last to Irún, the mood was jubilant. We were transferred to a first-class carriage. The new director of the Prado, Fernando Álvarez de Sotomayor, a family friend, had come to join us, together with other authorities. Our arrival at Madrid was a triumphant moment.'

I wondered what it must have been like to have

travelled with *Las Meninas*, and to have brought it back
safely to Madrid. 'An extraordinary sensation, absolutely
extraordinary. I had been terrified all the time something
would happen to it, but what a mission all the same. For
me no other painting in the world equals *Las Meninas*. I
still can't believe how privileged I was for the opportunity
to have helped it in the only long journey it has ever done.
Or will ever do.' Once again he seemed to be disappearing
into his own thoughts. He was staggering his words. 'The
journey to Geneva marked my whole life,' he observed after
a few moments of silence.

'I even got married immediately afterwards,' he smiled,
pointing to his brother Ricardo's portrait of the young
blonde. 'We had met shortly before I went away to Geneva.
To be honest, I'd never paid her much attention then. But
somehow when I got back to Spain, the whole world seemed
a more beautiful place. I finally fell in love with her. We've
been married now for over seventy years.'

His wife, as if responding to this cue, as if bringing Ángel's
story of *Las Meninas* to its final happy conclusion, entered
the room shortly afterwards. She looked remarkably young,
though she was only two years Ángel's junior. The three
of us huddled closely together on the sofa to leaf through
a coffee-table book on Sotomayor, who had announced
that the Geneva exhibition had been a triumph for Spain
and above all for Franco. In the book about him, he also
described the stupefied reaction of the Madrilenians on
discovering that the Prado's paintings had been returned
to the museum 'intact'. 'Absolutely nothing had been lost

of those last vestiges of the Spanish Empire, and, as if all the pain and sorrow of their absence had increased the love for what had been the royal collection, donations to the museum flowed in as never before . . .'

And so a fairytale ending was given to a Civil War story that did not reflect well on anyone other than Timoteo (who, I later learnt, died in exile after struggling to survive as a painter), Sert (who tried up to his death in 1945 to have Timoteo recognised), and the Macarróns themselves, true professionals with a dedication to the saving of art that transcended politics and personal ambition. I left Ángel's house that evening with a glowing sense of having been with someone whose long life had been a fulfilled and contented one.

The next morning I went to Madrid's Filmoteca, where, on Mauricio's advice, I located in its archives a documentary reel chronicling *Las Meninas*'s 'glorious' return to the city in November 1939. A welcoming committee was shown waiting at the Estación del Norte, applauding as a train with belching smoke approached the platform. Then the camera panned to a line of open trucks outside. A male voiceover, speaking over a background of cheery band music, described the general emotion as *Las Meninas* was hoisted on to one of the trucks, together with the Titian portrait of Charles V. The teenage Ángel Macarrón, obviously exhausted but putting on a smile, could be made out in the group shot taken in front of this, alongside a row of suited worthies. *Las Meninas* had come home.

4

THROUGH THE PALACE GATES

Not a sound in the streets, just a ringing in my ears, and the rumble, half-remembered, half-imagined, of a train travelling through the night. It was three in the morning, and a memory of an old couchette compartment, the air rancid, the upholstery grey and wrinkled, the window impossible to open, came to me sporadically as I lay on my psychiatrist friend's couch, tossing and turning, falling in and out of sleep, moving from one association to another, heading back to an ever-receding Madrid.

The faint light of day silhouetted the blinds of the study. I was gradually coming into consciousness. At some stage in my dream, the train had reached its destination, and I was walking down the Gran Vía, towards its intersection with the Calle de Alcalá, taking in a Madrid similar to the

one I had known in the late sixties, with that same sweetish smell of tobacco and cheap perfume, with that look of an incongruous modern accretion in the middle of a parched wasteland.

I was now fully awake, but still lying on the couch, and my mind continued to dwell on a Madrid I recognised as that of the turn of the nineteenth century, a vibrant and industrialised metropolis recently emerged from long isolation, with idiosyncratic and mysteriously acquired late-night hours, and a wealth of eclectic, *belle époque* apartment buildings that could have been lifted straight from the Côte d'Azur. This was the Madrid that appalled so many foreign visitors and made them long for the wild, empty landscapes glimpsed from the train from Irún. They ignored this modern city as best as they could as they headed straight to the Prado, spurred on by the prospect of seeing one artist in particular. An artist who had come to achieve during these years an almost godlike status. Diego Velázquez.

I pictured myself as one of these visitors, climbing the steps to a museum that had been radically re-hung in 1899 in honour of the third-centenary celebrations of the artist's birth. Nationalism, tinged with an unmistakable spiritual yearning, had influenced the new layout. In 1898 Spain had lost the last of its important overseas possessions – a blow to national pride that had profoundly affected a generation of Spanish intellectuals headed by the Basque philosopher Miguel de Unamuno. Spain, he argued, was in desperate need of spiritual renewal. He urged his countrymen to

draw sustenance from the Castilian heartland, and from the glories of the nation's past.

The Prado's central octagonal gallery had been cleared of its Raphaels and other Renaissance Italian works to make way for a selection of Velázquez's greatest achievements. The Sala Velázquez was like a shrine to an artist whose works had been mainly hidden from public view right up to the opening of the museum in 1807. And at the heart of this shrine was a painting that had previously been hung among the medley of works stretched out along the museum's long gallery. *Las Meninas* was now in its own low-lit room, attached to the shrine's northern side. On entering this inner sanctuary, people took off their hats, spoke in low voices, and tiptoed around so as not to destroy the atmosphere of worshipful solemnity. Every so often someone would be observed bursting into tears.

There were of course other visitors who disliked this room's churchlike theatricality and the sentimentally nationalistic and mindless emotional reactions it inspired. The sort of visitor I was now imagining myself to be. An artist visitor from abroad. Someone who believed that Velázquez did not need all this surrounding bombast and trickery to be admired. Someone whose obsessive devotion to Velázquez had a purely pictorial basis to it, and who did exactly what I so often do in museums – ignored everybody else, and went sufficiently close to the canvas to arouse the concern of the attendants, getting lost in a world of brushstrokes.

It was artist visitors such as these, rather than any writers or critics, who were the principal forces behind the turn-

of-the-century cult of Velázquez. Painters such as Wilkie and Courbet had hailed him earlier for a naturalism that corresponded closely to their own pictorial concerns. However, Velázquez's new admirers were finding in his art qualities that made him more precociously modern still. His informal-seeming compositions and fluid, impressionistic technique were exactly what Manet, Whistler and other progressive artists of their day were trying to achieve, being often virulently attacked and mocked in the process. That an artist working in the seventeenth century should have shown the way to modern artists reacting against the stultifying influence of the Academy must have seemed utterly astonishing, humbling and inhibiting. Velázquez represented a peak of perfection that no one could hope to equal. Renoir's response to seeing *Las Meninas* in 1881 was utterly understandable, and all too common. He wanted to give up painting altogether.

As a teenager faced for the first time with *Las Meninas*, I had the arrogance to want to paint more than ever. I now remembered this as I remained recumbent on the couch, waiting for the energy to wander off into Madrid's streets, and gradually realizing that the deeper I delved into *Las Meninas*'s past, the more I was uncovering my own.

Buried beneath all my years as an art historian, and then as a writer, was a child whose first and strongest ambition in life was to paint. My whole outlook on the world was once a predominantly visual one. My art teacher at prep school was convinced my future lay in painting, and made me

promise always to keep her informed of my life's progress (I never did). By the time I was at Westminster, under pressure to study at Oxford or Cambridge, I was determined to go to art school. I did sketches wherever I went, and had a whole sketchbook of the people, places and paintings I had observed in the spring of 1969, during that first trip alone to Spain. My thumbnail version of *Las Meninas* looked crudely and unintentionally like a Picasso.

It was only on my return to Spain the following year that I discovered that Picasso had been obsessed by the same painting. My knowledge of art had increased vastly in the meantime, and my plans to become an artist, wholly disapproved of by my parents, had been tempered by a more realistic scheme to learn art history. I became the first person at my school to do an A level in this then widely maligned subject, for which I was obliged to write a miniature thesis. I chose, pretentiously, to do one on Hispano-Flemish painting of the fifteenth century. This gave me an opportunity to travel to parts of Spain I had always wanted to see, including Barcelona, where I went to the city's recently opened Picasso Museum.

With *Las Meninas* still fresh in my mind, I was able to enjoy even more this museum's display of Picasso's fifty-seven variants of the picture. But I was puzzled as to why Picasso had chosen greatly to accentuate the light source on the left-hand side of Velázquez's painting. Until I put my developing art historical skills to work and discovered that Picasso had last seen the picture in 1902, when it had hung in its special room where light had flooded in from a window

on this side. Picasso's paintings were heavily influenced by memories of a room last viewed by him over fifty-five years earlier.

I also found out something else: that Picasso had seen the painting once before, as a fifteen-year-old on a visit from Málaga with his parents. This was in 1895, when *Las Meninas* still hung in the Prado's Long Gallery, when the child Picasso could have unwittingly brushed shoulders with many of the work's Impressionist and neo-Impressionist admirers. Even perhaps with the man who had come to fascinate me since my previous trip to Spain, someone whose life seemed to offer a solution to my conflicting artistic and academic aspirations. He was the author in 1895 of one of the greatest books ever written on Velázquez, or on any artist. Unfortunately, he came to be remembered, if at all, largely as the cousin of Robert Louis Stevenson.

The name of R. A. M. Stevenson first cropped up in my life over lunch in the sixteenth-century dining room of Westminster School. This room, serving as a preparation for future lives spent in Oxbridge colleges or antiquated law chambers, had a typically collegiate arrangement of serried rows of long wooden tables laid out perpendicular to a raised high table at the furthest end, reserved for caped scholars. The presiding matron had the Waugh-like name of Miss Holmes à Court, and the tables were supposedly fashioned from wood from the defeated Spanish Armada, which gave me occasional pangs of guilt as I dug my knife into grooves filled with black grease.

I would have loved to have sat with the scholars, but, even had I done well at the school entrance exams (and I had only just scraped through), I would have been excluded from their table by my non-Protestant blood. Instead, I ate my lunch at the opposite end of the room, frequently in the company of two teachers who were widely mocked by the rest of the pupils, and who must have felt as outcast as I often did. One was the language teacher Dr Sanger, an often hysterically irritable, ferret-like figure with the same blue suit he had brought over as a refugee from Vienna. The other was the art teacher Les Spaull, who had unruly grey hair and a moth-eaten sports jacket with green leather patches. Though his classroom was the newest and most cheerful in the school, it was the least used. Learning how to draw and paint was thought of as the last resort of the thick. In any case Spaull's outlook on art was that of another era. He would frequently recall how, as an art student at the Slade, he was obliged to watch dissections at University College's anatomy theatre. This had left him with a lifelong interest in the history of surgical operations, a subject he regularly brought into a lecture course that began with the caves and didn't get further than the pyramids.

What he taught me about art history was gleaned entirely from the discussions at lunch with him and his good friend Dr Sanger, both of whom treated me as an initiate into their exclusive world. I plied them with questions, to which they sometimes replied by telling me of books I should read. On my first return from Madrid, full of the joys of *Las Meninas* and Velázquez, Sanger mentioned having recently come

across a 'very balanced and sensitive short introduction to the artist' by someone called Philip Troutman. But Spaull, without even having read this book, was dismissive of it. 'There's R. A. M. Stevenson's *Velázquez*,' he said, 'and little else.'

The copy of the Stevenson from the school library had never been loaned before, and would be repeatedly renewed by me until I left the school a year and a half later. It was a modern edition with an introduction by the long-time editor of *Apollo* magazine, Denys Sutton. Sutton's introduction hooked me before I got on to the book proper. I became intrigued by the personality of Stevenson, an archetypal bohemian with a fundamental shyness and insecurity. After studying at Cambridge and acquiring there a passion for rowing, 'Bob' aimed to become a landscape painter. His halcyon days were spent between Paris and the nearby artist colonies at Barbizon and Grez-sur-Loing, where, surrounded by painters from all over the world, he entered his true element. Exotically dressed, brilliant in conversation, and given to impetuous high jinks, he had a charisma that drew to him numerous admirers, despite his basic shyness.

One of these was his younger cousin Robert Louis, whose parents had thought of Bob as the worst possible influence on their son. Robert Louis, a more obviously serious and hard-working person than his cousin, nonetheless moved to Grez to be with him. Everyone in Grez was convinced that Bob was by far the greater genius of the two, though no one was entirely sure where exactly his talents lay. After returning to Britain, he worked as an art critic, and was briefly a lecturer

in art at Liverpool, where his nonconformist manner and desire to provoke caused the intended stir within the city's academic community. He described his fellow art historians in a way I would later find only too pertinent – 'duffers who talked about "schools", and attributions to this and that master – and queried about dates, and the *cinque-cento*, and that rot'.

He went back to being an art critic, supplemented by handouts from his evermore successful cousin, who found Bob a sadder and now impossible person, someone whom a mutual friend from their French days perceived as having lost his former buoyancy and gained instead 'a subdued and slightly apprehensive manner'. His criticisms of contemporary artists were well received, but the only work of his that would ever be reprinted was his Velázquez monograph, which was published five years before his sudden death at the age of fifty.

When I finished Sutton's introduction and started reading Stevenson himself, I lingered on a line that emphasised the importance for the artist of regaining the 'innocent eye' of a child. Unknown to me at the time, this was a sentiment identical to one expressed by Picasso. It is also one that epitomises the spirit of his Velázquez book, which, for all the complexity of language, is characterised by a freshness and directness in its approach to the artist. Based on just a few days' stay in Madrid, it does not study the subject matter of the paintings, nor does it give more than a skeletal summary of the artist's life and times, nor does it go in for psychological analysis other than to make a telling comparison between

the restrictions of working at the Spanish court and the puritanical repressiveness of an Edinburgh childhood.

Instead Stevenson's approach is that of the painter understanding a work of art in a purely pictorial way, unburdened by facts or prejudices, trying always to see the essential, viewing a painting as he did the Spanish countryside, of which he said that 'no trivialities encumber the large structural features'. At the heart of Stevenson's spontaneous method is his belief in the 'dignity of technique', an aspect of art generally ignored by the British, who, in his view, so often talk about painting in fundamentally literary terms, and actually have no feeling for it, only a sense that they should. 'Under a mistaken conception of culture as the key of all the sciences,' writes Stevenson in his characteristically provocative way, 'intellectual people too often feel obliged to pretend an interest in arts for which they have no natural inclination. They cannot believe that the least taught ploughman whose senses are in tune with the pulse of nature may make a better artist than the man of loftiest thought who is encased in nerves insensitive to the character of shapes and colours.'

Velázquez's art is seen by Stevenson as a technical progression falling into three main stages, and leading to ever-greater mastery of 'unified vision'. From such early works as his 1630 painting of *The Topers*, in which the 'parts obey a purely formal instead of an impressional unity', Velázquez went on to achieve 'at least a decorative unity' in the 1645 *The Surrender of Breda*. But it was not until his late period, and *Las Meninas* in particular, that he

became the master of a unifying technique whose careful contrivance and coalescing of several fields of vision go at first completely unnoticed. 'What a rounded vision swims upon your eye, and occupies all the nervous force of the brain, all the effort of sight upon a single complete visual impression. One may look long before it crosses one's mind to think of any colour scheme, of tints arbitrarily contrasted or harmonized, of lines opposed or cunningly interwoven, of any of the tricks of the *métier*, however high and masterlike.' In this and other late pictures of the artist, 'nothing seems to interpose between you and the mind of Velázquez. You seem to be behind his eye, able to judge and to feel, with all the power and sensitiveness of that unrivalled organ.'

When Stevenson refers to Velázquez as the first Impressionist, he is referring less to the artist's handling of paint, light and colour than he is to the way in which he treats every part of a composition in relation to the whole. Defining this in terms of Velázquez's 'breadth of view', Stevenson finds this manifested above all in *Las Meninas*, which, though seeming at first 'cold, empty and stiffly arranged' in comparison to such characteristically flowing and colourful baroque works as those of Rubens, or indeed *The Surrender of Breda*, is nonetheless sensational for the way in which its figures (breathing and intensely alive beneath their 'stiff clothes') fit in so naturally and precisely within their subtly gradated surroundings. The painting's atmosphere, for Stevenson, is so binding and palpable that it seems to absorb all those people who come within its orbit.

In one of Stevenson's several encounters with Whistler, he

spoke to him about having seen *Las Meninas* on a summer day when 'an old peasant with faded blue-green clothes came in and sat down on the green bench in front of it, and straightaway became part of the picture, so true was its atmosphere'. Stevenson was always the most astute of observers, which is also why, in the words of one of his friends, 'every visit to a gallery was for him an adventure and every picture a romance'.

I was convinced when younger that I had found in Stevenson a like-minded spirit, and I was certainly persuaded by his example that knowledge of how to paint should be an essential part of any art historian's training. Unfortunately, as with Stevenson, my pictorial ambitions far outshone my talents as a painter. An American contemporary of Stevenson, L. Birge Harrison, described Stevenson at Grez as 'simply endeavouring to demonstrate both to himself and to others his right to be taken seriously as a landscape painter, and wasting considerable quantities of perfectly good pigment in the effort'. In my case, I was wasting both pigment and wall space. I foresaw for myself a future as a muralist in the grand baroque tradition.

As my parting gesture at Westminster School I executed an illusionistic mural at the end of one of the school's longest corridors. The idea had been to extend further the corridor, but the perspective was all wrong, and I had never used oil paints before. The subject was a mystical vision taking place in the school's seventeenth-century library. The open door at the very back, with a silver-enhanced light flowing in, was a clear homage to *Las Meninas*. But no one recognized this.

There were other and more spectacular pictorial disasters to come, by which time I had embarked on my thwarted career as an art historian. I reread Stevenson in 1976, after having been commissioned to write a short monograph on Velázquez by a publisher that subsequently went bankrupt. Though Stevenson's speculative, unfactual style of writing was the antithesis of all that the Courtauld had taught me, the intelligence and passion of his approach made most other works about Velázquez seem dull and prosaic. This new encounter with Stevenson had also a more unexpected effect: it reawakened a hidden yearning for the sort of bohemian life he had once led.

In 1982, after completing my PhD, I was able to experience a tame version of this after taking up a post of art history teacher in an 'artist village' in the south of France. At the same time I acquired much new material on Stevenson's youth while beginning to research, throughout Europe and America, an ambitious book on late-nineteenth-century artist colonies such as Grez-sur-Loing. Stevenson's love of playful camaraderie – of the kind that led a group of his young American colleagues to organise noisy baseball games within earshot of Monet's lily pond – came into more vivid perspective when shown against a background of the inevitable sexual and professional jealousies and frustrations aroused from the bringing together of artists within tight-knit rural communities. The resulting book, ironically titled *The Good and Simple Life*, was the one I hoped would take the art historical world by storm. It didn't. Anecdotes, however revealing, were out of fashion.

I hadn't made a single use of the words 'discourse' or 'gaze'. And, as one Bloomsbury specialist said in a review for *The Burlington Magazine*, who could possibly be interested in the art of places such as Hungary or Scandinavia?

Writing the book had made me recognise more acutely Stevenson's feelings on leaving Grez and returning to a world in which he was no longer the protagonist, to a Britain he must have found lustreless, parochial and mean-spirited. My added knowledge of the young Stevenson had given me an especial empathy for the older man, making me almost feel as if I could now read his thoughts as he travelled by train to Madrid in 1895. He was not thinking, as he so often did, of his life's failures: of having given up painting; of his precarious existence writing articles that would almost instantly be forgotten; of being married to a woman whom his cousin disliked; of not having had any children; of their continual money problems. Instead I saw him briefly returned to his earlier exalted self, heading off on another artistic adventure, travelling through what he described as 'the scenery of Velázquez's pictures', on his way to see for the first and only time a work of art in which his own unrealised brilliance could find at last some form of outlet.

I was finally up from the couch and aiming with a stiff back towards Madrid's Royal Palace. I was entering the Habsburg city, the city founded in 1566 on a rocky outcrop above the insignificant Manzanares and then largely neglected for over fifty years. Philip II was more interested in the palace monastery of El Escorial, while his ineffectual successor

Philip III was persuaded by the Duke of Lerma to transfer the new Spanish capital to Valladolid. Then, in 1611, the court returned definitively to Madrid, and the city soon outgrew Seville. By 1656 it had a population of 160,000, a size that would barely increase until well into the nineteenth century.

I was at its eastern limits, walking through the elegant area once taken up by Philip IV's Palace of the Buen Retiro, behind which was the Paseo del Prado, a fashionable promenade in Velázquez's day, transformed under the Bourbons into the axis of Enlightenment Madrid. The Prado Museum, conceived in the 1790s as a natural history museum, was adapted over a period of more than twenty years to house the royal art collections. *Las Meninas*, making its first major journey, was brought from the Royal Palace to the museum's Long Gallery, where it would hang for most of the nineteenth century alongside Titian's *Charles V at the Battle of Mühlberg*. The collections were opened to the public in November 1819, 'except on rainy days and when there is mud around'.

The rain came in short heavy showers as I rushed across the Paseo del Prado and into that part of the city which had expanded so rapidly after 1611. At its entrance was a small statue to Cervantes. The district is still known as the Barrio de los Literatos. Madrid is the only city in the world to have at its heart a district named after writers. Every Spanish writer you can think of, from Cervantes to the mediocre Echegaray (who won the Nobel prize in a year when the great novelist Pérez Galdós was also a contender), lived or

is commemorated here. The history of Spain's Golden Age literature is written in its streets. The Golden Age itself lies barely beneath its surface.

The buildings have nearly all been rebuilt. They bear little resemblance to the predominantly adobe structures of before, most of which were no higher than one storey, thanks to a law of Philip IV that obliged all second floors to be at the disposition of the court. But historical pedantry has usually deserted me in this district. I have often wandered around its quiet, sober grid of narrow streets thinking that its four- or five-storeyed buildings, with their grey plasterwork sometimes painted to resemble blocks of granite, were straight from the seventeenth century. And similar delusions were coming to me now as I sheltered from the rain in a bar I'd known of old, with the picaresque name of the Lazarillo.

The greasy pine tables didn't have the authenticity of the Armada-hewn ones from Westminster School, but the gruff, unshaved barman, the oak barrels behind him, the hanging hams dripping their fat, the cracked terracotta plates, the chunks of Manchego swimming in oil helped in unison to evoke the days when Cervantes and Lope de Vega were neighbours, the playwright Calderón lived ten minutes away, and the house directly opposite, obscured by rain, was closely associated with two poets painted by Velázquez. One of them, portrayed with venomous smirk and large black glasses, was the satirist Francisco de Quevedo, the house's owner. The other was Quevedo's arch-enemy and one-time tenant here, Luis de Góngora, a bald and austere figure. 'Be ashamed, Don Luis, go purple!' wrote Quevedo in a poem

that cruelly referred both to Góngora's elaborate verse and to a premature arteriosclerotic condition that almost certainly worsened after Góngora was expelled as tenant in the winter of 1625, on what was perhaps a day like the present one. Damp and freezing.

And as I absorbed a couple of engraved portraits of the rival poets, hanging on the Lazarillo's walls as if the two men were regulars at the bar, another seventeenth-century scene passed through my consciousness, of the elderly Lope de Vega emerging from his house further down the street, a red-brick house that still survives together with the very furniture that belonged to the writer, and the small garden that was one of the great passions of his later years. Housewives and drinkers from the taverns were all coming out to see him go by, some even hoping to touch his robes, as if these were sacred relics. Few other writers before him could have enjoyed such popularity, or such a reputation for holiness. Few other writers were also such masters of illusion. It was what he had in common with Velázquez. They were people who were not as they appeared. They were artists unsurpassed in creating illusions of reality.

A brief pause in the rain allowed me to continue my walk, to follow Lope de Vega into what soon became the heart of the Barrio de los Literatos, the Plaza de Santa Ana, a square as architecturally unprepossessing as London's Leicester Square, but with historic bars, a towering art deco hotel favoured by bullfighters, and a soberly classical National Theatre built on the site of the Corral del Príncipe, the largest of several Golden Age theatres that had brought constant

colour, humour, animation and sensuality to a notoriously austere city choked by convents. They had once made Madrid a theatrical capital unrivalled even by London.

I looked at my watch. It was nearly midday, the time when the plays at the Corral del Príncipe were scheduled to begin. The city's passion for drama never ceased to amaze all foreign visitors. The theatre would already have been packed, with a loud commotion sounding as Lope de Vega made his way through the main entrance, aided by a court official and his bailiffs. But tensions were soon mounting, as the invariable delay before the performance got longer and longer. Fights were already breaking out, with people trying to get in without paying, and men attempting to enter the actresses' dressing rooms.

The atmosphere inside was like that of a football match, with even a large group of thugs, 'the Musketeers', stationed in the middle, bearing bells, whistles and rattles, waiting to determine by their actions the success or failure of a particular play. Some playwrights, such as the hunchbacked, pigeon-chested and Mexican-born misanthrope Juan Ruiz de Alarcón, would be booed whatever they wrote. But Lope de Vega never had much cause to worry, and not simply because many of the Musketeers were in his pay. He was someone who responded to the exceptional impatience of the Spanish audiences by writing works that were short on philosophical speeches, and full of action, word-play and black humour. He was also continually writing new plays. All Spanish playwrights of his era were forced to be prolific, but none of them managed to match his estimated two

thousand works, of which an astonishing five hundred or so survive today. Writing under this pressure was not conducive to the creation of a *Hamlet*, but, as the Shakespeare scholar Jonathan Bate has said, Lope de Vega is one of the very few playwrights to have Shakespeare's universality. His works have been continually reinterpreted according to the concerns of each succeeding generation. They cover every possible theme, some of them surprisingly modern, such as religious bigotry and sexual equality. They include greater roles for women than the plays of any of his contemporaries. The naturalism and freshness of their dialogue bring distant worlds eerily alive, in a way that finds perhaps its closest parallel in the paintings of Velázquez.

I was moving away from the Plaza de Santa Ana and reflecting further on the relationship between the two men, each of whom must have had enormous respect for the other while inhabiting diametrically opposed Madrids. In my imagined vision of the Barrio de los Literatos in its heyday, with its constant brawls, vicious rivalries, literary hooligans, and abundance of actresses, prostitutes and bars, there was little room for the notoriously reserved Velázquez, whose life and fame were circumscribed by the closed and elite world of the court. Lope de Vega himself, despite his immense learning, was too much of a populist to be accepted by this court, which was perhaps all for the good, as he described the Royal Palace as a place 'where even the curtains yawn'. He needed the hurly burly of the Madrid I was mentally recreating as I resumed my walk towards the city's Habsburg core.

The term 'Golden Age', so appropriate in the context of Spain's heady cultural life of the early seventeenth century, seems almost a mocking one when applied to the Madrid in which this renascence took place, a city notoriously crime-ridden, and with so much rubbish being thrown onto its streets that locals were forced to defend this habit by saying that such contamination of the environment was necessary to counteract the dangerous purity of the Madrid air in its natural state. And on top of all this was the city's state of near penury. 'Madrid,' wrote Lope de Vega to one of his patrons, 'is still as your lordship left it, Prado, coaches, women, dust, executions, a lot of fruit – and very little money.'

And a persistent smell of burnt flesh, I wanted to add, recalling the descriptions of heretics being thrown to the fire in the Plaza Mayor, the arcaded main square I was now nearing, or thought I was nearing, until realising that I was lost, in an unfamiliar street, disoriented by the return of the rain and by too much absorption in the past. I was searching for a street name, unaware of the bollard in front of me, which hit me hard on the leg, almost knocking me to the ground, next to a four-storeyed building, probably of the early nineteenth century, with a ground floor in dark grey granite, and a plaque recently placed by the Comunidad de Madrid. 'On this site,' it read, 'stood the house where the painter Diego de Silva Velázquez lived on settling in Madrid in 1623.'

Nothing in life happens purely by chance, I reminded myself as I hobbled onwards, eventually coming out into the now sanitised Plaza Mayor, where street performers,

oblivious to the light rain, were performing to bedraggled groups of tourists holding umbrellas. I walked off into the narrow streets beyond, stopping below a tall corner building hung with the large sign 'Posada del Peine'. Inside was a self-styled boutique hotel, with exposed red-brick walls, display cabinets with Lladró figurines, and a brochure promoting the place as one of Madrid's longest-established hostelries. It took me a while to accept that this was once the cheap and grubby pension where I had stayed in 1970.

'I shall be moving in two days time to a pension behind the Plaza Mayor,' I told my parents in an endlessly extended letter begun on 1 April 1970 in the Old Castilian town of Toro, and eventually sent from Madrid on 7 April. In the absence of my school sketchbooks, this is the only document of mine chronicling my early Spanish experiences. I cringe today while reading it. If I had been my parents I would seriously have doubted my child's sanity. Instead of reassuring them by saying how much I was enjoying myself (which I was, immensely), I outlined each change of my mood and cautiously summarised the journey so far as being 'very satisfying (which does not necessarily mean "happy")'. What comes across are those moments I once felt when travelling of the most acute morbid loneliness – moments that I deceived myself then had been provoked by the solitary expanses of the Castilian landscape.

The teenager on the point of suffering a major emotional crisis is clearly apparent in the letter, as is the person who Dr Sanger predicted would always be a romantic. I was loving

what I perceived at the time as the strangeness of Spain, finding, for instance, in a Romanesque tower at Salamanca Cathedral an element of fantasy that looked ahead to the art nouveau buildings of Gaudí. I was also quite taken by what was for me the uniquely Spanish experience of being allowed to climb the scaffolding in front of the high altar of a Toro church, holding a sketchbook in one hand and a lighted candle in the other (I badly sprained my back in the process). And I made a comment that encapsulated my later belief in the difficulty of separating the appreciation of a work of art from the circumstances in which you view it: 'the chaos and "dangers" involved in Spanish sightseeing give a more mysterious and fantastic aura to the artistic treasures'.

A true romantic, Dr Sanger was always telling me, was not someone with a sentimental attitude towards the world, but rather a person who combined passion with cynicism, someone capable of committing an act of madness in the knowledge of its ultimate futility. I considered myself a romantic in this nineteenth-century sense of the term while also accepting 'romantic' clichés about Spain I would later spend much of my life repudiating. This was certainly true of my initial feelings towards Madrid, where I went to stay in 1970 after a fortnight's immersion in a provincial Spain that seemed, from Toro at least, to be 'far from civilization'.

My last night before Madrid was spent at El Escorial, where I climbed through a forest of oaks and pines to the rock-hewn seat where Philip II had supervised the construction of his overwhelmingly austere palace/monastery. I described to

my parents the arrival of dusk over a landscape marked in the far distance by the lights of a large city that filled me with dread.

My fluctuating emotions indeed took a downward turn on arriving the next morning at the modern flat on the edge of the Barrio Salamanca, where I had been invited to stay by Royce. Royce, implausibly in retrospect, had found a flat to share for the month with a trio of Liverpudlian students with Beatles haircuts and a passion for football. They hadn't yet been to the Prado. They hadn't heard of Velázquez. They were surprisingly friendly towards me, even though I probably epitomised for them the utter absurdity of the effete public schoolboy. 'Don't forget your beret,' they teased, referring to the hat I had acquired in Toro in the mistaken belief that this would make me look more down-to-earth and authentically Spanish. 'We won't be able to recognise you without it.'

'In this modern flat in the middle of Madrid,' I wrote to my parents, 'all the atmosphere and charm of Spain seems to fade away.' I kept clear of it as much as I could, spending most of my time in Madrid in the streets or in museums, and moving after two days to the Pension del Peine, a similarly charmless place, but at the very heart of the old town, and only a short walk away from a monument I had left to the very end of my stay in the city – the eighteenth-century Royal Palace.

The simplistically romantic view I then had of Spain as a land of extreme contrasts of light and shade was highlighted after my first night at the pension, walking from my

cramped and windowless bedroom to the palace's daunting and blindingly sunlit forecourt. I was instantly uplifted, even though the building itself, Italianate and grandly classicist, belonged to what I thought of as an internationally bland period in Spanish architecture. The only reason for my wanting to visit it was to see another of the works I hoped to include in my A-level thesis on Hispano-Flemish painting – an altarpiece attributed to the Flemish-born miniaturist Juan de Flandes.

The elderly guide in charge of the obligatory three-hour tour of the palace promised I would see the picture at the very end. Soon he was reprimanding me for behaving 'like a lion in a cage', and telling me to listen to what he was saying if I wanted to learn anything. This public humiliation had its effect on me, for I can still remember much of what he told me about the palace's history. He was a lover of anecdotes, vividly bringing to life the fire that had conveniently half-destroyed the Habsburg palace in 1734, only nineteen years after their dynasty had been succeeded by that of the Bourbons. 'The Bourbon king Philip V,' said the guide, 'saw this as the perfect opportunity for his family to make their architectural and symbolical mark on Spain.' They were also keen to replace with marble one of the features they most disliked about the old building – its terracotta floors, such as the one in *Las Meninas*.

A leading architect from Italy, Felipe Juvarra, was brought over to Madrid to design and supervise the work, but he died of a chill here in 1739, having conceived a building that would have been four times the size of the present massive

one. He was succeeded by his Italian pupil Sacchetti, who called in some of the main Italian decorative specialists of his day, including the Venetian frescoist Giambattista Tiepolo, later a central figure in my PhD dissertation. My interest in pictorial illusionism was probably initiated by witnessing, on the ceiling of Madrid's Throne Room, the way in which Tiepolo's virtuosic handling of paint, colour and perspective had managed to make convincing such a potentially ridiculous subject as the triumph of the Spanish monarchy, flanked by allegories of the four continents.

Tiepolo, as the guide told us, was another Italian who died in Madrid. He had left his wife back in Venice, but showed no desire to return to her and his native city after completing his frescoes for the Royal Palace. 'He wanted to escape from his mother-in-law,' the guide jokingly claimed, trying to explain an aspect of Tiepolo's life more realistically interpreted as the artist's realisation that the Bourbons were probably the last powerful European patrons to want to commission such baroque apotheoses. His work was going out of fashion everywhere, and, even in Spain, was being heavily criticised by his chief rival at the Spanish court, the German neoclassical painter Mengs.

Shortly before reaching at last the Juan de Flandes altarpiece (which I was only able to see for a fleeting moment, and at a considerable distance), we paused in one of the near-identical rooms making up an interminable suite, all heavily gilded, with chandeliers, Flemish tapestries, painted ceilings and Empire clocks. This one, according to the guide, had been the bedroom of one of the daughters of Charles

III, the Infanta María Luisa. He claimed that the celebrated painting we now call *Las Meninas* had hung here in the 1780s. He had obviously done his homework. 'The work was known then as a portrait of the Infanta Margarita. It was also referred to until the nineteenth century as a portrait of the family of Philip IV. Only in around 1840 did a curator of the Prado give the painting its present title.'

Overcoming my habitual shyness of the time, I cheekily asked if a bedroom was too modest a setting for one of the world's greatest paintings. He replied that the work's reputation in the eighteenth century was not as great as it would be later, or indeed had been earlier. Artists such as Mengs criticised *Las Meninas* for being overly realistic, for having such grotesque elements as the foreground dwarves, for not having the idealistic touch of their adored Raphael or Murillo. 'And this,' the guide mused, 'was reflected in the changing valuation in the inventories. By the 1780s the painting was worth much less than other works by Velázquez.'

Its value then, he continued, was almost a third of what it had been around the time of the 1734 fire, shortly after which it was transferred to the royal dining room together with *Charles V at the Battle of Mühlberg* and other grand testimonies to the displaced Habsburg dynasty. The work, he finally added, directing towards me a rather severe glance, was lucky to have survived the fire at all.

In my memory the forecourt of the Royal Palace had always been flooded in brilliant sunshine. Now only a beam of evening light broke through the slowly dissolving

greyness of the sky, giving a red glare to a handful of panes on the south facade. I was looking at all this from a distance, behind black ironwork gates that were soon vanishing in my imagination, leaving the vast public square that had succeeded the earlier palace, a square once known for its performing acrobats and limbless beggars, but which was now completely empty, though soon to draw a growing small crowd of gaping onlookers, observing what to some of them might have seemed a world falling apart.

It was fifteen minutes past midnight on 24 December 1734. The King and Queen were elsewhere, and most of the palace staff fast asleep, when a handful of guards noticed the first flames of a fire that would last for over a week, fanned by a strong wind from the south. The cause of the fire was never fully established, but suspicion fell on a group of youths seen lighting one of the palace chimneys during drunken Christmas Eve celebrations.

The fire spread immediately to the main, south facade, devastating within hours the witch-hat-crowned tower known as the Torre Dorada, the upper floor of which contained the palace archive. Papal bulls and other documents dating back to the Middle Ages went up in flames, as did a massive and unique collection relating to the New World. In the meantime, monks of the Order of San Gil dedicated their initial, frantic attention to saving the holy relics and silver and gold ornaments contained within the Royal Chapel. Only then did they turn to the Habsburgs' extraordinary collection of paintings, including some of the most important works to be seen anywhere by Titian, Rubens and the early

Flemish School, and Velázquez's near entire output after moving to Madrid in 1624.

Unbelievably, most of the more renowned treasures were saved, one of the exceptions being a large painting by Velázquez representing the unusual subject of Spain's expulsion in 1608 of the country's Islamic population. The difficulties faced by the monks in rescuing such works were due to a combination of the height at which so many of them were hung, and their being often incorporated into the actual walls. The dangerous and chaotic situation was made worse by the palace authorities, who, in an attempt to prevent the building being ransacked, insisted on the main entrance being closed, forcing the monks to throw most of the paintings out of the windows. This is what happened to *Charles V at the Battle of Mühlberg*. This was also the fate of *Las Meninas*, which got away with just a light loss of paint after being tossed from a second-floor room on the palace's south-western corner. The same room, according to Palomino, 'which the work represents, and where it was painted'. A room in which the work had apparently remained propped up against a wall for more than seventy-five years.

I was staring towards this room across the square I had begun crossing. I had envisaged my progress through Madrid in terms of a moving presence on a seventeenth-century map widely acknowledged as one of the greatest examples of urban cartography ever produced. Its author, Pedro Teixeira Albernaz, was a Portuguese cartographer in

the service of Philip IV. His map of Madrid, known simply as the Plano de Teixeira, is remarkable for a minuteness of detail whereby even the humblest of buildings are shown in elevation. Following its streets is like physically entering the seventeenth-century city. Texeira makes the world in which he lived as tangibly alive as the figures in Velázquez's paintings. That it was created in 1656, the same year as *Las Meninas*, seems strangely coincidental.

The facade I was approaching was essentially little different to how it would have appeared in 1734, the main difference being that its south-western corner was then encased in a walled garden later pulled down to expand the public square in front of it. A rather insignificant frontispiece at the very centre of the facade was flanked by two doors at either side, the one on the far left, entered from the garden, being a fictive one. I made my way towards the doors, and opening the right-hand one, entered the palace.

CODA

Ed Vulliamy

OUT OF THE PAINTING

We will never know what Michael Jacobs found when he returned – as he prepares to do in the last paragraph he ever wrote – to the room in the Royal Palace of Madrid in which *Las Meninas* had been 'propped up against a wall for more than seventy-five years', after an unmerciful fire which the painting miraculously survived.

We'll never know whether, after 'staring at this room across the square I had begun crossing' – his mind's eye reading from a map devised in the same year, 1656, that *Las Meninas* was painted – Michael found some key to definitively unlock the secrets of the painting he loved more than any other and which has obsessed and defied so many. The painting which to Michael represented not only an allegory of life, but also its essence. Indeed, Michael's

exploration is of 'the confusion in Velázquez between painting and life itself'. We'll never know whether Michael did manage to breach the captivated bafflement with this strange state of affairs he shared with many others, yet failed to commit his discovery to paper, or whether he – literally – died trying.

But we know one thing, poignant and precious, from the book he left unfinished: that Michael's half-book serves as a map, a historical arsenal and artistic inspiration indispensible to any serious lover of painting – scholarly or passionately amateur – as he or she proceeds in Michael's slipstream. To anyone who proceeds to stare and stare again in wonder not only at *Las Meninas*, but at any painting which grapples with the enigma of representation. For in this half-book, beyond a fragment, we have not only a typically Jacobs-esque narrative of his life with Velázquez – one of chance encounters, aperitifs, musings and restless autobiography – but also this manifesto for the liberation of how we look at painting. Something which had to be understood and written, as Michael's one-time flatmate and co-author Paul Stirton puts it, remembering his friend, 'in that balance between readability and scholarship'.

Michael keeps returning to this phrase 'life itself' as though in counter-current to what he calls – in his merciless portrayal of researchers at the Warburg Institute – the 'sunless' world of art-historical academe. ('Sunless' was Michael's idea of hell; from him, the ultimate insult – he was a heliotrope who belonged to the same landscape and climate as the vine and bougainvillea.) Donatello described sculpture similarly: 'it is

the world,' he said. The extraordinary all-round philosopher Giacomo Leopardi turned the idea round: 'Everything is art,' he wrote in his great treasure trove of learning, *Zibaldone*, 'and art creates everything among men' – though he qualified his idea complicatedly and brilliantly over the book's 4,524 paragraphs, or propositions.[1] Perhaps this is the alchemy, mystery and *dichotomy* of great art: that it is of and contains the world, yet escapes – and offers escape – from it. This problem was certainly the setting for a great debate between Plato and Aristotle – whether beauty is separate from, or intrinsic to, an object – and it preoccupied Michael Jacobs too.

Michael's rediscovery of *Las Meninas* began with his enthrallment at Michel Foucault's contemplation of 'the gaze', and his idea that in *Las Meninas* 'we are looking at a picture in which the painter is in turn looking out at us'. Michael used to say: 'We must make this clear, Ed, what Foucault said, if only because of the rumpus it caused.' The 'rumpus' involved more rigid art historians, especially in America, who were (as Michael put it) 'miffed that a French philosopher was meddling around in their business', and objected to – as they saw it – art being used in the service of philosophy.

Given the history of the 'rediscovery' of *Las Meninas* by French writers during the nineteenth century, it is fitting (though frustrating for Spaniards) that this crucial text on Velázquez should be written by a French philosopher. Foucault's observations form the introduction and conclusion

to a book he published in 1966 about representation and perception entitled *Les Mots et Les Choses* – 'Words and Things' – translated annoyingly, and differently, into English as *The Order of Things*.

Foucault's book is not about Velázquez, but what he called 'epistemes' – derived from the Greek word for knowledge or science, to mean in this case the historical *a priori* which, said Foucault, 'defines the conditions of possibility of all knowledge' at any given time, and shifts between them. *Las Meninas* demonstrated, he thought, a shift between classical and modern ways of representation. And no wonder Michael was so caught, willingly, on this hinge. He was a man of modern – indeed, avant-garde – instincts, but classical taste; he talked in this book about reconciling 'my passion for the old masters with my championship of today's avant-garde'. But when pushed, Michael loved the Renaissance and Baroque far more than he loved modern painting, if he loved it at all. (He certainly had no time for the commodification of much contemporary art, and liked a remark by the Irish artist Brian Maguire, whose work he admired: 'I am called a neo-expressionist, but prefer to define my work by (*a*) the fact that the painters who've influenced me most are Goya and Gericault, and (*b*) by what I am *not*: "Britart" kitsch and commodity.')

Foucault, with a very different notion of modernity in mind, wrote of *Las Meninas*: 'The painter is looking, his face turned slightly and his head leaning towards one shoulder. He is also staring at a point to which, even though it is invisible, we, the spectators, can easily assign an object,

since it is we ourselves who are that point . . . The spectacle he is observing is thus doubly invisible: first, because it is not represented in the space of the painting, and, second, because it is situated precisely in that blind point, in that essential hiding place into which our gaze disappears from ourselves at the moment of our actual looking.'[2]

He continued: 'From the eyes of the painter to what he is observing runs a compelling line that we, the onlookers, have no power of evading: it runs through the real picture and emerges from its surface to join the place from which we see the painter observing us; this dotted line reaches out to us ineluctably, and links us to the representation of the picture. In appearance, this locus is a simple one; a matter of pure reciprocity: we are looking at a picture in which the painter's eye is in turn looking out at us . . . And yet this slender line of reciprocal visibility embraces a whole complex network of uncertainties, exchanges and feints.'

The mirror at the back, says Foucault, reflects 'that which all the figures in the painting are looking at so fixedly, or at least those who are looking straight ahead; it is therefore what the spectator would be able to see if the painting extended further forward, if its bottom edge were brought lower until it included the figures the painter is using as models' – be that us, or 'that which was always there before we were, the models themselves', be that the King and Queen or no.[3]

Foucault, argues one of his main supporters, Estrella de Diego, 'is naming uncertainties, or to use his own word, discontinuities'. Her interpretation of Foucault, broadly

speaking, is that the Renaissance had established a value in imitation of nature and rules of perspective around a geometric system and a single vanishing point, which would come to delineate the scientific world of the Enlightenment. Foucault is interested in the shifts between this order of things and an era which questions the certainties of representation and even 'collapses our age-old distinction between the Same and the Other', as Diego puts it.[4]

The Baroque, with its allegories, mannerisms and melancholies, is such a period of shift. One could add to Diego's point the dramatic expression of that shift which obsessed Walter Benjamin in his consideration of *Trauerspiel* mourning plays and their notion of 'melancholic contemplation of things which derives enigmatic satisfaction from its very recognition of their transience and emptiness'.[5] Michael and I talked a lot about the work of Samuel Beckett, and Benjamin's line is Beckett before Beckett, in a way – as Michael and I used to say when we discussed the Baroque. In *Las Meninas*, writes Diego, 'everything in the painting is slippery, every action is suspended; it is *about* to happen or has *just* happened'.[6] The Same and the Other co-exist in a new and elusive way, she writes, as the painting plays 'a game of visibility and invisibility'.[7] In this way, 'Foucault is not interested in what *Las Meninas* represents; he wants to explain how it becomes a model of representation'.[8]

Foucault wrote that 'as soon as they place the spectator in the field of their gaze, the painter's eyes seize hold of him, force him to enter the picture, assign him a place at once privileged and inescapable'.[9] And this begs a word about

the stares from within paintings by an earlier artist whose compositional constructions are also cogent to *Las Meninas*, for Velázquez was not the first to deploy a stare in this way, as part of a 'sacred conversation', of which *Las Meninas* is a secular version. And to Foucault's words 'privileged and inescapable' one might dare add: 'forbidden'.

Since my youth, I have felt and been pinned by the stares that shoot like darts into the eyes of the viewer from within paintings to create that sense of peeking into the forbidden. The early innovations in this method were by Piero della Francesca, like the figure attendant on the Virgin Mary at the back of the *sacra conversazione* at the Brera in Milan, with golden hair, clad in green velvet with a claret collar. His is a gaze at once imposing and irresistible, drawing you into and involving you in the painting and its spaces, chambers and strange composition, dominated by a cockleshell dome from the tip of which hangs an egg. The Brera egg has been the subject of endless speculation: it is opaque, which simultaneously invokes the ideas of fertility and translucence, which was a symbol of the immaculate conception because light passes through matter without disturbing it, as with the hymen of the Mother of God. But, more than this, the cockleshell from which the egg hangs is also the site and symbol of the birth of Venus, suggesting a Renaissance humanist connection between Christianity and the more erotically articulate gods of the classical pantheon. In both instances, the stare, unswerving into yours, simultaneously warns the viewer, somehow, that this is a glimpse of something forbidden. It includes and excludes simultaneously.

The same stare comes from what seems to be an angel in Piero's *Madonna di Senigallia* at the National Gallery of The Marche in Urbino. The figure is similar to that in Milan, dressed in silver-grey this time, arms crossed over his chest – and throws a fixed squint right at the viewer, again as invitation and warning at the same time: understand this, or fail at your peril. A Foucault-esque stare is hurled, very differently but with equally intransigent directness, by a soldier from within the heat of battle in Piero's fresco cycle depicting the Story of the True Cross in Arezzo. The trooper, surrounded by a forest of spears and the clamorous thick of combat, glances at you as a sneer, challenge and invitation to share his contempt for war – the din and the pity of war – simultaneously luring you into, and separating you from, the scene. There is no evidence that Velázquez went to either Arezzo or Urbino, or that he saw Piero's work. But these stares – along with Piero's art of composition – are crucial to understanding *Las Meninas*, which is a secular variation on the silent sacred conversation; that glimpse into the forbidden world of the King, his daughter and her personal entourage in spaces every bit as complex and strange as those beneath Piero's cockleshell.

Between Piero and Velázquez, the stare from a painting became almost a trope in Renaissance art. In the tradition of Piero's soldier, the stare was used to separate a figure from a scene to spine-chilling effect by a mannerist painter – working until 1620 in Ferrara, which Velázquez *did* visit – called Ippolito Scarsella. Scarsella depicts Judas Iscariot at the Last Supper, in a striking yellow robe, sitting on our

side of the table opposite the Messiah, who sits behind it facing us, predicting his betrayal. Judas stares out at us over his right shoulder as though to say, with diabolical defiance: 'You see? The man is talking about me.' Staring at the viewer also became a device for self-portraiture by the artist: a precursor of Velázquez's gaze is that of Filippino Lippi in the chapel of Santa Maria del Carmine in Florence, who twice stares out in a fresco cycle narrating the life of St Peter. On one occasion Lippi meets our gaze from among a group witnessing the saint's upside-down crucifixion, as though challenging us to acknowledge the significance of this savage execution. In each instance, the person staring creates a scene in which the viewer also stands and observes, himself observed.

In that vein, Foucault proposes of *Las Meninas* that: 'The entire picture is looking out at a scene for which it is itself a scene,' adding that in this case, 'a condition of pure reciprocity [is] manifested by the observing and observed mirror.'[10] And three hundred pages later, after an epic exploration of man's perception of his condition, Foucault draws his philosophical conclusion, that:

Man appears at his ambiguous position as an object of knowledge and as a subject that knows: enslaved sovereign, observed spectator, he appears in the place belonging to the king, which was assigned to him in advance by *Las Meninas*, but from which his real presence has for so long been excluded. As if in that vacant space towards which Velázquez's whole painting was directed, but which it was

nevertheless reflecting only in the chance presence of a
mirror, and as though by stealth, all the figures whose
alternation, reciprocal exclusion, interweaving and
fluttering one imagined (the model, the painter, the king,
the spectator) suddenly stopped their imperceptible dance,
immobilised into one substantial figure, and demanded
that the entire space of the representation should at last
be related to one corporeal gaze.[11]

Maybe there are no words to describe a visual masterpiece
any more than, say, a Bach prelude, but that would not
stop Foucault – and it does not stop Michael – from trying.
Michael cites the Serbian novelist David Albahari's dictum
that, he paraphrases, 'the greatest secret is that there is no
secret'. The painting is what it is, the impact it makes upon
you and what you make of it, with your imagination. We
could say the same of a Bach prelude or a Jimi Hendrix solo,
when all is said and done. But one could not necessarily
apply this same aesthetic Zen to a Shostakovich quartet or
to Delacroix's painting of Liberty: some works of art do
demand to be 'read', and have something programmatic –
even didactic – to say. Michael was too curious, and too
committed a communicator, to leave things unexamined
and unspoken of.

Similarly, what interested Michael as a connoisseur of
cuisine was the way ingredients combined to make a taste,
even if they were individually indistinguishable. Of what is
a dish made? And upon reading Foucault, Michael began an
exchange with Velázquez's gaze, and of this idea of a painting,

with its secret ingredients, that stares back at us. What is it here that spellbinds us? What is the unspoken mystery, and how should we approach it? Michael wrote, after reading Foucault, that: 'this was in turn a vision that raised in me grand expectations of the study of art history that could never be realised' – and therein lies the manifesto upon which this book embarks, as continued in our conversations.

Michael came into my life far too late, and even later in his. But our syncopation and friendship was, I like to think, immediate and organic for reasons that were not at first obvious. We were initially introduced by my editor John Mulholland, by his design, at a house party he gave one Christmastide. We thought the synergy was due to many mutual friends and parallel tracks over decades that had somehow failed to cross. Also to a mutual passion for The South, with all that that means, which John also shared with Michael, so that in the cold grey of wintry London we formed a triad of yearning for the Mediterranean, Aegean or Latin America – and this bonded me immediately to Michael. But to me, the South meant primarily Italy and Mexico, not Spain, and my interest in the Hispanic world was recent, almost amateur – I do not even speak Spanish properly – in contrast to Michael's lifelong collision of love and expertise (John's too, for that matter). And while Michael's immersion in Latin America was lyrical, cultural and historical – as captured in his wonderful books about the Andes and Colombia – my experience of the subcontinent was more to do with narco-traffic and violence, plus a long

history since schooldays of fascination with Aztec and Maya cultures, in which Michael had scant apparent interest.

Other things separated us: Michael was uninterested in football (bafflingly, given his social instincts and love of football-mad countries), which I adore, not least for the conversations the game instantly generates with strangers abroad. I find the 'foodism' he loved boring; Michael liked complicated recipes, I enjoy *cucina casalinga* – housewives' cooking, as the Italians still get away with calling it. Michael was a poetic anarchist – I once asked what his politics were, to which he replied 'jovial anarchism!' – but not a revolutionary, which I am. Michael was not an angry man, I am. Michael loved a crowded roomful of strangers – I don't any more. But we soon found each other to be playing in the same key, and our love for the South was crucial to what would become our mutual love of painting: the South as a way of life; a way of thinking and feeling, to do with light, passion, profanity and earth from which the olive grows. The South as half-light inside a building while the sun is bright outside, the scent of musk on walls of old stone, the cool interior during the impenitent heat of afternoon. We met again, in London a number of times and at the book festival in Hay-on-Wye, near the Welsh village in which my father spent his childhood. There, I met Jackie Rae, his lifelong love and companion, later wife. I was by then enthralled by Michael's books about Spain – *Between Hopes and Memories* and *Factory of Light* – and Latin America – *Andes* and *Ghost Train Through the Andes*, which I read eagerly, upon our meeting.

Then, finally, we went South together – to 'my' terrain, however, to Mexico. It was an unforgettable trip: to the Hay Americas book fair in Xalapa, where Michael and I – with fellow writers Peter Godwin and Santiago Gamboa (whom I knew from Sarajevo) – abandoned official festival business and were taken, against all advice in a town with a scary narco-cartel presence after dark, on an all-night bar crawl by two gutsy young women oozing confidence and ease. Here was the Michael his friends knew of old: fearless in pursuit of a good time, dancing in his very own way, relishing the young female company but without intention, trying drinks in no particular order, speaking in waterfalls of fluent Spanish to all who would engage him. Even a roadblock by heavily armed state police – who famously double up as gunmen for the Zeta cartel which controls the city – failed to faze Michael Jacobs as the eastern sky quickened. This was the man who, in his book *The Robber of Memories*, could turn being kidnapped by Colombian FARC guerrillas into a comic farce.

Back home in England, other factors and passions acted as riptides between us and to bind us, and among their most important currents were: Italy, Ireland – and painting. Italy came first: Michael's father, Captain David Jacobs, had met the actress Mariagrazia Paltrinieri during the war in her native Sicily, and married her. Michael was born in Genova, studied in Treviso, and was of course immersed in Italian art. His mother Mariagrazia is in her way the main character in Michael's book before this one, *The Robber of Memories*, which concerns his distance from his mother

while she faded, suffering from Alzheimer's. (It is still bitterly astounding in the wake of this book that Mariagrazia in the event outlived her son.) Michael's Italophilia comes second only to his Hispanophilia; Italy was my first love abroad, and will be my last, albeit a complex and equivocal one, like all durable marriages. I spent my formative years living there and studying at the university in Florence, alternating a passion for the Renaissance with meetings of *Lotta Continua* ('Struggle Continues' – the only political organisation I ever joined), and went on to live in Roma and Napoli during later years.

Then came Ireland: when I first visited Michael's house in Hackney and saw paintings by his grandmother's sister Estella Solomons, my heart stopped. I knew about this family of Jewish Irish Republicans, had always adored Solomons' work (she could paint ultramarine blue like a great master), and was fascinated by her, combining as she did artistic sensibilities with founder membership of *Cumann na mBan*, the women's wing of the IRA. This militant Irish Republican heritage is the one Jacobs family connection that gets left out of homilies and edited out of obituaries (including that which I wrote), though Michael was extremely proud of his grandmother, Sophie Solomons, a famous opera singer and, like her sister, Republican. The opticians' practice of their father, Maurice Solomons, was mentioned in James Joyce's *Ulysses*, and Michael wrote a book about the adventures of their cousin Bethel, who was both related and betrothed to Sophie, and who built a railway across the Andes, thereby blazing Michael's own trail in many ways. I was meanwhile

– and still am – in the process of reviewing a collection of intimate letters written to my great-aunt Gladys Hynes (a painter in the colony at Newlyn about which Michael writes in another book) by Desmond Fitzgerald Sr after he had founded the Irish Republican Brotherhood, and later as Minister for Propaganda in the revolutionary Provisional Dail, before partition and establishment of the Free State. The letters illustrate how Republican and artistic circles like those of Michael's forebears overlapped effortlessly in those days – W. B. Yeats, mutual acquaintance of Fitzgerald and Gladys, is a recurrent figure in the correspondence – and they would almost certainly have all circulated together, Estella, Sophie, Fitzgerald and my great-aunt Gladys; Michael and I loved to wonder where and how.

We were certainly bonded by our shared genealogical indefinability, of which we were fond but which made us restless dissidents and cage-mad strangers in the England where we had grown up and to which large parts of our lives were condemned. Michael was proud of his bastard genes (Irish–Jewish–Italian–British), as a travelling man should be – as am I (Irish–Welsh–English–French–German). And Michael loved this in Velázquez, who was born in Andalusia of local, Portugese and perhaps Jewish ancestry. There was an element of the traitor in both of us, as articulated in this book by Michael's elated leaving of the cliffs of Dover aboard the Channel ferry as a boy – I felt, and still feel, the same.

Then Michael came for the first time to the flat in which I then lived, behind Notting Hill Gate in London. Michael

and I had already discussed his book on Velázquez briefly, and – aboard an overnight flight from Mexico City to London – we had talked at length about Michael's admiration for his PhD supervisor Anthony Blunt when he was Director of the Courtauld Institute, and about his loyalty to Blunt after he was exposed as a Soviet spy. I had by this time read Michael's excellent *Nude Painting* and *Mythological Painting*, and I think he was surprised to find not only these but half a wall of my home lined floor-to-ceiling with books about the Italian Renaissance, which we had not discussed; I was hugely gratified by his compliments on the collection.

So now came our first real conversation about painting. Michael was bounding back from a book fair in Romania, furious at English second-home-buyers in Transylvania (which he had travelled in Communist Ceauşescu days, and about which he guarded his expertise jealously). I was immobile, injured in an accident – a smashed-up left leg held together by a barbaric 'Ilizarov frame' which pins and stretches bone in the manner of the Spanish Inquisition. We chatted over Turkish Efes beer for him, morphine for me. Our discussion at first concerned not Velázquez but Giorgione, whose extraordinary work *The Tempest* had been an early obsession for both of us. Giorgione was – with this picture and his devastating portrait, in early *chiaroscuro*, of an elderly lady holding a scroll reading *col tempo*, 'with time' – part of my own interest in what I like to call 'the dark Renaissance'. Michael had himself set out to 'investigate' this painting, which in this book he classes as among 'Europe's great problem pictures'. Alongside, that is, *Las Meninas*.

The discourse on Giorgione led Michael to talk also about his fixation with Velázquez – *Las Meninas* in particular – when he was a teenager, during his first-ever solo trip abroad. His enthusiasm was seen as unenviably sad, even a little mad, by his peers at school, including the man, Royce, who would later send him a reproduction in the form of a puzzle.

So Michael talked about the sneering he faced over his obsession with the mysteries of the Spanish masters, and I replied that my early adventures in Firenze with Donatello and Masaccio had had a similarly obsessive impact upon me, drawing the same reaction from my college- and schoolmates. I had been fixated by what I saw as a darker, pessimistic 'wing' of the humanist revolution in Florence during the quattrocento, a more existentially desolate vision than the accepted wisdom of Alberti's dictum: 'Man, the Measure of all Things'. My inspirations were the scream of Masaccio's Eve – expelled from the Garden, but also from the edifice of saints and the medieval world of cosmic certainty – and Donatello's Maddalena in wood, praying, clearly, to nothing. If God was dead or gone, the response of these artists seemed, rather than celebrating mankind's assertion of himself like Lippi or Botticelli, to cry instead: 'Oh fuck, we're alone!' The fact that this Godless desolation was expressed in Christian imagery was all the more compelling. No one else seemed to see or agree – just as no one had seen or agreed with Michael's passionate reaction to Velázquez, and what he now called 'nerdy curiosity lured by danger in the painting'. To my surprise, Michael took some of these unformed

teenage ideas about 'dark Renaissance' painting seriously, even making connections between them, via Giorgione and Velázquez, about whom I knew little. He talked that night about 'these intangible things, not at all comforting but which demand an instinctive reaction to a painting, stripped of all preconceptions, to what is there, and where it leads, however damned alarming'. I was bowled over: aged fifty-nine, more than forty years after first visiting Florence in 1972, I had finally found a soulmate in these matters, interested in not only the mysteries of these paintings and sculptures, but also the existential depths they threatened to contain.

This conversation with Michael occurred in mid-September 2013. He was in fighting form, his wanderlust as unabated as mine had been curtailed by injury. Michael was sympathetic towards my wound, and even more so towards the immobility (his idea of Room 101 was to be parked off the road). He added with nonchalant irritation that he had to go to the doctor too, outraged, for he hardly ever needed to. Some back trouble, probably lumbago. Ten days later, he had been diagnosed with aggressive cancer of the kidney and, according to first reports that reached me, given 'between one year and three to live'. My new friend – probably the most effervescent person I had ever encountered – was, suddenly, about to die. For some time, however, Michael insisted on saying, when discussing his condition: 'Of course, it's nothing compared to what you're going through, Ed.' Once, I dared to correct him: 'Michael, there's one big difference. My body wants me to get better, yours is out to get you.' 'Quite so,' he agreed simply, and changed the subject.

Not long after his diagnosis, Michael talked about how the book on *Las Meninas* was intended to proceed, his intention for it to see the light of reading-day despite his condition, and how I should undertake some attempt at literary midwifery towards that aim. He accepted that he and I might need to work together in some way, on the basis of our mutually passionate response to the Renaissance and Baroque, but more, I think, because of our contrapuntal friendship, common view of the world, and serious interest in each other's work, whatever it was. There was one unforgettable afternoon: I arrived at the house in Hackney, and we went for lunch, heading for his favourite restaurant at that time: a funky Italian trattoria/diner called Ombra, at the canal on Mare Street. I could only walk in pain, not otherwise. Michael was starting to hurt badly too and he had had a special orthopaedic chair installed in his basement. We made it some way along the short distance on foot, then both decided that we really ought – and needed – to take the bus. It was poignant: we rode one stop – my first bus journey since the accident, and probably Michael's last. Ombra means 'shadow', appropriately, though Michael came up, typically, with a better explanation for the choice of name: in some parts of the Veneto, he explained, it means the glass from which you drink your *digestif*.

And so we expressed how appalled we both were at the notion – and reality – that neither of us was able to enjoy a glass of wine over lunch, drugged as we were on morphine, antibiotics, whatever. The earringed, pony-tailed cook and the waitresses were playing Fabrizio de André's superb

account of 'Desolation Row' by Bob Dylan, translated into Italian as *Via della Povertà*. With that devastating song drifting on the air, Michael and I at last began to discuss *Las Meninas*, and the book.

This first conversation about 'our' work began what was to become 'my work'. The plan was for Michael to sit with me on as regular a basis as he could muster and dictate his ideas on the painting. I would write them up so that Michael could read what he had said, then edit and alter this to his liking on the page. The second conversation was around a performance by the London Symphony Orchestra of Berlioz's *Symphonie fantastique*, under the baton of electrifying Valery Gergiev. We met early before the concert in the Barbican bar with its unwelcomingly bright orange easyJet check-in look (and bartenders even slower than easyJet's, which is saying something) for more unwelcome soft drinks and welcome discourse on Velázquez. Michael was almost amused by the spectacle of us both hobbling, decrepit, to our seats, generously given by the LSO as a gift. Gergiev and his orchestra played a heart-stopping account of the symphony, and Michael joked at what a 'psychedelic experience' it was to hear that particular piece, with its opium reveries and frantic, satanic passages, on a heavy dose of class-A medication.

The third session – a long one – was back at Hackney, and the fourth at the corner of the table during what must have been one of Michael's last big outings to dinner. This was a precious occasion: I had in town two friends, David Rieff, who had previously met, and become immediately

fond of Michael, and the *Guardian*'s correspondent from Athens, Helena Smith. Michael by now sortied only in company: his best friend Des Brennan from Scotland was along, and announced that 'I'll be drinking for Michael' tonight; also a striking Scottish actress called Fiona Bell, and a Welsh friend called Erica Davies, one of Michael's longest-standing from Courtauld days. We convened at one of my favourite restaurants in London – the Patio, a Polish bistro in Shepherds Bush run by a former diva from the People's Opera in Warsaw – and had a wonderful time, with vodka for everyone apart from Michael and me. Though reluctantly sober and in pain, Michael was the life and soul of the table. But he and I stole a good fifteen minutes to ourselves in the corner, during which he burst forth on Petrarch's writing about composition, and said he was ready to start dictation of the book. He said the same a month later during another lunch back at Ombra.

The problem was this: once Michael had succumbed to this modus operandi, he seemed to have admitted that he would die. And this is something he outwardly refused to do, almost until the last days. Even a month before his death, he was still wanting to plan the trip we would undertake together to Piedmont, 'when I'm a little stronger', in search of the origins of the dwarf Pertusato. I think he felt that even to send and show me what he had written hitherto was similarly 'bad voodoo', and would hasten his end – I never saw it until it was sent to me by Jackie Rae a while after his death.

The plan was further interrupted by Michael's inability,

because of pain, to come one weekend to Glastonbury, where I had moved and where we were to attempt a disciplined weekend's work. And then by his being understandably unable to refuse the chance of going to his real home in Frailes, in Andalusia, for Christmas and what he must have known would be a last goodbye to his dog Chumberry, his people there and the landscape he loved. So that we never actually sat down, notebook in hand, shorthand at the ready. What we did do, though, was discuss the book and painting at the encounters we could steal – in fact, at all of them, until the last days – while I took surreptitious notes which I then wrote up each night after our meetings. I set about reading everything about Velázquez I could get my hands on: Michael's favourites – Palomino, Stevenson and Foucault – and very many others, including authors he disdained. Unable to get to Madrid to contemplate *Las Meninas* for myself, I spent hours staring at reproductions of the painting and mustering up the aura of the original, which I'd last seen in 2008, in my mind's eye.

Michael has begun the book with 'a puzzle', and this is how he conceived his task: to complete the picture from the constituent pieces, the creative and artistic ingredients, with which Velázquez has, as Michael said, 'so remarkably completed the whole'. But to do so not in an academic way at first – rather, by appreciating what he typically loved in 'the quintessential Spanishness of the work, its exotic and surreal character, its mixture of sombreness and sensuality, its element of the grotesque', as well as its place in the

twilight of Spain's Golden Age. He wanted to piece *Las Meninas* together for himself and explain it to anyone he might one day call a friend, and not for the 'sunless' world he had come to know at the Courtauld and Warburg. There he had been told regularly: 'You're an art *historian* and not an art *critic*' whenever he proposed meanings in art that could not be substantiated by historical fact or probability. 'I came eventually almost to accept that there was no place in art history for too much emotion or imagination.' In our conversations, Michael urged the liberating opposite of this straitjacket, with scathing humour at the expense of 'dry, Anglo-Saxon unfeeling art history'.

Michael had much to say about his tutor at the Courtauld, however: Anthony Blunt, whose treatment by the British establishment and media had influenced his relief at departing from the cliffs of Dover. Blunt will be primarily remembered not for his scholarship and crystalline writing on Poussin, the Renaissance and the Baroque but for being the Communist 'traitor' against whom all but Michael and a few others in the art world ganged up when it was expedient to do so, but toasted twenty years later when the coast was clear. Michael talked about how his own loyalty to Blunt cost him, he believed, a career in academic art history had he wanted one, though it is possible he liked and concocted this modest, political, implicitly underrating view of himself. Michael was, actually, offered a prestigious lectureship at Edinburgh University and later promised something at Columbia in New York by Edward Said, whom he came to know. But in the recollection of Jackie

Rae, Michael 'turned it all down for fear that getting tied to one thing may prevent him from accepting a more tempting project further down the line'. Michael as Mr Micawber, then: waiting for something to turn up while discarding an *embarras de richesses*, wanting, really, just to go his own way. Significantly, this was also the career non-strategy of the one art historian whom Michael really admired on Velázquez, R. A. M. Stevenson (cousin of Robert Louis), who did spend time in a steady job, the Roscoe Chair of Fine Art at University College, Liverpool, despite objections by city fathers at the appointment of this 'dirty Bohemian'. But Stevenson left it to plough his own furrow. As Denys Sutton notes in his introduction to Stevenson's book on Velázquez: 'Stevenson's decision to surrender a post with a regular salary, however small, must have required some courage, especially in view of his known improvidence.'[12] It all contrasts markedly with Velázquez's own, as Michael put it, 'toadyism at the court of Madrid, and obsession with attaining yet another stupid but grand position, thus wasting precious time he could have spent painting or enjoying life'.

I think it is fair to see Blunt and Velázquez as the two great influences on Michael's love of art. The latter was first love and grandmaster, of course, but Blunt was the facilitator, the nurturer of discipline, the guide – Michael once said he had been 'taught by Blunt how to look at the making of a painting the way a Velázquez demands to be looked at'. Michael intended Blunt's teaching of Renaissance composition, as applied to *Las Meninas*, to be part of his book, along with Blunt's own story.

Anthony Blunt, from the Paddington area of London, was a mathematics scholar at Trinity College, Cambridge, who switched to modern languages and – while still a student – bought a painting by Poussin for £100 and met Guy Burgess who, he said later, converted him to Communism. Blunt visited the USSR in 1933, and – it is believed – recruited in turn Kim Philby and Donald McClean into service for the NKVD Soviet secret police and intelligence agency, at the time busy with revolution in the West and, before long, war in Spain. Between them, these men constituted four of the famous 'Cambridge Five' spy ring, of which Blunt became known as 'the Fourth Man' after his 'outing' by Prime Minister Margaret Thatcher in November 1979. It is unlikely that he actually joined the Communist Party, urged as he was by Burgess at one point that he would be more effective to the cause without a Party card.

During World War II, Blunt attained the rank of major in the British Army, seconded to MI5 but passing intelligence to the Soviet Union, a distrusted ally. As part of the 'Ultra' intelligence core, Blunt was privy to transcriptions of intelligence on German manoeuvres decrypted from the Enigma coding machine, and was able to supply top-level information relevant to the Red Army – even to its game-changing victory at the Battle of Kursk – and thereby to the outcome of the war.

Blunt had another life all the while: he had already published, in 1940, the groundbreaking short book *Artistic Theory in Italy, 1450–1600*, and after the war devoted his attention and brilliance to art history. He became

synonymous with deepening our understanding of the French classicist painter Nicolas Poussin. As Director of the Courtauld, where he taught for twenty-seven years, Blunt shaped it into an institute renowned for research and expertise. He was appointed Surveyor to King George VI, and thereafter to Queen Elizabeth II, of the royal collection of art. Blunt taught such prestigious art historians and curators as John White, Nicholas Serota and Neil MacGregor – and Michael Jacobs, who was one of his favourite and most original students. Jackie Rae remembers Blunt during the early 1970s learning, as was she, about Michael's unchangeable ways: 'Tony would ring and ask me: "Jackie, *where on earth is he*?" I think he knew something was up, he was not going to be forever at the Courtauld and Michael's PhD was past due. I'd reply, in all honesty: "I have no idea, I really don't know." Michael was off again. On that occasion, he was, actually, working on artists' colonies, which became a good book.'

Blunt retired from the Courtauld shortly afterwards in 1974. His espionage activities had been known to MI5 from 1963, but the intelligence authorities agreed to grant him immunity and keep them an official secret – to the chagrin, it emerged, of many in the establishment. However, with the appearance in 1979 of a book based on his case, Andrew Boyle's *Climate of Treason* (in which Blunt was code-named 'Maurice'), the newly elected PM Margaret Thatcher responded gleefully to pressure by revealing Blunt's wartime Soviet service to the House of Commons, in response to a choreographed question from a backbench Labour MP.

Michael spoke to me with fondness about Blunt as man and teacher, and with deep respect for his love for painting and calibre as an art historian. And he was sickened, he said, by the 'baying maelstrom of indignation and bullying', as Michael called it, unleashed against Blunt after Mrs Thatcher's announcement. Blunt was a 'pansy aesthete' (*Evening Standard*) and a 'treacherous Communist poof' (*Daily Telegraph*), while the *Sunday Telegraph* accused him of a tip-off to the Nazis resulting in the deaths of twenty-nine Dutch agents working with the British Special Operations Executive – the paper had got the wrong Blunt, but refused to retract its story. Old enemies from the art world, propelled by jealousy, accused Blunt of abuse at the Kincora Boys' Home in Northern Ireland, without evidence. 'It was open-season bile,' recalled Michael, 'the British national sports of bullying and patriotic self-righteousness, off the leash. Not just in the press – the public relished it all, and MPs were lining up to join in.' As Miranda Carter notes in her biography of Blunt: 'No senior art figures came forward to defend him publicly – and would not until after his death.'[13] The distinguished historian A. J. P. Taylor, however, did say that if Blunt was expelled from the British Academy, as was a plan led by his peer J. H. Plumb, he would resign from it. In the event, Blunt's membership of the academy was left in abeyance.

Three letters in Blunt's defence were written by former students, to *The Times*. One was signed by Michael alone, calling Blunt's espionage 'a minor and ultimately irrelevant aspect of his life'. 'There was no response from the paper,'

Michael recalled, 'but I received death threats by telephone, and no end of abusive mail, most of which I didn't bother to read very carefully.' The young correspondents to *The Times*, former students who had kept in touch with their mentor, were rounded on in the paper's columns by the supposedly learned commentator Bernard Levin for what he called their 'moral blindness'.

Michael helped Blunt get to and conceal himself in the home of John Golding – painter, art historian and expert on cubism – in Barnes, outer London, which acted as sanctuary for a while, but to which he was eventually traced amid a glare of hostile publicity. When Blunt returned home to his flat at Portsea House in Bayswater, Michael was, he remembers, 'among those who took it upon ourselves to walk the ring of journalists and whoever outside, visit and chat. And when the siege was finally lifted and they found better things to do – such was their attention span – I kept in regular touch, always. His lover [John Gaskin] was going bonkers by then, accusing Blunt of betraying him and cracking up generally, so we put together a rota – shopped, visited, chatted and I'd also cook him a meal every now and then.'

There was a famous episode in February 1980 at the Gate Cinema in Notting Hill Gate when Blunt determined to attend a screening of *La Cage aux Folles*, but was recognised and sent packing by booing and a slow handclap from the entire audience; 'I took him to the cinema that night, but then urged him to leave, and ushered him out,' recalled Michael. He relates, though, how Blunt alternated between distress

at these changed circumstances, and 'remarkable calm. We were several hours sitting in the flat, and for many of them, he'd work, as he always worked – focussed and quiet – on a book about baroque Rome.' Art historians recall a lecture he gave at Oxford during this period as 'one of the best of his life'.[14]

Michael's knowledge of Spain helped him understand how 'it had been Spain that turned Blunt into a Communist' during the Civil War and the overthrowing of the Republic by Generalissimo Franco's Fascist insurgency, backed by Nazi Germany, in 1936. 'Faced with the rise of Fascism and Britain's neutrality over Spain, Blunt was hardly alone in finding a reason to support the Reds,' said Michael. (Miranda Carter makes the interesting point that though this is true, many international Marxists became disillusioned when they saw the NKVD in action *against* many on its own side in Spain – Trotskyites, anarchists and libertarian socialists like George Orwell – as well as in support of the Republic. Blunt, as one who did not go to Spain to fight, had not yet experienced that erosion of faith in the USSR.)

With hindsight, something that outraged Michael almost as much as the reaction to Blunt's treason was the conduct of some of his Courtauld colleagues at a reunion years after Thatcher's announcement. He was contemptuous towards those who distanced themselves from Blunt when politically necessary in the late 1970s and early 1980s, but were generous to a fault about his academic prowess when gathered for cocktails long afterwards. 'They were all blathering on "*dear Tony*" this, "*wonderful Tony*" that –

the same people who had kept their distance when it suited them, when it mattered, to advance their careers. Or worse, had joined in the clamour against the man who taught them everything they knew.'

Mark Jones, former Director of the Victoria and Albert Museum, now Master of St Cross College, Oxford, was a fellow student of Michael's at the Courtauld and signatory, with Erica Davies and Giles Waterfield, of another letter to *The Times* in support of Blunt. 'Michael was a true cosmopolitan,' Jones now recalls, 'who insisted that the idea of treason against a particular country had no meaning for him. I had sympathy for Blunt because I admired his engagement, so rare among middle-class academics; his recognition of and response to the advance of Fascism. His mistakes, it seemed to me, arose from a desire to confront evil and injustice. And his treason arose from the view that it was wrong to deprive the Soviet Union, which people seem to forget took the main brunt of the struggle against Nazism, of information which could help them in that struggle. Easy and repulsive, I thought, to condemn a man who had taken risks for the right reasons, from the comfortable vantage point of hindsight.'

But there is a more sophisticated connection between 'those rare middle-class academics' like Blunt and people like Michael Jacobs and Mark Jones. 'Come off it,' Michael used to say, 'everyone at the top with an interest in these things knew Blunt was a spy. They just had the sense not to want to do anything about it. They'd lived through the war. They understood that it isn't all cowboys and

Indians.' 'Everyone says Blunt betrayed his country,' says Jones, picking up his friend's theme, 'but we thought it said something interesting about him, that he thought about things. The generation that lived through the war,' he reflects, 'was very different to that which was born just after it. People knew perfectly well that he was a spy. But things were nuanced then; they didn't see things in black and white, in that way the Thatcher generation did, and the Bush–Blair generation does. The mood changed: for instance, there was not before such a strong feeling for acts of military commemoration that we see today.'

And 'this more nuanced view was very much Michael's,' recalls Mark Jones. 'Though he was of the post-war generation, he was a complete internationalist in a way not many people can claim. He felt little idea of "our side" or "our country" against yours; little or no sense of "homeland" really.' It was a view that permeated every area of Michael's life, not just politics. I discussed with Jones my surprise at Michael's lack of interest in football, given its immediate access to conversation and the passion it commands in Latin countries he loved. 'He had no interest in teams, supporting a team wearing these colours, dissing the opposition wearing other colours,' Jones recalls. 'I think that Michael and I reacted against the lesson we were supposed to learn at school: "play up, play the game!" – we did not want to "play up" for any team, and the experience of not being part of a team made you anti-team, and the whole experience of school put us off.' (Michael attended Westminster, Mark Jones, Eton.)

In the wake of Mrs Thatcher's announcement, Buckingham Palace immediately retracted Blunt's knighthood, after which the institutions of Britain could not follow suit fast enough, stripping him of honorary doctorates, fellowships, editorships and all. With one exception: on 9 February 1980, the convocation of London University was called to vote on a motion to strip Blunt of his emeritus professorship, but faced a campaign by Michael, Mark Jones and others. 'We argued the case, as I've just explained it to you, with some passion – and to our surprise, we won,' says Jones. The motion was defeated by 246 votes to 147.

There was also, says Jones, 'Michael's sense of politics as a complete waste of time. I was interested in politics, and so was Erica [aka Erica Davies, our guest at the Polish restaurant that night, Jones's partner during the Courtauld era]. But Michael thought politics vulgar, or at least not as important as the higher things which Michael admired in Blunt, and himself thought to be important.'

Michael's Hispanist friend Gijs van Hensbergen, who arrived at the Courtauld after Michael and became an expert on *Las Meninas*, puts it very simply: 'If you had Blunt for a tutor, you forgive him anything. As for his lectures: I've never known anything like it. Sixty minutes on the dot, no notes. There were times when, ten minutes before time was up, you'd be completely and totally lost, for all one's best efforts to keep the thread of the argument. Then, ten minutes before the end he would start to tie up all the knots, everything fell into place and on the dot of the hour, all that he had said became crystal clear – total

illumination. It really was extraordinary.' Anthony Blunt was the inspiration, then, not only for Michael, but for a generation of Velázquez enthusiasts.

There remains the academic influence of Blunt on Michael; that of the clarity with which Blunt looked at and wrote about painting which tempered but did not conceal his passion for it, and his teaching of – and writing on – Italian Renaissance composition, highly cogent to Michael's exploration of *Las Meninas*. This especially was to be an important component of *Everything is Happening*.

During Michael's years at the Courtauld, he squatted, rent-free, in Regent's Park Road, central London, with his best friend Paul Stirton, who would become co-author of many books, including very readable and intellectually substantial guide books to galleries in Britain, Ireland, France and Eastern Europe. Stirton had arrived at the Courtauld from Edinburgh in 1975, having been 'very active in left-wing politics', to find the place 'toffee-nosed, and I'd fairly sound off about that,' he recalls. Stirton was studying for a Master's degree, specialising in Symbolism, while 'Michael was doing his PhD, so didn't attend classes'. Stirton had been influenced by the Hungarian art historian Frederick Antal, and his gratifyingly undogmatic brand of Marxist cultural history. Antal had been part of the Budapest 'Sunday Circle' led by Georg Lukacs, and befriended Anthony Blunt after his flight from Nazism; Blunt commissioned Antal to conduct classes at the Courtauld. 'A number of people had gone to the pub after an evening lecture,' Stirton remembers. I got

fairly drunk and was wittering on about the deficiencies of
the Courtauld and the level of intellectual discourse. And
this well-spoken English guy was listening politely. As we
joked and laughed at our pathetic concerns, I mentioned
that I was staying in a flat at Marylebone with people I didn't
particularly like. And the man, Michael, said immediately:
"Why don't you move into my place? It's a squat in Primrose
Hill, it's huge and you can have a room."'

After which 'Michael and I became inseparable. We drank,
we visited galleries, and we slagged off the establishment
where we studied. Michael was something of an outsider
at the Courtauld and we shared the same salt-and-peppery
view of art history, which was a relief to me after a year
of feeling the pressure to act as a professional Scotsman
in London.' When Michael was asked by Phaidon to write
books on *Mythological Painting* and *Nude Painting* for a
new series, and to recommend others for further titles, 'he
got his friends to write them. I did the Renaissance, Mark
Jones did Impressionism,' recalls Stirton, who now lectures
in design history at Bard Graduate Center in New York.
'We were all very different people, our set: Michael had no
time for academic art history, I'm an academic and Mark
has been knighted. Michael's thing was that he hated the
po-faced people who took themselves and their work too
seriously. I take my work seriously, but it's not brain surgery,
for Christ's sake, it's art history. And for all our differences,
Michael and Mark and I all agreed that you have to have
some perspective, send yourself up a bit – and not depend on
having a few half-baked ideas blown out of all proportion.

Michael was actually a very good scholar, but he believed in stepping back, finding a personal response to the period he was working on to get a fresher view. He believed that way you actually get closer to the spirit of things.'

For that reason, Stirton believes, Michael 'had ceased to be an art historian, though he never moved away from art. He understood the character of art. He could be hard on art historians, perhaps too hard, and yet art was what shaped his view of culture and history. He just didn't like the rigidity of art history in the academic way. He wanted to write books that would allow him to travel, without being too restricted by the brief.' Michael and Paul Stirton began writing travel guides to Hungary and Romania, Communist at the time, together. 'But even then, he was hankering to go off on his own to write these more impressionistic histories, based on personal experiences in Spain, or Latin America. Whatever he wrote about, art was at the centre of things, and the visual arts never went away. In the last fifteen years of his life, he became an obsessive Hispanophile, and in that regard: Velázquez had never gone away.'

'This book was a coming back for Michael,' says his friend van Hensbergen. 'He had written wonderfully about Spain, then ventured to Latin America for these marvellous travel books. Now, he returned to Velázquez – his first love in painting – for a book that would close the circle.'

'Michael,' says Stirton, 'always believed in the wonder of *looking*. Yes, there may be a profound message in a painting, but Michael didn't want to dress it up in philosophical trappings. By all means approach a painting in a scholarly

manner, but never lose the wonder.' And Stirton makes a further relevant point: 'Michael separated art from moral judgement about life. He doesn't judge the art in relation to the character of the artist – he was amoral in the best sense. It's D. H. Lawrence's idea of "Never trust the teller, trust the tale. The proper function of a critic is to save the tale from the artist who created it." Michael was an iconoclast, and Velázquez was a courtier, a toady – but there was only one man who could paint *Las Meninas*.'

During one of our conversations, Michael set out the principles that underpin what he says about his engagement with, and wonder at, *Las Meninas* and all painting: that 'whatever mystery or "answer" I want to find in Velázquez's painting would lie in the poetic and artistic, rather than the documentary, meaning of the work.'

Las Meninas directs you literally outside itself, and Michael urges our appreciation and Proustian exploration of painting to entwine past, present and future, what Michael called 'the world within your mind and that without the gallery. Painting as a place to which we refer as point of reference, make associations with our own experience and the world beyond.' Foucault was attacked precisely for this, by those who worried that works of art would have no value beyond being a tool for philosophy or politics, and should be taken, like that Bach prelude, for what they are, alone. But Michael liked Alberti's dictum: 'For their own enjoyment, artists should associate with poets and orators who have many embellishments in common with painters and have a broad knowledge of many things.'[15] Indeed, Michael

thought artists should associate with just about everybody.

Not that Michael had much time for the opposite extreme to the purists: he was equally unimpressed by the Marxist idea that all art must be accounted for in its social and economic context. In this book, he is derisive towards narrow Marxist criticism which supports that view. And he may well have thought politics 'vulgar', as Mark Jones says, in contrast to the higher claims of art and aesthetics. But, like Blunt, Michael was a moral man engaged with the world, who may perhaps have been interested in the splicing between 'politics' and 'the political' – as described in a recent book I showed him by the Greek lawyer–philosopher Costas Douzinas, a professor at Birkbeck College in London. 'Politics,' Douzinas says, should refer to 'horse-trading' by and between political parties who share common interests as a ruling elite and fabricate differences for electoral effect, while 'the political' should describe urgent everyday realities of, tensions within and real-life riptides beneath our society in crisis.[16] Douzinas writes how in France, political scientists talk about *La Politique* to describe the former, while *Le Politique* refers to the latter. So that Michael, ever-disdainful of political parties, nonetheless – on his way to the Prado to see his Velázquez again in 2012 – heeds the demonstrations by the *Indignados* (the 'Indignant' movement on the streets of Madrid which has since grown to become *Podemos*, Spain's biggest party in the polls, protesting against austerity specifically and capitalism generally) and takes them with him into the museum; they become part of the experience. Michael was not an overtly angry man, but his passage in this

book on 'politicians who exploited all their privileges while telling others to tighten their belts' and 'bankers who had offered ridiculous incentives to purchase mortgages only to kick out onto the street many of those who did' seethes with rage – which is not dispelled before the painting and which cannot but infuse the picture, at least for a while, until the spell of escape, and the gaze, work their magic.

So Michael saw the experience of a painting as being one that encouraged associations with one's own life, 'with the world left outside the gallery', as he put it. In his book about artists' colonies at the end of the nineteenth century, *The Good and Simple Life*, he is scathing about how most painters wanting to live that life considered 'the downtrodden country folk . . . as little more than quaint components of the rural scene. Their social conscience was as little stirred by them as was that of seventeenth-century artists by pipe-playing goatherds in the Roman Campagna.'[17] At moments, although he is the antithesis of a 'political' art critic, Michael's writing reads like Walter Benjamin fresh from his Frankfurt School, but with a glass of Sangria in his hand.

Conversely, and more importantly, Michael's way – he said during one of our lunches at Ombra – was 'to let a painting release the imagination, send you off the leash and deep into the picture itself too, not tether you outside it, but rather lure you, seduce and betray you if necessary. That's how Velázquez worked, and that is how I need to work on his painting; to take up his invitation to get behind the eye staring out at us. That's how we need to look at it,

that's how it enables us to take refuge in the painting – you know, to rise above, well, all this crap.' And Michael waved a hand across a newspaper lying on the table, reporting the latest toxic babble of 'politics' rather than 'the political'. Or, as he writes in this book: 'I diagnosed Velázquez as taking increasing refuge in the realm of the imagination,' and therefore: 'I began seeing *Las Meninas* itself as a refuge from the disintegrating world outside. In the stream-of-consciousness state to which I was gradually being reduced, everything seemed to lead back to *Las Meninas*.'

So: the world in the painting, but the painting as an escape from the world – there appears to be a paradox here, but there is none. Michael loved Samuel Beckett, and was terribly proud of the fact that his grandmother Sophie, the opera singer, had been among the first to recommend that Beckett go to Paris to write. I had reread much Beckett during the period of my injury (a dangerous thing to do!) and Michael and I talked often about Beckett's fundamental idea that everything contains its own negation, and his vivid portrayals of a place in existence that is apparently self-contradictory, or a kind of limbo. 'Beckett setting up shop in the void' is how Professor Declan Kiberd put it in a lecture recently, making a terrifying analogy between the metaphysical void and the no man's land between trenches in World War I.[18] I once pulled out an exercise book and read something I had noted, from Beckett's *Happy Days*, to Michael: 'Sometimes all is over, for the day, all done, all said, all ready for the night, and the day not over, far from over, the night not ready, far, far from ready.' 'Excellent!'

replied Michael, 'that's the place where *Las Meninas* exists.'
Painting as a *zone*, a hinge not just between 'epistemes' in
history but between spaces of consciousness, light and dark,
day and night, 'life itself' and death.

There is of course something psychedelic in all this.
Michael had a keen eye for the surreal and unreal; sense
within nonsense, logic within apparent dichotomy, a visual
equivalent of that which was captured in language by
Beckett. Sometimes, Michael saw unreality where a simpler
explanation would apparently suffice. His consideration, in
another book, of Gauguin's important painting *Vision After
the Sermon* leads him to write: 'Gauguin's picture is very
unreal: one of the wrestlers has a pair of wings, and some
of the onlookers are inexplicably praying.'[19] The scene is
indeed of a wrestling pair, one of whom is winged, watched
by Breton peasant women in headgear like sails. And it
very obviously depicts, albeit with striking innovation of
palette and composition, Jacob wrestling with the angel: a
well-known mystical and allegorical subject painted with
surprising rarity, though it is the subject of Delacroix's
famous fresco in Saint-Sulpice, Paris, and of one of the great
Romanesque cathedrals, in Vézelay. On this interpretation,
which would be mine, the painting is visionary, but not
unreal at all, the prayers entirely explicable. But Michael
does not want to accept even this pigeon-hole explanation.
Michael regards the 'inexplicable' picture as 'central in the
history of symbolist painting' in 'retreat from the realities of
modern life'. The history of the painting bears Michael out:
it was carried in triumph by artists at the Pont-Even colony

for donation to the priest in the hamlet of Nizon nearby – who refused it, 'saying that it was not sufficiently religious', for all the apparently obvious illustration of Genesis 32: verses 22–32.

But what really interests Michael about Gauguin's picture is that it has 'evoked timeless and spiritual qualities', and has done so 'through the strangeness of the overall composition.'[20] And this, an early critical observation, is one Michael picked up time and time again during our conversations about *Las Meninas* – what he called its 'strange sum of the parts into the stranger compositional whole'.

This brings us to the matter of *composition*, as taught by Blunt, and its relation to what, Michael tells us in this book, he regards as the key to painting generally (and to unlocking *Las Meninas*): 'dignity of technique' – the phrase he gratefully takes from R. A. M. Stevenson. Michael believed that, he told me, 'the alchemy of *Las Meninas* lies in the way that "dignity of technique" achieves the composition'.

So, we must start where Blunt began, ergo where Michael began, at the beginning: what is 'composition'? And how does Velázquez, in this painting, stretch its laws, and those of perspective as defined in the Renaissance, when he studied, as taught by Blunt at the Courtauld? In our conversations about *Las Meninas*, Michael said he believed the mystery and appeal of the painting to lie in a complex design which combined the lines 'drawn' by the exchanges of gaze between the painter (and others in the picture) and the viewer/sitter, and the use of multiple perspective planes and the spaces they define. To investigate this, Michael planned to go back

to Petrarch and the supposed 'invention' of compositional perspective during the early Renaissance, and examine how it was used, and its influence on Velázquez.

Velázquez would have been learned in the perspective systems first forged in Italy, and Michael and I talked about how a theory of composition began with – or was revived from antiquity by – Petrarch in his *De remediis utriusque fortunae*, written between 1354 and 1356, the book sometimes said to contain the invention of perspective, and almost certainly taught to Velázquez by Pacheco. Taking a form from Seneca, Petrarch presents a one-sided dialogue between Gaudium, who declares his love for painting, and Ratio – reason – who posits arguments against this enthusiasm, which Petrarch crafts into self-defeat, thereby justifying Gaudium. Here is a wonderful exchange, as translated by Thomas Twyne in 1579, who captures the original Latin better than modern English can:

> Gaudium: I am specially delyghted with painted tables, and Pictures.
> Reason: Thou conceivest delight in the pencill and colours, wherein the price, and cunning, and varietie, and *curious dispersing* [my emphasis], doth please thine eye; even so likewyse the lively gestures and lyvlesse pictures.[21]

After Petrarch, Leon Battista Alberti – as related by Blunt in his famous book (*Artistic Theory in Italy, 1450–1600*, which Michael admired enormously) – set the laws that

governed art within those of his civic philosophy that 'the highest good is the public interest', thereby underwriting this rapport between painting and the world so precious to Michael. 'Many of Alberti's ideas on these general and philosophical and political subjects are reflected in his writings on the aesthetic field,' wrote Blunt. Painting thus 'gives a picture of the activities of man, like a written history – as Alberti put it: "one painting with words, the other with the brush"'.[22]

But Alberti stipulates: 'Since painting strives to represent things seen, let us note in what way things are seen.'[23] Blunt develops this further argument from Alberti, and discussed it with Michael: 'Though the exact imitation of nature is the first function of painting,' says Blunt, 'it has another and more important duty. The painter must make his work beautiful as well as accurate.' Petrarch finds beauty in what he so gratifyingly calls the 'curious dispersing' of 'varietie' to make a composition. For Alberti, 'Beauty is a kind of harmony and concord of all the parts to form a whole.'[24]

Estrella de Diego, whom we met earlier supporting Foucault, makes much of the Renaissance notion of perspective as being a 'pyramid' which guides all lines, and thereby the viewer's attention, towards a single vanishing point. She posits that this straitjacketed – aesthetically almost tyrannical – approach predicted the Enlightenment, an inflexibly scientific world view and 'intelligent colonialism'. She sees the multiplicity of perspectives in *Las Meninas* as a break from Renaissance thinking. But Diego decries the sheer weirdness of what the Italians were doing, and what

Velázquez would have seen them doing when he visited Italy. No one puts it better, or more ominously in his way, than the genius Giacomo Leopardi: 'Once man had changed, nature had to change too.'[25]

R. A. M. Stevenson wrote in the nineteenth century about 'the nervous force of the brain' – a good expression – working across a picture. This idea echoes one that Alberti had introduced: that perspective was not just a matter of geometry, but also what Alberti called the 'truth of the eye', which worked in its own way – so that 'composition' would entail a contrapuntal relationship between this 'truth' and Euclidean geometry.[26]

The entwinement between perspective and 'the truth of the eye' to achieve an eeriness of composition – of the kind we have in *Las Meninas* – was advanced in Italy by Piero della Francesca, a mathematician as well as a painter, who in his written exercises explored the relationships between geometry, space and the workings of the eye. In one painting, Piero plays tricks with perspective and eye level, and makes the seasons themselves share a space in defiance of one another. This is the *Resurrection* in Sansepolcro, which has three different eye levels, dividing the perspective horizontally towards three vanishing points. The picture is also divided left from right by a bold and suggestive piece of thematic symbolism: Piero paints a landscape in winter behind one shoulder of the risen figure, and in spring behind the other. In another of his frescoes, the *Madonna del Parto*, Piero creates spaces on a plane which operate like a series of chambers, spaces unto themselves, yet leading to others. The

painting features what were described at a conference on the fresco as 'positive and negative spaces within a painting' that enabled Piero to 'treat a volume of space as a substantial form which is at the same time open and closed'.[27]

None of this reflects Diego's rigid idea of Renaissance perspective – quite the reverse: as Michael and I agreed, Piero paves a way towards the ambiguities in *Las Meninas* and the way in which its perspective systems and uses of space lead us outside the frame. In the *Madonna del Parto*, the geometric spaces expand well beyond the fresco itself, to create a dodecahedron (a sphere made of twelve pentagons, similar to a football), which, I found out later, was the shape made in lead which the Etruscans buried with their dead. This explains the pagan origins of the location of the chapel and graveyard, formerly Etruscan, *outside* the Tuscan town of Monterchi – rather than as usual in the church on the central piazza – for which the fresco was painted. (And where the fresco remained until – recently and unforgivably – it was moved into a building beside the town, complete with booming video and gift shop.) This revolutionary use by Piero of multiple perspective and of 'closed and open' space, and their extension beyond the frame, is crucial to the mystery of *Las Meninas*.

One of the trails I was able to follow after Michael's death was that laid in his notebooks, given to me by Jackie Rae. It was quite frightening to open them; not fancy Moleskines, just ordinary budget school exercise books full of almost illegible handwriting in fountain pen, sometimes biro. They are three in total – not many, indicating how much of

Michael's work happened in his head (and heart) and how little of it was written down in his impossible hand (there are no signs of notes on any computer – unlike me, Michael owned and used an iPad, but was otherwise as hostile as I am to the intrusion of digital gadgets and cyber-communication on our lives).

The notebooks are filled for the most part with referenced observations by other historians and art historians. They seem intended to ensure proper footnoting, and show awareness of what had come before on *Las Meninas*. But when it comes to the nineteenth-century writer R. A. M. Stevenson, Michael underlines and annotates in a way that indicates his keen enthusiasm, and his desire to deploy this man and his work on Velázquez. Unsurprisingly so, for in Stevenson's writing, we can see a heredity of argument and joy in the painting that connects Alberti's 'truth of the eye', via the tricks in Piero's *Resurrection* and *Madonna del Parto*, to *Las Meninas*, and illuminates Michael's intentions for *Everything is Happening*.

Stevenson was the slightly older cousin to Robert Louis of *Treasure Island* fame. In his book, Michael gives us an idea of the centrality of Stevenson to his understanding of *Las Meninas*, but when I found Stevenson's book on Velázquez, it was revelatory about how Michael's work on Velázquez might have progressed. Michael tells us here how no one had ever borrowed the copy he found in a library, and nor had they from that library which had withdrawn and sold, second-hand, the edition I came upon.

First, and importantly, there is the matter of Stevenson's

personality itself, as described in the introduction to his *Velázquez* by Denys Sutton, to which Michael refers. 'He was no respecter of persons or institutions,' wrote Sutton; 'he was ever a Bohemian in fact.' I can feel Michael sitting up in his chair already. Young Stevenson established something called the LJR Club – 'the initials stand for Liberty, Justice and Reverence' – which 'began to disregard "everything our parents taught us", and socialism, atheism and the abolition of the House of Lords were amongst the topics debated'.

In his famous cousin's words, Stevenson 'had the most indefatigable, feverish mind I have ever known; he had acquired a smattering of almost every knowledge and art; he would surprise you by his playing, his painting, his writing, his knowledge of philosophy and above all by a vague, disconnected and totally inexplicable erudition'.[28] Robert Louis Stevenson had earlier written to his cousin thus: 'I remember very well your attitude to life, this conventional surface of it. You had none of that curiosity for the social stage directions, the trivial *ficelles* of the business [of art]; it is simian, but that is how the wild youth of art is captured; you wouldn't imitate, hence you kept free – a wild dog, outside the kennel – and came damn near starving for your pains.'[29] One cannot imagine Michael starving, but for the rest, Stevenson was a man after Michael's heart, and vice versa.

Stevenson moved to Paris in 1894, enrolling in the studio of Charles Auguste 'Carolus' Duran, alongside John Singer Sargent, where he lived like a 'Chekovian permanent student', writes Sutton, and was once arrested and accused

of spying for Germany. With his cousin, he canoed the Meuse and Somme 'helped along by Burgundy and tobacco', and although 'a romancer', he was even like Michael when it came to flirtation and women: 'After having picked up and taken out a couple of laundresses, he made it clear that his intentions had been strictly honourable,' writes Sutton.

Stevenson immersed himself in the Impressionist movement, as a revolutionary wave in artistic thinking, brilliantly described in Zola's novel *L'Œuvre*, which Michael and I talked about a great deal, and which had been a mandatory text for study at the Courtauld. Zola unfolds a dialogue, among other things, between two friends: his painter character Claude, portrayed as a depressive mutation of Manet, and Sandoz, who closely resembles Zola himself; it explores the entwinement of the former's early Impressionist painting and the latter's Naturalist writing. Sandoz seems to channel Stevenson when he says: 'This is the idea. To study man as he really is. Not this metaphysical marionette they've made us believe he is, but the physiological human being, determined by his surroundings . . . That's the point we start from, the only possible basis for our modern revolution . . . And that means a new art is bound to spring up in the new ground', which was to be Impressionism.[30] In this spirit, Stevenson's writing peels back the word 'impression' to its raw state of *impact*. As did Petrarch with his 'curious dispersal', Alberti with his 'the truth of the eye', Piero with his mapping of space – and certainly Velázquez in *Las Meninas*.

In one insightful passage, Stevenson, showing an interest in what the French poet Baudelaire called *correspondances*

between music and vision, talks about painting as 'the art of space' and music as 'the art of time', which he regards as 'the only pure art'. His idea is connected to Michael's admiration for the 'dignity of technique'. Stevenson writes: 'Every shade of the complicated emotion in a symphony by Beethoven depends entirely on technique – that is to say upon the relations established amongst notes which are by themselves empty of all significance.'[31] Michael's enthusiasm for Stevenson was shared by his friend Paul Stirton, who wrote about 'Stevenson's attempts to understand the mysterious alchemy whereby marks on canvas can form recognisable shapes, assume meaning and develop conceptual significance'.[32]

This is in no small measure the genius of *Las Meninas*. Michael does not quote this passage from Stevenson, but well he might: 'The mind glides past these ghosts of objects unless they are made too strange; hence they should not fix the eye but play loosely in a free medium . . . Now, after some study, you will find in *Las Meninas* this same art of distributing the attention. Wide as it is one looks at it easily as a whole, and at every subdivision as an inseparable part of a scheme. The central Infanta, by the force of light, by the surrounding definitions, by the strong opposition of the open door . . .'[33]

Mark well the open door in this scheme of things, for to this Michael will return. The eye, writes Stevenson – and this is one of Michael's central arguments – 'is gratified unconsciously by this artifice, and the *impression* [my emphasis] of unity is made almost overwhelming, although

the means used in no way intrude themselves, and you would swear that all that is was executed in the same style and by no subtler magic than a reflection in a mirror'.[34]

In *Las Meninas*, the magic is achieved in part by multiple vanishing points, not a unitary one, and a multiplicity of subjects. Like Piero, Velázquez is challenging nature, with a view to surpassing it. The magic, said Michael, lies in Velázquez's technique in guiding what he called in conversation 'the eye's unconscious habit' across the planes, spaces, forms and colours, masses and definitions to achieve 'the perfect composition, like a spell, the perfect pictorial synthesis'. Among the things Michael wanted to say in his book was that Velázquez had achieved in this painting what he called 'the culmination to perfection' of 'all those adventures in optics and composition' which had occupied the greatest artists and philosophers of art from Petrarch onwards. But to what effect, to say what?

This would be revealed in time, as Michael's health deteriorated. But it begs the question: what if a painter were to try and paint an 'art of time', to use Stevenson's expression? What if a painter were to try to use technique – which Stevenson calls 'the indivisible organic body of a man's conceptions' – to capture a passing of time, of life towards death; of generations, not just by portraying them, but by means of 'composition' to achieve an 'impression' of these things?

And if a painter were to do this, how are we supposed to react? Michael wanted it both ways. For all Stirton's point about Michael not wanting the message of a painting to be bogged down in 'philosophical trappings',

Michael welcomed the philosopher's intrusion into the world of art history, just as he welcomed the world. But he also advocated the understanding of a work of art 'in a purely pictorial way' in the total sense. My notes from our conversations are full of the words 'spontaneous' and 'existential', as well as: 'What is there on the canvas to be seen and entered into, if only we'd look at it – if only we'd look *for* it?' For Michael, all facets of colour, line, tint, tone – as well as character and mood – were in this painting harmonised into a whole, and the whole had a vividly personal impression on the viewer.

But who is the viewer nowadays, exchanging Velázquez's stare? Michael carved a politically incorrect and dangerous path between academe and mass tourism: as we have seen, he distrusted the former, but had little regard for – and feared – the latter. In his book *The Robber of Memories*, in which he defies the ease of modern travel by navigating the river Magdalena from its release into the Caribbean Sea to its Andean source, he is appalled to reach a wonder of pre-Colombian sculpture in the remote jungle alongside an American who asks: 'You gotta wonder what they were smoking to do this shit.' We know the feeling, now that everyone is everywhere, with just as much right as we have to be there: even in the Colombian jungle, let alone while trying to admire a painting in the Louvre or Uffizi among hordes of people looking at the canvasses through the lenses of their iPhones before proceeding to the next 'selfie' with David's *Death of Marat*. I found myself trying to enjoy a Turner painting the other day while a loud conversation

behind me ran: 'Four years ago, we could've smashed those Tesco brands.'

This is not snobbery – Michael and I just lamented being the last generation to have been able to savour the masterpieces in anything like peace. Michael pondered this guiltily and undemocratically – feeling bad about the implied elitism but without any ideas towards a solution. In *Everything is Happening*, he writes about the mirror with which the crowds could see reflections of *Las Meninas* becoming a greater attraction than the painting itself, and he talked about the need to forego his favourite paintings these days, because the heaving crowds made it impossible to look at them.

With mass tourism and the exhibition spaces that support it, painting loses the aura of the original of which Walter Benjamin wrote, in reaction to the proliferation of reproductions. The painting itself now becomes part of the 'disintegrating world' from which Michael sought refuge in painting – and herein lies a savage, Beckettian irony.

Michael Baxandall wrote that in Renaissance times, 'everyone agreed that only an informed beholder could draw real satisfaction from paintings, as indeed from literature; but "informed" in what sense?'[35] Michael answered this good question by quoting Baxandall's summation of a dictum among the Renaissance thinkers themselves, when they tried to work out the distinction between 'moral virtues and intellectual virtues'. As Baxandall put it: 'moral virtues being irrational and of the affections, intellectual virtues being rational and concerned with truth and falsehood'.

'It needs a stiff shot of the former,' Michael said, 'with a dash or more of the latter.'

Even through the massed crowds, the truth of the gaze remains. And not just Velázquez's gaze. Someone else exchanges your stare, over his shoulder, at the very back of *Las Meninas*. He is the only person other than you who surveys the entire scene.

During the months before his diagnosis, Michael discussed *Las Meninas* with his fellow Hispanist and friend Gijs van Hensbergen, purveyor to Michael of the theory of the Infanta's addiction to 'chocolate'. Michael and van Hensbergen originally met on an evening that neither would ever forget. 'I was president of the student union,' recalls van Hensbergen, 'and had organised a Viennese ball. During the day of the ball, I went up for a seminar with John Golding (of all people) in the middle of which he received a call and broke down in a flood of tears. It was Blunt, telling him the news. We kind of all knew by then – or at least one aspect: a lecturer had given me a photo of Blunt in drag and told me to keep quiet about it. I hid it in my copy of Blunt's book, signed by Blunt. Anyway, that evening, it was all over the six o'clock news – that Blunt had been a spy. And that evening Michael came to my ball, and we met.' From then on, 'he came to visit us in Spain'; Michael and van Hensbergen teamed up to conduct upmarket, bespoke tours of Spain for visiting millionaires. One, unforgettably, involved taking an American former jazz-club dance champion in her nineties, and her 'boyfriend aged twenty-five', around the sights of

Galicia, which required 'finding a hairdresser and then a late-night club for them to go to at the end of each day. She would stay in the club until three or four in the morning, while we slept, and be up at eight, ready to go sightseeing while the twenty-five-year-old boyfriend slept in.' Michael and van Hensbergen shared their mutual passion for the country, its food, its art, its greatest painter – and his greatest painting.

'I've always been obsessed with *Las Meninas*,' says van Hensbergen. 'It's the most extraordinary painting that ever existed.' Van Hensbergen talked more recently with Michael about 'illusion in *Las Meninas* – art as artifice, the 3D spaces in a two-dimensional canvas. We wondered whether Velázquez had used a ground glass lens to achieve what he had in *Las Meninas*' (a machine equivalent to a *camera obscura* possibly used by Vermeer, which projected a reproduced upside-down image, retina-like, of what it saw onto a surface). In the projection of the painting, says van Hensbergen, 'the King is of course us, and in the mirror at the other end of the room, we are the King and Queen'. But Michael and van Hensbergen wondered: what is Velázquez painting? 'A double portrait of the King and Queen has never been found, and if that is what he is painting, then it is the picture he never got to paint. I don't mean literally – I mean maybe in every sense.'

This, argues van Hensbergen, intensifies the sense of forbidden fruit in *Las Meninas*, the illicit nature of the scene similar to those paintings by Piero della Francesca from which the Virgin's attendant and the soldier stare at us. 'Velázquez's brief gaze is just about to come to us,' senses van

Hensbergen, 'so that we are being allowed to see something which we are not really allowed to see. This is as about as intrusive as one can get in the parameters of court etiquette. We are seeing the King and Queen seeing their daughter. It's not really a portrait of anyone, nor is it a group portrait either. It's something we should never have seen. It's like a diary written by an artist which they never wanted to be seen until after they die.' Cora Gilroy-Ware, curator of a compelling exhibition at Tate Britain on the sexuality of *putti* and nymphs in British art after the Napoleonic Wars, adds eerily to van Hensbergen's idea of taboo, citing the trope in the Bible, classical myth and other legends of men peeping at women bathing – depicted avidly by romantic painters (and Rembrandt, indeed). 'It was seen as both a privilege and a transgression,' she says, 'which could lead to madness.'

Of all those present in *Las Meninas*, says van Hensbergen, 'the one person who also realises this is that man at the rear. He seems to sense this too, that he is not supposed to be there. He's just sneaking a peek, as are we. But then, he is standing next to the reflection of the King and Queen.' He is the one person who looks across the entire length of the room, and its projection towards us; the one figure who cannot see the mirror from where he stands, yet has either come from, or makes his way back into, the zone behind it, which is also behind us, albeit invisible.

There was one unforgettable conversation with Michael at Ombra, about valedictory painting and sculpture by our favourites. Michael chose – oddly, I thought at first, but I now see its crucial ramifications for *Las Meninas* –

Manet's final masterwork, *A Bar at the Folies-Bergère*, in which the lovely figure of the barmaid stands before a mirror in which the action is reflected, though the angle is either impossible or the result of an optical trick by the artist, as in *Las Meninas*. This theme was emerging: mirrors and death. In Albert Camus' play *Caligula*, the mirror heralds death – in Velázquez it faces us and in Manet it looks behind us at a reflected world.

It was long after Michael died that my teenage daughter Claudia enlightened me further as to Michael's choice, very gratifyingly, while we were at the National Gallery together for an exhibition called 'Inventing Impressionism'. The show included another very late portrait by Manet of which I was entirely unaware – from a private collection – of another barmaid also standing before a similarly placed mirror, and a shadowy figure to the right of the canvas. I told Claudia about Michael's valedictory choice, pontificating away. 'But of course Dad, it's the doppelgänger isn't it? See yourself, and it's a sign you're going to die.' She was right, of course; I was flabbergasted, as much by Claudia's young insight, as by the point she had made.

So I see now a bitterness in Michael's choice I missed at the time; a bitterness, though, that cannot have occurred when he used to look at Manet's painting in the Courtauld, with Paul Stirton. 'The *Bar at the Folies-Bergère* was hung in pride of place in the old gallery at Woburn Square,' recalls Stirton, 'on the end wall of a corridor, looking through a tunnel of rooms towards Manet at the end. It exuded magic, even at fifty yards. I remember looking at it with Michael:

he had a harsh word to say about most paintings in those days, and he never shared the taste for Impressionism. But we would stare in wonder at that picture, in silence. The mid 1970s, this would have been.'

My choice was brutal, I suppose: Donatello's shattering scenes of mental and physical violence on the bronze pulpits at San Lorenzo in Florence, especially the violence of soldiers towards the crowds at the crucifixion, and – on the opposite, southern pulpit – the figure of the risen but exhausted Christ, arrived directly from his execution on Friday and Saturday in Hades. Donatello cast the scene on the eve of his death, and one account relates that it was reluctantly commissioned by the church, out of respect for the dying master. We can see, this account says, 'the shift, as it were, towards the second pulpit, expedient for the maintenance of the maestro, until his death, which was already foreseen as imminent'.[36] The sculptor is portraying his own death, or at least the sentiments of tumult he felt as the death foretold approached. Thus Michael and I tiptoed towards another idea: the valedictory painting in the beholder's eye, not that of the artist, the way in which a painting can change, and reveal its meaning, as one approaches death. And by stealth, though it was not spoken, we talked about how a painting might change – or the emphases within it change – when one knows one is dying.

Michael broached the subject in a way that drew, estimably and typically, not on the matter of his death, but on the above points of composition which he had established anyway. He talked about how the 'truth of the eye' leads towards the

back of *Las Meninas* and that figure we find there walking through the open door, the smallest and apparently least significant player on the stage that is this canvas. I recalled a line used to describe the figures in Piero della Francesca's disconcerting and surreal depiction of the Flagellation – another painting of fixed stares, though not towards the viewer – and did so with a shiver: it contains what the leading authority on Piero calls 'the curious effect of distanced plane which paradoxically acquires its dramatic pathos through a reduction, not a magnification, of the figures'.[37] Eugenio Battisti refers here to the fact that the tethered Christ, and those whipping him, are in the background, while the foreground features the elders of state; likewise, the figure most 'reduced' by Velázquez's 'distanced plane' was now the most important to Michael, by far.

Earlier work on *Las Meninas* had found different significances in this mysterious figure. In 1888, the German scholar Carl Justi devised an interesting scenario to explain the scene in *Las Meninas* whereby the royal couple, sitting, become weary and the Infanta is 'sent for' to relieve them. 'The light, which, after the other shutters had been closed, had been let in from the window on the right from the sitters, now also streamed in on their little visitor. At the same time, Velázquez requested Nieto to open the door in the rear, in order to see whether a front light may also be available.'[38] Another interpretation, cited by Justi, has Nieto, the Queen's doorman, holding the door open so that some of the entourage may leave the room, hence the stirring of the mastiff by the dwarf Pertusato.

Michael's focus concerned this dark, mysterious figure at the rear of the 'stage' that is *Las Meninas*. Perhaps he has just arrived, but had a second thought, upon beholding the 'forbidden scene'. In an earlier book, Michael had described this figure as one 'who hesitates to come into the room', which is already an enigmatic remark, given that if he was about to enter, he seems to have decided against and turned away – why?[39] Or perhaps he is looking back as he leaves the painting through a doorway leading to a lit stairway up which he ascends, one foot a step further than the other.

His suspension in the picture is rather like that of the figure in another, so well known it has been ravaged by fame: Vermeer's *Girl with a Pearl Earring*. I used to find refuge in this picture over and over again while testifying on, and listening to the narrative of, war crimes at the International Criminal Tribunal for the former Yugoslavia in The Hague, much as Michael sought solace from the disintegrating world in *Las Meninas*. Despite today's mass fascination with the girl's gaze to the point of commodification, it survives because Vermeer, like Velázquez, is greater than his latter-day marketeers. Is she turning towards us or away? Is she about to speak, or has she just spoken? The drapery of her headscarf across her shoulders suggests both, simultaneously, so that Vermeer's picture becomes a portrait of time itself. Just as Michael came to see Velázquez's inclusion and positioning of this fleeting figure as being, among other things, a portrait of something similar – time, timelessness and the consequences of time. Whatever the figure of José Nieto signifies, he appears to be both arriving

and leaving at the same time, which makes him defiant of and omnipotent over time. Rather than creeping around the edge of the scene, he controls it. Like the Fates, Clotho, Lachesis . . . and Atropos.

Early on in *Everything is Happening*, Michael enthuses about 'the possibility that the composition's exact mathematics should harbour secret codes. The hint of wondrous worlds lying beyond the mirror and the open door beside it.' As he grew ill, Michael made two discoveries. The first was that the source of the reflection in the mirror, the King and Queen, is not directly opposite it, but further left, so that the royal couple appear to be receding from us, from view – occupying what Piero would have called an 'open' space, and visually disappearing in time, that is to say: dying.

Michael's second discovery concerned 'the open door beside it', to which the 'truth of the eye' is inevitably led from the mirror, through which the opaque and disconcerting figure enters and/or departs at the rear. An observation which gives Michael's notion of 'wondrous worlds beyond' an almost unbearably ironic focus: he had calculated that although there are too many vanishing points in the painting for the perspective lines to converge at any single point, they do run through that open door, to dissipate in the light beyond.

According to Michael's notes, he had been reading the writer Norbert Wolf, who, in his monograph on Velázquez, finds that 'countless investigations and mathematical studies of the perspective of *Las Meninas* by architects and engineers, art historians and theatrical experts, show the

vanishing point of the composition is the open doorway in the background'. Such a conclusion suggests, he says enigmatically, 'that the source of the reflection in the mirror, in line with the laws of optics, is not directly opposite it but further left. The reflection of the royal couple in the mirror thus seems to be vanishing out of reach.'[40] Carminati finds that 'the vanishing point, where all the lines meet, more or less coincides with the head of José Nieto Velázquez'.[41] In her essay on Foucault and Velázquez, Estrella de Diego makes a similar point, locating the open door as the painting's epicentre with regard to light by calling it 'the real luminous spot', rather than the Infanta.[42]

Foucault has much of interest to say about the open door and the figure of Nieto. He sees one of the purposes of the mirror being that 'it stands adjacent to a doorway which forms an opening, like the mirror itself, in the far wall of the room. This doorway too forms a bright and sharply defined rectangle whose light does not shine through into the room. It would be nothing but a gilded panel were it not recessed out from the room by means of one leaf of a carved door, the curve of a curtain, and the shadows of several steps. Against this background, at once near and limitless, a man stands out in full-length silhouette . . . He may be about to enter the room; or he may be observing what is going on inside it, content to surprise those within without being seen himself. Like the mirror, his eyes are directed towards the other side of the scene; nor is anyone paying him any more attention than to the mirror. We do not know where he has come from . . . Like the images perceived in the looking

glass, it may be possible that he too is an emissary from that evident yet hidden space.'

Foucault adds his view that 'the ambiguous visitor is coming and going out at the same time, like a pendulum caught at the bottom of its swing. He repeats on the spot, but in the dark reality of his body, the instantaneous movement of those images flashing across the room, plunging into the mirror, being reflected there, and springing out from it again like visible, new and identical species. Pale, miniscule, those silhouetted figures in the mirror are challenged by the tall, solid stature of the man appearing in the doorway.'[43]

For all the 'dark reality' of this man, for all his unthinkable challenge to the reflected King and Queen in the mirror, for all his demonstrating exactly Battisti's point about 'dramatic pathos through a reduction, not a magnification' on the 'distanced plane', Foucault did not give a name to the significance of this figure. Michael, however, did just that.

Michael's obsession with this man – whom he called, significantly, 'the other Velázquez' – and what he signified was explained poignantly. 'He's moving over to the other side,' said Michael by telephone one day, so that I could not see his eyes as he spoke. I hung up the phone, eyes full, and looked at the note I had taken: 'That's what the picture is about, Ed, life itself and life's decay until we reach the other side. And that's where our vanishing points lie to rest – through that door, up those stairs, to the other side of the doorway he's standing in.' Beyond the open door, behind the wall and mirror, the 'open space' which Michael now called 'the other side', lay the obliteration he faced.

Michael died before the Tate's exhibtion on nymphs, with
its furtive glimpses of bathing women. But he felt, I think,
that his new vision of Nieto's surreptitious transgression into
the room of *Las Meninas* could, like that of the privileged
peep, lead to madness.

Michael writes in *Everything is Happening*: 'The mystery,
if there was one, was that of life itself.' In his conversations,
the opposite was true too: the equal mystery of *Las Meninas*
was of 'death itself', at which Michael was staring. As a man
and friend, he was defiantly hopeful, full of the life force,
and sharp to the end. He even corrected me on his place
of birth while in an apparent stupor, less than forty-eight
hours before his death – I was saying to him how interesting
his heritage was for a man born in London, where we now
were. Apparently out of nowhere, he retorted: 'I was born in
Genova.' On that same day, hours from death, he was quick-
witted enough to make funny remarks about Milwaukee,
Wisconsin, whence a group of relatives had come to visit.

But the figure at the back of *Las Meninas* had become
Charon the boatman, and his staircase the river Styx.

Michael's friends, 'his people', who gathered for the funeral
and wake at a pub in Hampstead – and for a memorial some
weeks later in Shoreditch and another in Frailes – think of
him as caught unawares by his disease and snatched from
life. But I now imagine him to have been thinking about
his mortality even before his diagnosis. I was surprised to
find him say so overtly in the manuscript that *Las Meninas*
'held new depths of meaning for those ever more conscious

of mortality'. This is a melancholy awareness of death that many of us share, but Michael was less aware of death in public, and drank life more eagerly, than almost anyone I know. Yet in this book, his reaction to seeing himself in that angled mirror which tourists used to explore the eerie depths of *Las Meninas* is, with hindsight, even more disconcerting than Michael intended it; though we do not know when he wrote about the 'unsettling view of myself, baggy-eyed, weathered and balding'.

There is an element of self-deprecating humour here; I don't think I'm suggesting prescience. Yet the existential melancholy in these words is striking, and at odds with most of his previous writing and the tributes so beautifully paid to Michael Jacobs the *bon vivant* troubadour traveller.

In Michael's zero tolerance for 'sunless' expertise, almost unique among writers on art today, and from his singular and enlightened position, he has written here a passionate plea. A plea for pictorial cogency and dignity of technique epitomised by Velázquez, who, Michael believed, admits us 'behind his eye' more than any other artist. But what was behind Michael's eye? What was driving his book forward, where would he have ended?

Michael was preoccupied with a diametrically opposite idea to Foucault and all who came after him, who concentrated on what we have been calling the 'unseen presence' – the King and us, viewers of the painting – and on the way *Las Meninas* represents life, and represents representation. Instead, Michael was increasingly focussed on the open door at the back of the room. Towards and past that figure of the

'other Velázquez', to wherever he is heading on 'the other side', who, glancing towards us, urges us away with him. José Nieto Velázquez had become a mutation of Charon for Michael, looking back at him, head cocked to one side, as though beckoning, waiting. Michael was haunted by this man, whom he might have called 'death itself', already two steps up the stairs beyond the panelled wooden door at the back, the vanishing point bathed in light, into which Michael himself was vanishing.

Ed Vulliamy,
Bayswater/Glastonbury, 2014

BIBLIOGRAPHY

for *Everything is Happening* by Michael Jacobs

Anthony Blunt, *Artistic Theory in Italy, 1450–1600* (Oxford: Clarendon, 1962).

Jonathan Brown, *Images and Ideas in Seventeenth-Century Spanish Painting* (Princeton: Princeton University Press, 1979).

Jonathan Brown and J. H. Elliott, *A Palace for a King: The Buen Retiro and the Court of Philip IV* (New Haven: Yale University Press, 1980).

Michel Foucault, *The Order of Things: An Archaeology of the Human Sciences* (London: Tavistock, 1970).

Byron Ellsworth Hamann, 'The Mirrors of Las Meninas', *The Art Bulletin*, vol. XCII, March–June 2010.

Michael Jacobs, *The Good and Simple Life* (Oxford: Phaidon, 1985).

María Teresa León, *Memoria de la Melancolía* (Barcelona: Editorial Castalia, 1998).

Francisco Pacheco & Antonio Palomino, *Lives of Velázquez*, intr. Michael Jacobs, tr. Nina Alaya Mallory (London: Pallas Athene, 2006).

R. A. M. Stevenson, *Velázquez*, ed. Denys Sutton & T. Crombie (London: G. Bell and Sons, 1962).

Charles de Tolnay, *Velazquez' las Hilanderas and las Meninas: An interpretation* (New York: Garland Publishing, 1949).

Edgar Wind, *Pagan Mysteries in the Renaissance* (New York: W. W. Norton, 1958).

NOTES

to introduction and coda by Ed Vulliamy

Introduction

1. Jonathan Brown, *Velázquez, Painter and Courtier* (New Haven/London: Yale University Press, 1986), pp. 260–1.
2. Suzanne L. Stratton-Pruitt (ed.), *Velázquez's Las Meninas* (Cambridge: Cambridge University Press, 2003), p. 141.
3. Avigdor Arikha, *On Depiction: Selected Writings on Art, 1965–1994* (London: Bellew, 1995).
4. Joseph-Émile Muller, *Velázquez*, tr. Jane Brenton (London: Thames & Hudson, 1976), p. 220.
5. Marco Carminati, *Velázquez's Las Meninas*, tr. Susan Ann White (Milan: 24 Ore Cultura, 2011), p. 25.
6. Enrique Lafuente Ferrari, *Velázquez* (Geneva: Editions d'Art Albert Skira, 1960; English edition: New York: Rizzoli, 1988), p. 83.
7. Francisco Pacheco & Antonio Palomino, *Lives of Velázquez*, intr. Michael Jacobs, tr. Nina Alaya Mallory (London: Pallas Athene, 2006), p. 7.
8. Michael Jacobs, *Andalucía* (London: Pallas Athene, 1990), p. 96.
9. Ibid. p. 107.
10. Ibid. p. 105.
11. Pacheco & Palomino, *Lives of Velázquez*, op. cit. p. 13.
12. Ferrari, *Velázquez*, op. cit. p. 23.
13. José Ortega y Gasset, *Velázquez, Goya and the Dehumanisation*

of Art, tr. Alexis Brown (New York: Norton, 1972), p 92.

14. Xavier de Salas, *Velázquez* (London: Phaidon, 1962), p. 6.

15. Pacheco & Palomino, *Lives of Velázquez*, op. cit. pp. 181–2.

16. Carl Justi, *Die Familie Philippus IV*, 1888, quoted in Carminati, op. cit. p. 13.

17. Carminati, op. cit. p. 25.

18. Ibid. p. 68.

19. Michael Jacobs, *Mythological Painting* (London: Phaidon, 1979), pp. 66–7.

20. Elizabeth Ripley, *Velázquez: A Biography* (New York: J. B. Lipincott, 1965), pp. 60–1.

21. Michael Jacobs, *Nude Painting* (London: Phaidon, 1979), p. 49.

22. Carminati, op. cit. pp. 28–30.

23. Alisa Luxenberg, 'The Aura of a Masterpiece', in *Velázquez's Las Meninas*, Stratton-Pruitt (ed.), op. cit.

24. Ibid. p. 14.

25. Paul Stirton, 'The Cult of Velázquez', in *The Discovery of Spain* (catalogue), David Howarth (ed.) (Edinburgh: National Galleries of Scotland, 2009), p. 107.

26. Ibid. pp. 108–9.

27. Michael Jacobs, 'Colour and Light', in *The Discovery of Spain*, Howarth (ed.), p. 121.

28. Ibid. p. 123.

29. Michael Jacobs, *A Guide to European Painting* (Amsterdam: Chartwell, 1980), p. 142.

Coda: Out of the Painting

1. Giacomo Leopardi, *Zibaldone*, ed. Michael Caesar and Franco D'Intino, tr. Baldwin, Dixon, Gobbons, Goldstein, Slowey, Thom and Williams (London: Penguin, 2013), p. 1,074, para 2,568.

2. Michel Foucault, *Les Mots et Les Choses* (Paris: Gallimard, 1966), translated as *The Order of Things: An Archaeology of the Human Sciences* (London: Tavistock, 1970), p. 4.

3. Ibid. pp. 4–14.

4. Estrella de Diego, 'Representing Representation: Reading *Las Meninas* Again', in *Velázquez's Las Meninas*, Stratton-Pruitt (ed.), op. cit. p. 153.

5. Walter Benjamin, *The Origin of German Tragic Drama*, tr. John Osborne (London: Verso, 1998), p. 139.

6. Diego in *Velázquez's Las Meninas*, Stratton-Pruitt (ed.), op. cit. p. 154.

7. Ibid. p. 162.

8. Ibid. p. 158.

9. Foucault, *Les Mots et Les Choses*, op. cit. p. 5.

10. Ibid. p. 14.

11. Ibid. p. 314

12. R. A. M. Stevenson, *Velázquez*, ed. Denys Sutton & T. Crombie (London: G. Bell and Sons, 1962), p. 18.

13. Miranda Carter, *Anthony Blunt: His Lives* (London: Macmillan, 2001), p. 486.

14. Ibid. p. 421.

15. Leon Battista Alberti, *On Painting*, ed. John R. Spencer (New Haven: Yale University Press, 1956), p. 90.

16. Costas Douzinas, *Philosophy, Resistance and the Crisis* (London: Verso, 2013).

17. Michael Jacobs, *The Good and Simple Life* (Oxford: Phaidon, 1985), p. 13.

18. Declan Kiberd, 'Known Unknowns: Beckett after Joyce', lecture at the Beckett International Festival, Enniskillen, 2 August 2014.

19. Michael Jacobs, *The Good and Simple Life*, op. cit. p. 79.

20. Ibid. pp. 79–80.

21. Petrarch, 'Of Pictures and Painted Tables, the XL Dialogue', quoted in Michael Baxandall, *Giotto and the Orators: Humanist Observers of Painting in Italy and the Discovery of Pictorial Composition, 1340–1450* (Oxford: Oxford University Press, 1971), pp. 53–4.

22. Anthony Blunt, *Artistic Theory in Italy, 1450–1600* (Oxford: Clarendon, 1962), pp. 4–15ff.

23. Alberti, *On Painting*, op. cit. p. 68.

24. Quoted in Blunt, *Artistic Theory in Italy, 1450–1600*, op. cit. p. xx.

25. Leopardi, *Zimbaldone*, op. cit. p. 725, para 1,561.

26. See John White, *The Birth and Rebirth of Pictorial Space* (London: Faber & Faber, 1957; 3rd edn. Cambridge, Mass: Belknap Press, 1987), pp. 121–5.

27. My translation from unsigned introduction to compilation of papers given at the Convegno Internazionale sulla Madonna del Parto, Monterchi, 24 May 1980 (Commune di Monterchi, 1982).

28. R. A. M. Stevenson, *Velázquez*, ed. Denys Sutton and T. Crombie. op. cit. p. 14.

29. Ibid. p. 13.

30. Émile Zola, *L'Œuvre*, translated as *The Masterpiece*, tr. Thomas Walton (Oxford: Oxford University Press, 1993), p. 154.

31. Stevenson, *Velázquez*, op. cit. pp. 77–8.

32. Paul Stirton, 'The Cult of Velázquez' in *The Discovery of Spain*, David Howarth (ed.), op. cit. p. 109.

33. Stevenson, *Velázquez*, op. cit. p. 77.

34. Ibid. p. 127.

35. Michael Baxandall, *Painting and Experience in Fifteenth-Century Italy* (Oxford: Oxford University Press, 1972), p. 86.

36. My translation from Luisa Becherucci, *Donatello: I Pergami di San Lorenzo* (Firenze: La Nuova Italia, 1979), p. 10.

37. My translation from Eugenio Battisti, *Piero della Francesca*, vol. 1 (Milan: Istituto Editoriale Italiano, 1971), p. 319.

38. Carl Justi, *Diego Velázquez and His Times*, tr. A. H. Keane (London: 1899), quoted in *Velázquez's Las Meninas*, Stratton-Pruitt (ed.), op. cit. p. 125.

39. Michael Jacobs, *A Guide to European Painting* (Amsterdam: Chartwell, 1980), p. 142.

40. Norbert Wolf, *Velázquez, the Face of Spain* (Cologne: Taschen, 2011), p. 87.

41. Carminati, *Velázquez's Las Meninas*, op. cit. p. 30.

42. Estrella de Diego, 'Representing Representation', in *Velázquez's Las Meninas*, Stratton-Pruitt (ed.), op. cit. p. 153.

43. Foucault, *Les Mots et Les Choses*, op. cit., pp. 10–11.

Note

In Michael's book, he talks about his conversion to Cervantes' account of life as a series of apparently impossible chance encounters, but says he came to believe 'nothing in life happens by chance alone', implying some kind of magnetic force between people. When I found the book he so loved by Stevenson, I came to agree with him, when I realised . . .

My father entered World War II after two years as a conscientious objector, believing in 1941 that 'there will be no democracy left in Europe' if the Third Reich triumphed, and electing to overturn his principles and 'join a combatant unit'. His mother, an Irish Republican suffragette socialist, wrote to him that 'there come times when you men make it necessary to chose between two evils', and blessed his decision: 'good adventures, young man!' Dad despised the war, and my favourite story from that war concerns

his taking a convoy of fifty-five jeeps – which he was tasked to lead from Caserta to Vienna – on a wild detour of Tuscany and Umbria, in order that he might see and sketch the great buildings by Sangallo, Vasari and Bramante. He was not going to miss the chance, and was reprimanded for arriving in Vienna several weeks late, but cared not a fig. When returning on leave, Dad would visit an older woman in Brighton whom he adored, and who had a child and was erudite on painting. They had an affair, and Dad made the child a doll's house. We were led to believe that this 'Sonia' was a single mother, which would have been racy enough of Dad, in the day. It emerges she was not – she was married to an eminent art historian who was forever up in London living the good life and working away on R. A. M. Stevenson and Velázquez: Denys Sutton! What I would not give to tell this to Michael, and invoke his beloved Cervantes.

ACKNOWLEDGEMENTS

Gratitude tends to come last when writing books, so of course Michael never got round to the acknowledgements. But they can be easily imagined; indeed they were sometimes implied and in a couple of cases specified.

Any words would fail to adequately thank Jackie Rae for her love and courage during Michael's final weeks, then for her arranging of Michael's work into a publishable format. Also in those terrible days, Des Brennan became Michael's confidant; his devotion was so great he jokily referred to himself as Michael's new valet. It was also Des who collared me in the Polish restaurant that night of Michael's last dinner out and urged, with regard to finishing the book: 'You realise you have to do this'. Also around that table was Erica Davies, who we have met in the text and who was part of Michael's life from the Courtauld until his last day. Thanks also to Paul Stirton and Mark Jones, for their lifelong friendship to Michael, evident in the text, and their support for the book.

Thanks are in order to the people who fought the inevitable defeat against Michael's cancer: Tom Powles and all those at Bart's and the St Joseph Hospice in Hackney, London (especially the anonymous nurses to whom Michael

was so grateful for their prescription of 'marijuana and honey – splendid medicine!')

Deep thanks to Bella Lacey at Granta for her determination that Michael had written a book, not a fragment, which needed to be published, and for her expert edit. And to Will Atkins for his judicious copy-editing, Benjamin Buchan and Mandy Woods for their proofreading, and to Christine Lo for co-ordinating the edit. Thanks too to Cristina Fuentes La Roche, Director of the Hay Americas book festivals, for her support for Michael and establishment of a Michael Jacobs prize for travel writing. As one of the judges awarding the first such prize in January 2014 in Colombia – a country Michael loved as passionately as he did Spain – I came upon a world of words, colours, music, drinking and dancing where Michael's name lingers lovingly on everyone's lips, epsecially those at the Gabriel García Márquez Foundation who had inspired him and all his work: Jaime Abello, Ricardo Corredor, Natalia Algarín and Sergio Dahbar. Thanks likewise to the Colombian writers – and Michael's friends – Hector Abad, Santiago Gamboa and Daniel Samper; to the driving force of the former Colombian Ambassador to London, Mauricio Rodriguez, to his press attaché, Mercedes Osma Peralta, and to Johanna Zuleta.

In London, special thanks also to Michael's friend, and my colleague, Ruaridh Nicol, and to Ilona Leighton Goodall at the bookshop where Michael would arrive five minutes before closing, order a book, then propose an adjournment by all to the pub.

For my own part: thanks to John Mulholland, my editor

at the *Observer* and – more importantly – friend who engineered my introduction to Michael; and for all John's support for the book. Thanks to Mum and Victoria for their patience and care as I wrote my sections in pain, and to the surgeons in my own prolonged case, James Youngman and Shadi Ghali. Thanks as ever, when writing anything, to David Rieff and Paul Gilroy.

Above all though, at my end: Jon Lee Anderson is the finest reporter in the world, but – much more importantly – has become a friend in a way that I don't think would have happened had we not endured Michael's death together. Jon Lee and I were with Michael on the road – and thirty-six hours before he died, over two sessions of good conversation divided by a retreat from his bedside for an Italian lunch with a Piedmontese *Dolcetto d'Alba*, wishing Michael could join us. So thanks forever to Jon and his wife Erica Anderson for urging this work for Michael, and for those cold, overnight journeys back home to the West Country after Michael's funeral, and later at his memorial, swigging on a bottle of Mescal which Michael and I had bought together in Mexico, but which had lasted longer than he did.

INDEX